DEER WORLD

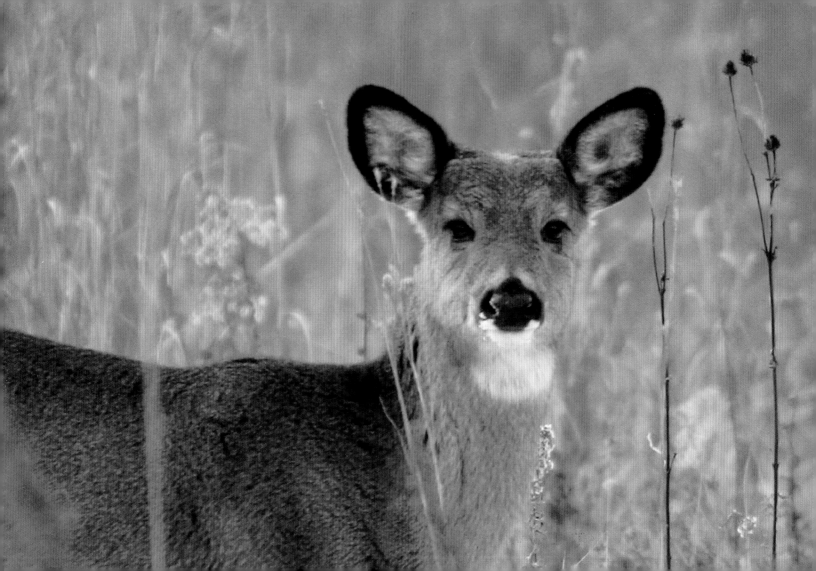

DEER WORLD

DAVE TAYLOR

The BOSTON
MILLS PRESS

A Boston Mills Press Book

Copyright © 2008 Dave Taylor Photographs copyright © 2008 Dave Taylor

Published by Boston Mills Press, 2008
132 Main Street, Erin, Ontario N0B 1T0
Tel: 519-833-2407 Fax: 519-833-2195
books@bostonmillspress.com www.bostonmillspress.com

In Canada:
Distributed by Firefly Books Ltd.
66 Leek Crescent, Richmond Hill, Ontario, Canada L4B 1H1

In the United States:
Distributed by Firefly Books (U.S.) Inc.
P.O. Box 1338, Ellicott Station, Buffalo, New York 14205

First Printing

The publisher gratefully acknowledges the financial support of our publishing program the Government of Canada through the Book Publishing Industry Development Program (BPIDP).

Library and Archives Canada Cataloguing in Publication
Taylor, Dave, 1948-
Deer world / Dave Taylor.
Includes index.
ISBN-13: 978-1-55046-501-3 ISBN-10: 1-55046-501-5
1. Deer--North America. 2. Deer--North America--Pictorial works. I. Title.
QL737.U55T39 2008 599.65'097 C2008-901570-3

Publisher Cataloging-in-Publication Data (U.S.)
Taylor, Dave, 1948-
Deer world / Dave Taylor.
[400] p. : col. photos. ; cm.
Includes index.
Summary: A year in the life of North American deer species in their natural habitat, including the two deer species indigenous to North America – the whitetail and the mule deer – as well as blacktail deer, elk, caribou and moose. Includes photos of other related animals such as wolves and bears.
ISBN-13: 978-1-55046-501-3 ISBN-10: 1-55046-501-5
1. Deer -- North America. 2. Deer -- North America -- Pictorial works.
3. White-tailed deer -- North America. 4. Mule deer -- North America. I. Title.
599.65/097 dc22 QL737.U55.T395 2008

Design by Linda Norton-McLaren
Editorial work by Kathleen Fraser

Printed in China

COVER This white-tailed buck bears the scars of rutting battles fought over the past few weeks. His genes will be passed along in the next crop of fawns.

SPINE White-tailed buck.

BACK COVER The deer of North America — elk, moose, mule deer, white-tailed deer and caribou.

RIGHT There is no truth to the notion that you can tell the age of a deer by the number of points on his antlers. Younger bucks do tend to have smaller antlers and mature bucks have bigger ones, but antler size is also determined by the quality and amount of food available.

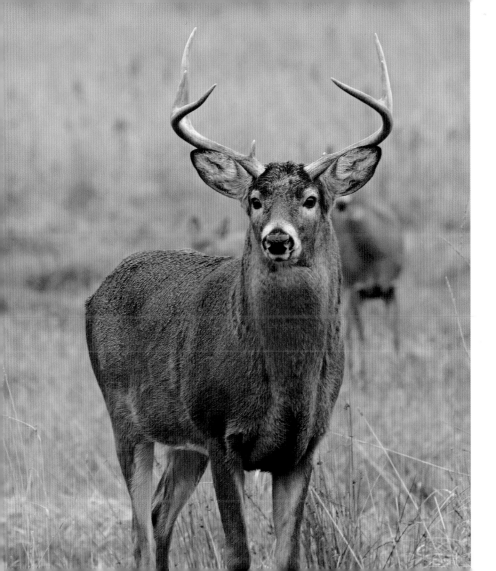

CONTENTS

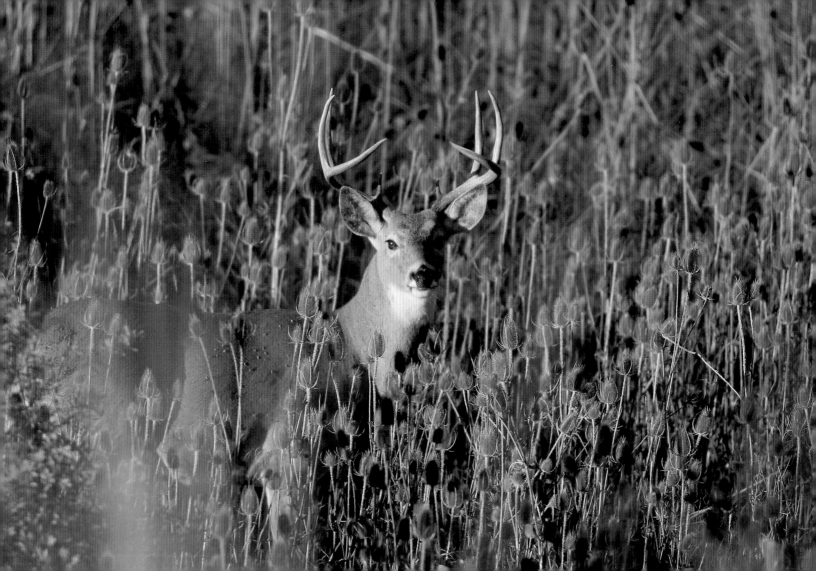

INTRODUCTION

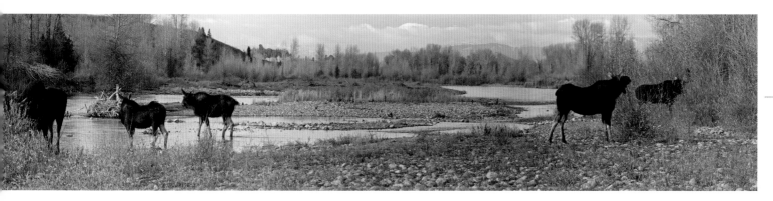

TOP In the fall moose build up their body weight for the long hard winter ahead.

LEFT The white-tailed deer is North America's most popular big game animal.

A s a wildlife photographer, I have entered the deer's world many times over the years. It is not hard to find your way into this world. I work at a city park called Riverwood, about a mile from where I live. The city of Mississauga, Ontario, population 700,000, surrounds it; however, the park happens to lie along a river and here twenty to thirty deer may be found. They are all white-tailed deer.

Deer are native to every continent except Australia and Antarctica. Although Africa is poorly represented by deer, Europe, Asia and South America all are home to many species. This book deals particularly with the deer of North America — and their world encompasses almost the entire North American continent. When we think of deer we usually think of whitetails, but mule deer, black-tailed deer, Sitka deer, moose, elk and caribou are all members of the deer family. All of these species are included here.

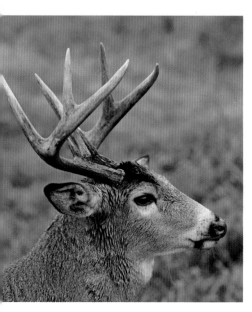

TOP In the fall, white-tailed bucks are constantly on the move seeking does.

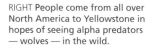

RIGHT People come from all over North America to Yellowstone in hopes of seeing alpha predators — wolves — in the wild.

This book follows the calendar year, and I have selected pictures to represent the natural events that occur on or near these dates. The progression shown throughout the seasons in a variety of locales should serve as a sort of diary for naturalists, photographers and hunters who want to experience this world. The captions for each photograph were written as a guide to understanding deer and their world.

There are no heroes or villains in this book. Some will no doubt perceive the wolf as a villain. Anyone visiting Yellowstone will soon learn that there are two distinct camps when it comes to wolves: wolf-lovers and wolf-haters. Yellowstone wolves attract people from all over North America who hope to view these alpha predators in the wild. Entire websites chronicle their lives. But as this book makes very clear, wolves are the main predator of North American ungulates. Since Europeans arrived here in the 1600s to farm and later to ranch, the conflict between man and wolf has been a one-sided battle. Wolves kill domestic sheep and cattle. They kill deer and elk. They kill our food. And what has been man's answer? They have to go! In the continental USA, wolves were virtually exterminated over the course of a few centuries. Old attitudes and prejudices die hard. Today wolves are still opposed by many ranchers and politicians. Wolves are still seen as "bad" animals by many. However, when wolves were restored to Yellowstone (where early park policy actively sanctioned their elimination), the now largely urban North American population applauded it. Wolves are wolves, just as deer are deer. They are part of a healthy ecosystem. Neither species is bad or good.

Many will read this book and not recognize that there is a central theme to it, one that encompasses deer but also includes all of the other species portrayed here. Every single species (with the possible exception of the loon) in this book has been hunted, trapped or "controlled" by humans. Another old prejudice that lingers on is that

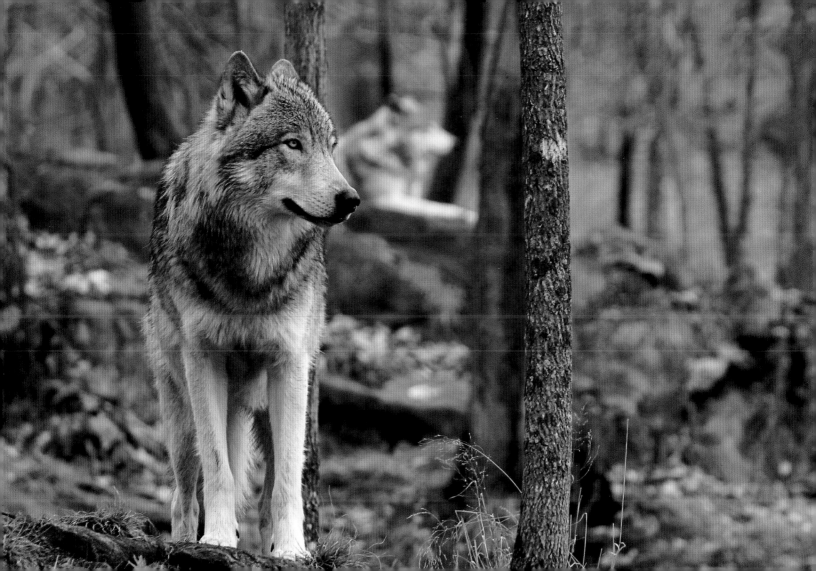

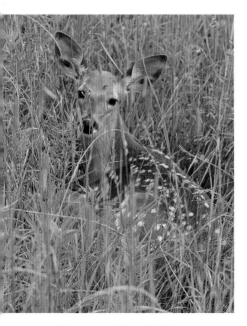

For some, a white-tailed fawn conjures up an image of Bambi, but others may see it as a pest that will destroy their gardens, or meat for the table, or a link in the natural food chain.

hunters and trappers are responsible for the near extinction of many species. To a degree that was true in the 1800s and early 1900s in North America. Hunters and trappers eliminated the passenger pigeon and almost caused the extinction of the bison, great egrets, wolves, beaver and other species.

But hunters and trappers were also the first to demand that wildlife be managed. The National Wildlife Federation, Ducks Unlimited and many other such groups in states, provinces and countries worked hard to have legislation passed to conserve wildlife. Yes, it was so their sport would continue, but until the environmental movement started in the 1950s, theirs was the primary voice clamoring for proper management. Urbanites by and large could have cared less until then.

I have not hunted for over thirty years now and have no desire to ever do so again. I am well aware, however, that the wildlife I enjoy photographing survives in no small measure thanks to hunters, anglers and trappers. That does mean that I am not aware of the pioneering works of Murie, Seton and others who toiled in the field unlocking the secrets of nature's complexity, including Olaus Murie, who helped elevate wolves to their present stature. Nor would I want to in anyway take away from the wonderful work of the National Audubon Society, the World Wildlife Fund, Green Peace, the various nature conservancies, naturalist clubs and the many businesses that have supported wildlife. I find it interesting when I am around members of both the hunting groups (the wildlife consumers) and the naturalists groups (the protectors) how much the two opposing groups have in common. They agree more than they disagree on wildlife issues.

I would be remiss in not acknowledging the fine work that provincial, state and national governments have done in enacting laws, creating parks and setting aside habitats for wildlife. This book celebrates their achievements.

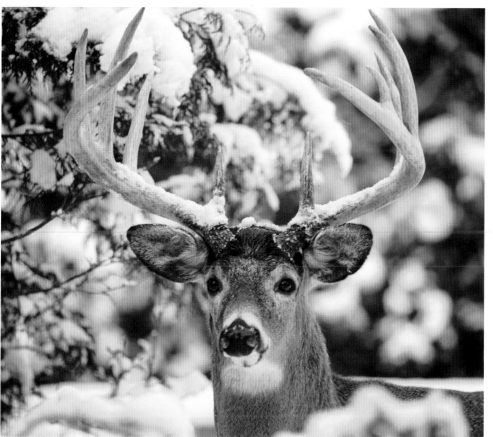

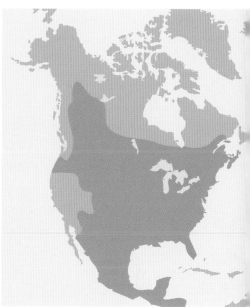

WHITE-TAILED DEER RANGE MAP
The range of the white-tailed deer is the largest of any North American deer species and, worldwide, second in area only to that of the Eurasian-North American range of moose.

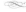

White-tailed deer can live in close proximity to people if there is sufficient shelter and food nearby.

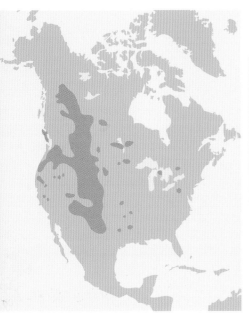

ELK RANGE MAP
Elk once ranged across most of
the continental United States and
southern Canada but are now
found mainly in the west.

Two young bull elks are merely
sparring at the beginning of the
rut in late August. Serious battles
are yet to come.

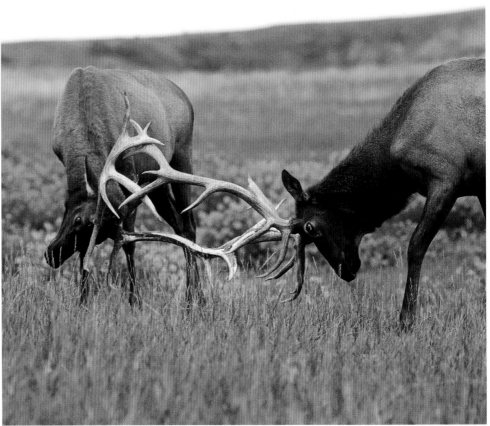

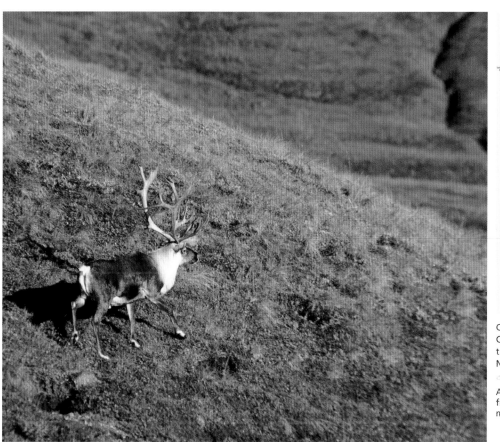

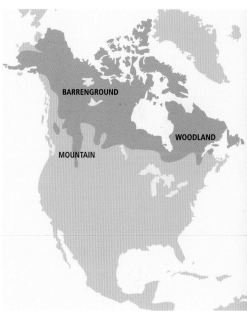

CARIBOU RANGE MAP
Caribou range is confined to the tundra and boreal forest regions of North America.

A bull caribou is easily distinguished from cow caribou by his well-defined mane and his large antlers.

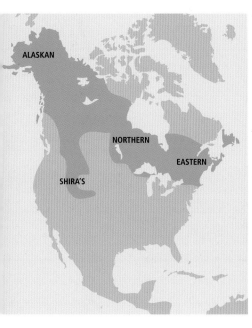

MOOSE RANGE MAP
The range of moose in North America is expanding as they make their way further south in the Rockies and the New England states.

Cow moose need the presence of a bull to enter into the rut.

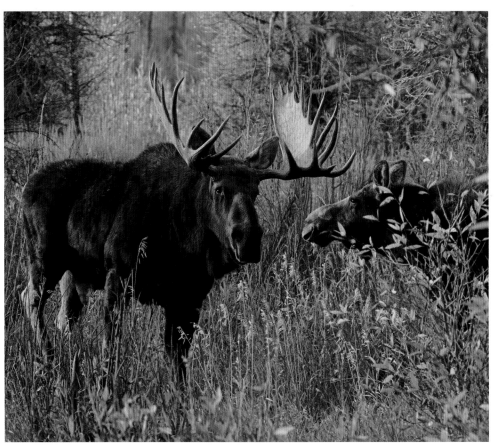

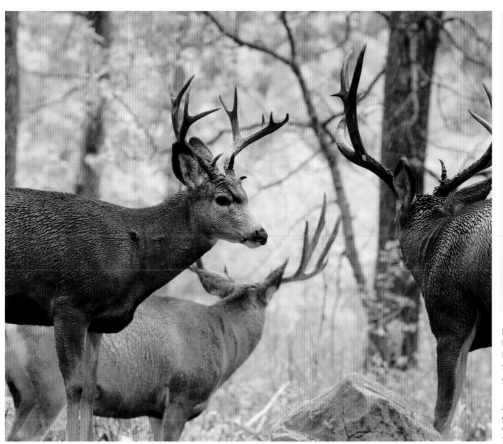

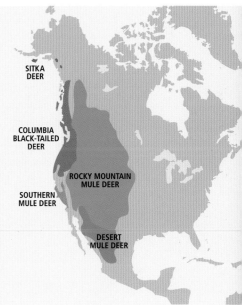

SITKA
DEER

COLUMBIA
BLACK-TAILED
DEER

ROCKY MOUNTAIN
MULE DEER

SOUTHERN
MULE DEER

DESERT
MULE DEER

BLACK-TAILED DEER AND MULE DEER RANGE MAP

Mule deer are closely related to black-tailed deer. The largest member of this group is the Rocky Mountain mule deer.

At the start of their rut in September, groups of mule deer bucks will "hang out" together. The younger bucks learn from the older ones.

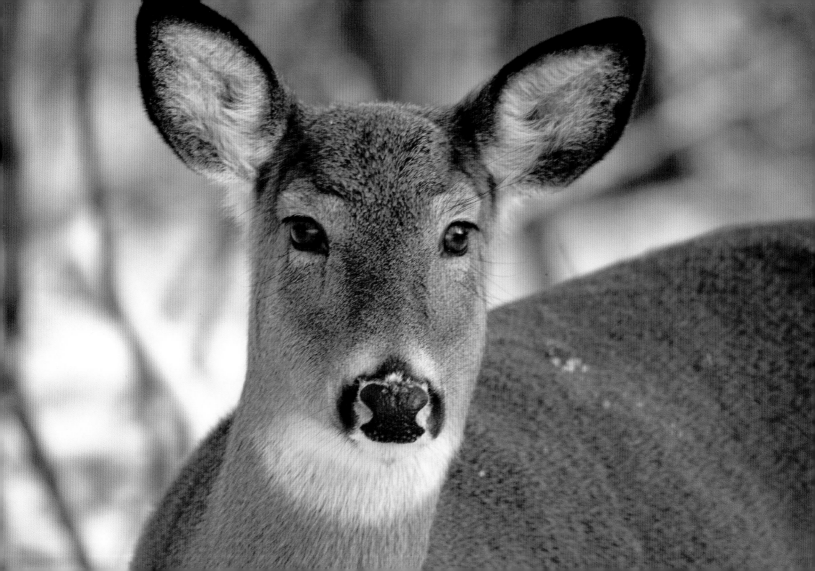

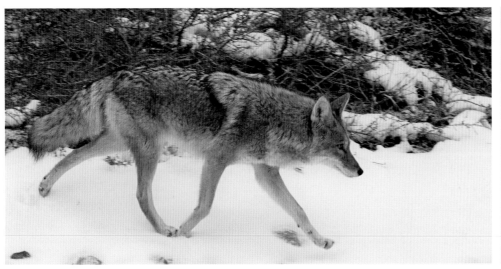

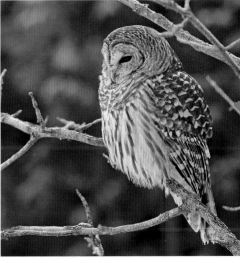

A word about the photographs. They were all taken with Canon cameras. Recently I've switched to digital, and more than half the images here were taken with Canon 20Ds. All my lenses are Canon. These days I use the 100-400 IS lens and the 300 2.8 lens with a 2X tele-converter. I have just recently upgraded to a 40D and a 500 f3 IS lens. The vast majority of the images are of wild, free-roaming animals. Fewer than twenty were taken under controlled situations; the cougar, lynx, bobcat and a couple of the wolf shots are examples. I consider myself lucky to have seen a cougar, lynx and bobcat in the wild even if I did not get a good shot of any of them.

While I enjoy photographing animals anywhere I encounter them, including zoos, I get the most pleasure seeing them in the wild. The white-tailed deer (left) was photographed not more than 2 miles (3 km) from where I live. The coyote was searching for prey in a meadow in the Colorado Rockies, and the barred owl was patiently waiting for a meadow vole to show himself near a bird feeder. Such encounters are to be treasured.

ACKNOWLEDGMENTS

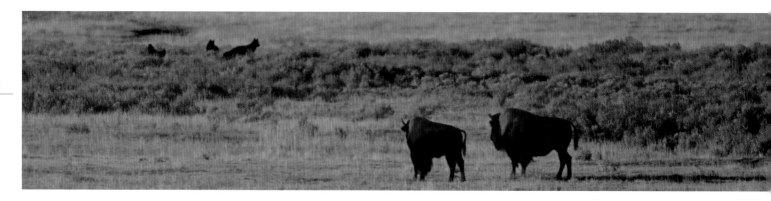

Two young bull bison watch carefully as a pack of wolves wanders by. Such encounters are a daily occurrence in Yellowstone. The wolf pack represents a real danger to even the largest bison.

One of the joys of doing what I do is the opportunity to meet and work with others who share my interests and passions. I want to thank and acknowledge the following people and businesses who added so much to my enjoyment of North America's wild places.

Gary Hall, a good friend and a fine photographer, has accompanied me on many trips to Africa and the Rockies. Captain Tommy Moore, Rockport-Fulton Texas, provided excellent advice and assistance in photographing whooping cranes and other Gulf Coast wildlife. While working with Tommy, my wife and I stayed at the Lighthouse Inn and we both thank them for their generous support while we were in town. Dean Wyatt, Knight Inlet Lodge, British Columbia, provided advice, accommodations and assistance with grizzlies of the Great Bear Rainforest.

Alistair MacLean joined me on two trips and provided good company while we were at Brooks Camp, Alaska, and Seal River, Manitoba. He too has joined me in Africa, and his friendship is one I value. Mike Reimer of Churchill and Seal River Lodge, Manitoba, was an excellent host and guide while Al and I were up there. He is a great guy to go polar bear watching with. Don McClement has shared many of my adventures around southern Ontario and I thank him for his advice and support.

There are countless biologists, photographers and others whose advice and knowledge greatly added to my own success. I thank them and one in particular, John Morrow, who really taught me how to approach Yellowstone.

I would be remiss if I did not acknowledge Canon Canada for their support over the years. John Denison, publisher, Boston Mills Press, has remained a person I felt I could always talk to whether or not we were going forward with the book I proposed. It is twenty years since we first did *Ontario's Wildlife* and his support is appreciated.

The people who helped put together this book were wonderful to work with. I thank my designer, Linda Norton, my editor, Kathleen Fraser, and managing editor Noel Hudson for their fine work.

Of course I must thank my wife, Anne, who has shared so many of my adventures in the wild from Texas to Alaska, Canada to Africa, and who continues to put up with me despite this.

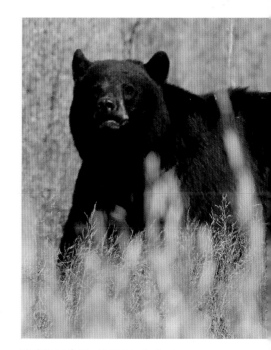

Black bears follow their nose to food. They can smell garbage that campers have buried under a mound of soil. More than any other sense, bears relies on their sense of smell.

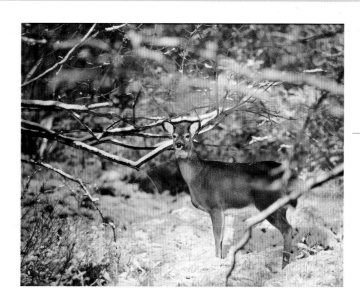

January 1

White-tailed deer are North America's most abundant deer. There are perhaps 19 million of them roaming the woods, farmlands and rural areas of the continent. There may very well be more whitetails today than there were when Columbus first came to the New World over 500 years ago. *Ontario*

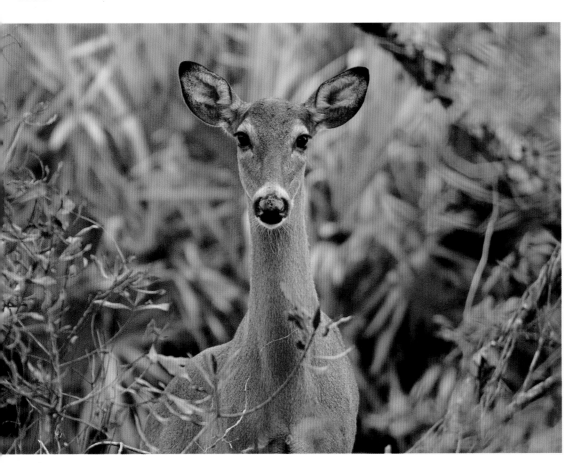

January 2

White-tailed deer are the oldest species of North American deer. Fossils from California indicate that this species (or one virtually identical) has been here for at least 3 million years. White-tailed deer were minor players 3.5 to 3.9 million years ago, seeking out a niche among the giant plant-eaters of those days — mammoths, giant bison, wild horses, camels and other vanished species.

Florida

January 3

Moose will lose between 10 and 12 percent of their body weight during the winter. To help combat this loss and the poor quality of the browse they are inactive in winter. *Ontario*

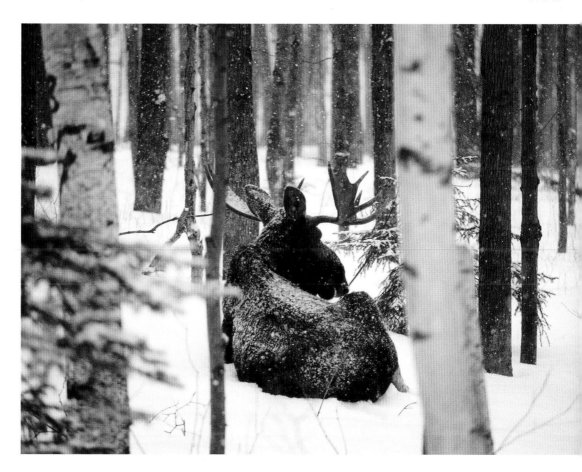

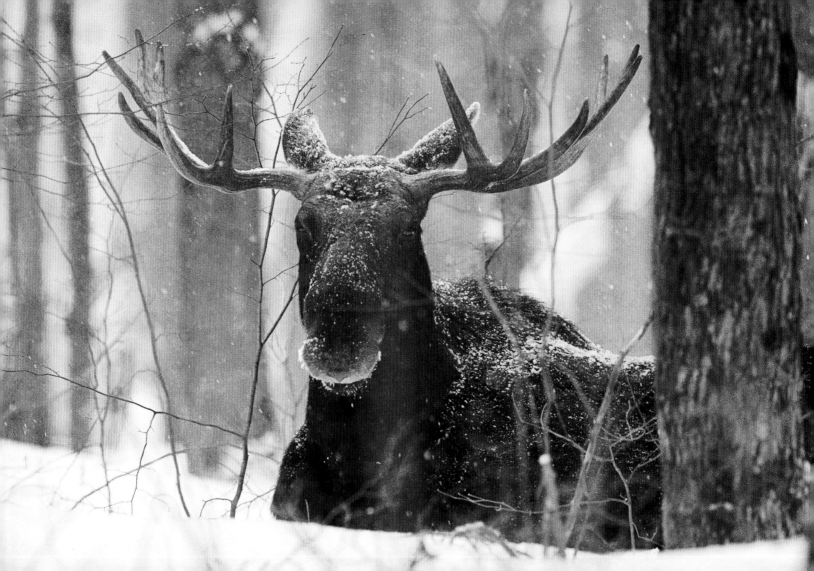

January 4

On a cold winter day with little wind, a moose will often select a spot bathed in sunlight to rest and ruminate. Its dark coat absorbs the sun's heat and warms the animal. *Ontario*

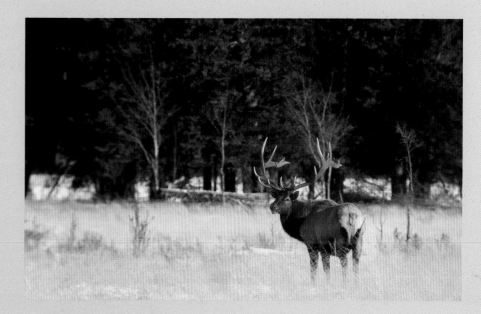

January 5

Bull elk retain their antlers long after the breeding season ends. In fact, they keep their antlers longer than any other male deer. Carrying that much extra weight comes at a cost in energy. Other deer drop their antlers as winter begins or when plant growth stops. There must be a benefit to the bull elk to offset this cost. Likely it is an adaptation used against predators, especially wolves. It does allow them to dominate lesser bulls and cows in prime feeding areas. *Alberta*

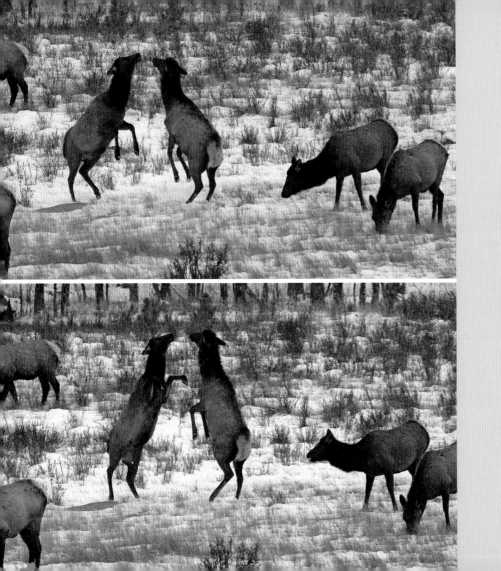
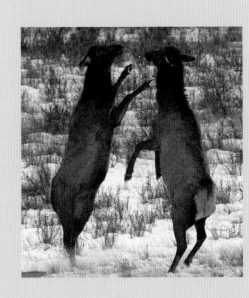

January 6

Herd animals live in a social system governed by dominance. The dominance hierarchy is established through aggressive behaviors. Cow elk will rear up and flail away at each other in order to show who is boss. The loser moves off to a less desirable bit of grazing. *Colorado*

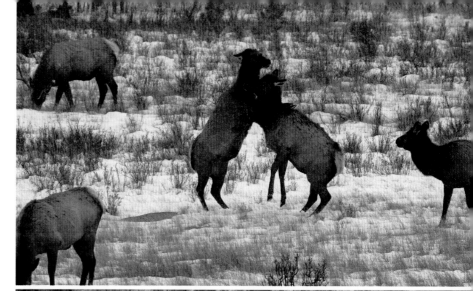

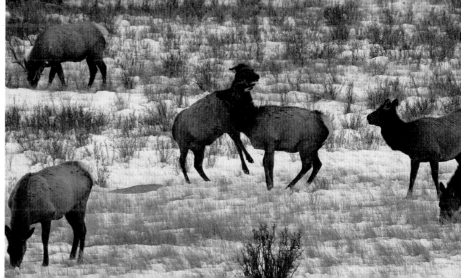

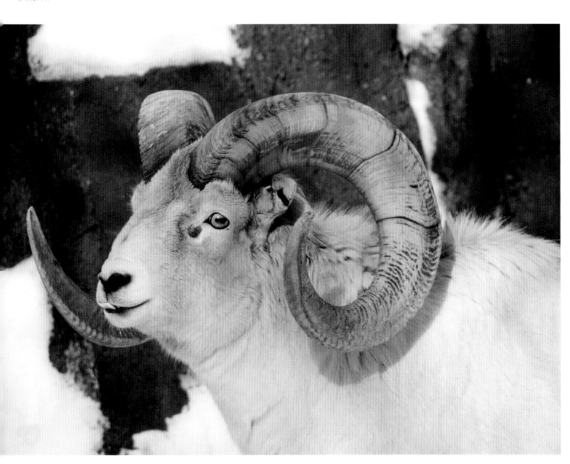

January 7

By January the Dall's sheep have completed their rutting season and the rams are beginning to form separate herds once again. They are classed as "thin-horned" sheep and are a relatively recent arrival in North America. Virtually identical sheep can be found across the Bering Strait in Russia.

Yukon

January 8

White-tailed deer make excellent use of any available cover. They will try to sneak away long before a predator is aware of them. Their winter coats provide excellent camouflage.

New York

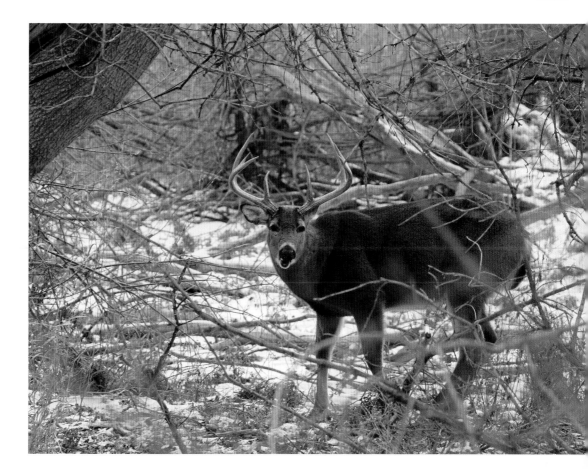

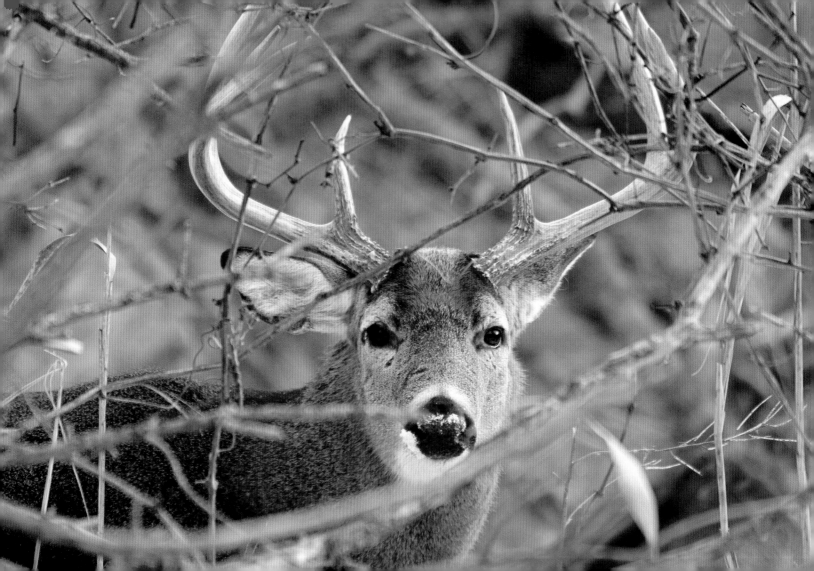

January 9

White-tailed deer are well attuned to their habitat. Ears and eyes (hearing and seeing) are equally important to this species. Ears allow the deer to pick up the sound of an approaching animal in dense woods where sight lines are limited. When deer feed in open fields, sight becomes the more critical of the senses. Deer have a good sense of smell but do not rely on it very much to detect predators. *New York*

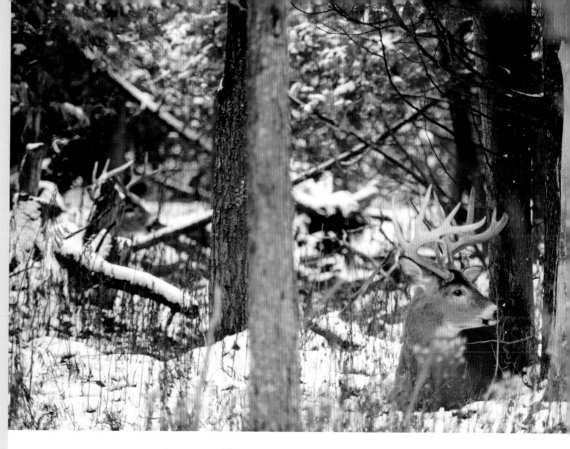

January 10

When resting in groups white-tailed deer typically lie down so that direct eye contact is not being made. Eye contact is a form of aggression, so most ungulates avoid it when at rest. *Ontario*

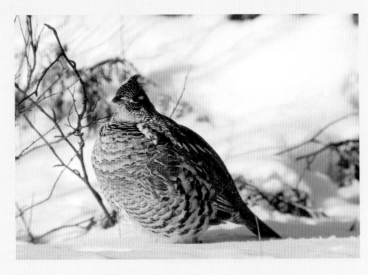

January 11

Ruffed grouse, like most over-wintering birds fluff up their feathers to catch pockets of air, which are warmed by the bird's body. The trapped heat insulates the bird beneath a layer of feathers. *Ontario*

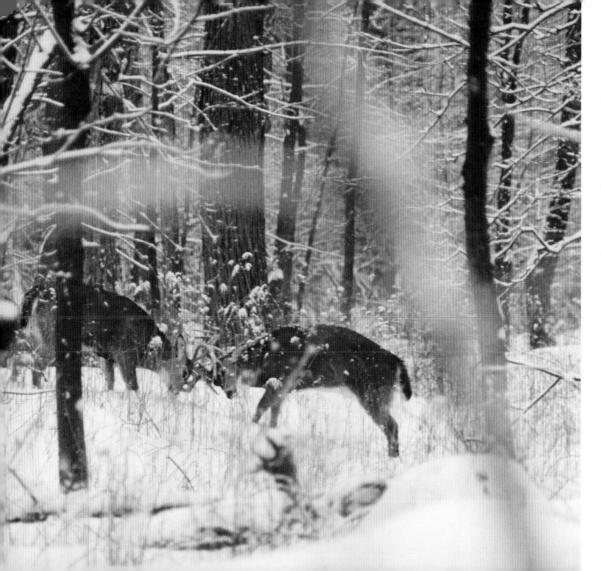

January 12

By January, most does in the north are pregnant. Fights between bucks are just sparring matches and are not serious. Such bouts are short lasting because the bucks know they need to conserve energy. *Ontario*

January 13

Bull elk also engage in bouts of sparring. Sometimes the contest is between two bulls of equal size, but it does not seem to matter. Little bulls will readily challenge mature bulls. More often than not, the mature bulls will respond and give the little guy an opponent. I have never seen these battles get out of hand, but in September a smaller bull would run for his life!

British Columbia

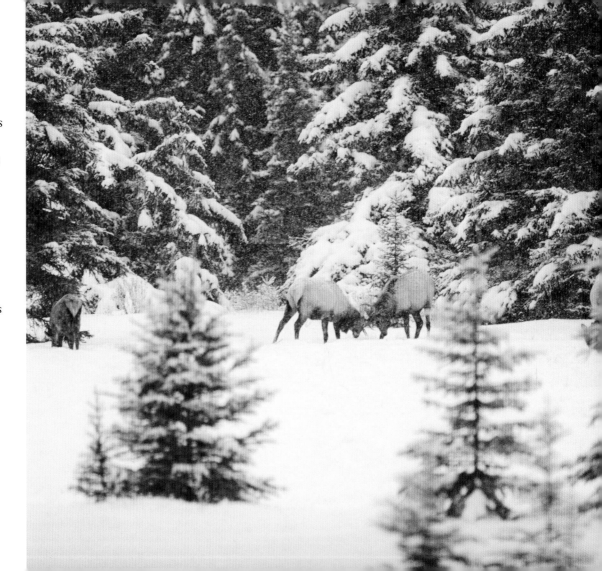

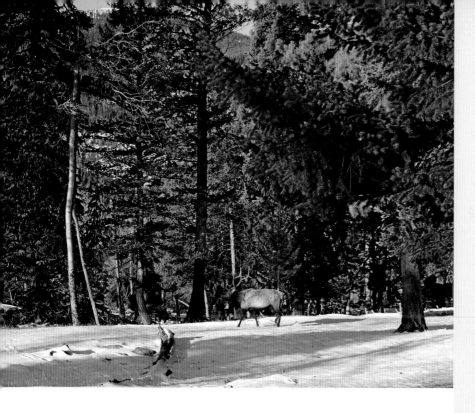

January 15

Elk seek out wind-blown slopes and meadows where snow depth is minimal. There they will find easier access to the grasses they require. Sometimes they will share these same pastures with bighorn sheep. *Alberta*

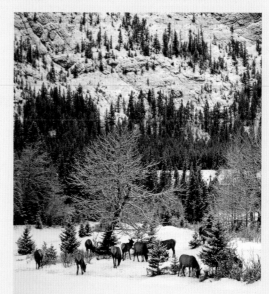

January 14

Bull elk are more confident in heavier bush than cow elk are. Their bigger size and impressive weapons give them the assurance to take more risks. Bull of many species share this behavior. The risks may be greater but so are the benefits, since females will avoid the better pastures if there is a risk of predators. *Colorado*

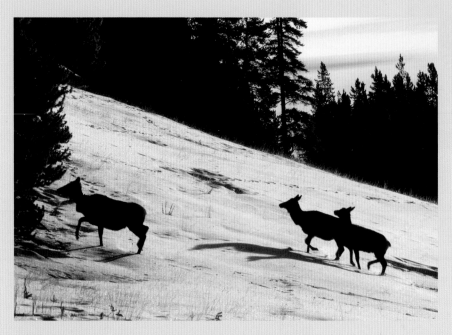

January 17

The average weight range of bucks male falls between 130 and 220 pounds (60–100 kg). Large bucks from the northern portion of the range will rarely exceed 350 pounds (160 kg). Doe weights range between 90 and 130 pounds (40–60 kg), rarely exceeding 165 pounds (75 kg). *New York*

January 16

Elk were mainly a prairie species and were encountered frequently by pioneers are they trekked westward. However, they were soon "shot out" and survived only in those areas where farming and ranching were, to say the least, marginal activities. As a result, elk survived in mountains and aspen parklands. Today, we mistakenly think of them as a mountain-loving species. *Alberta*

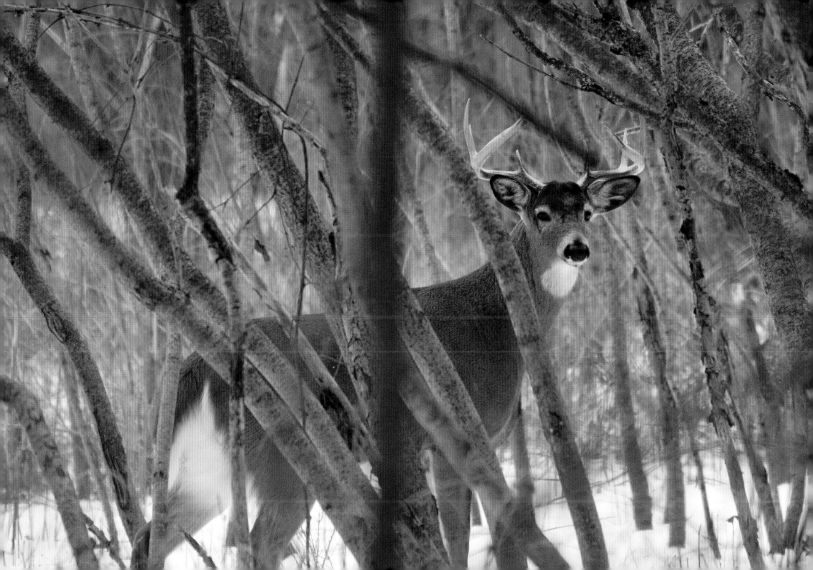

January 18

White-tailed does and their female offspring form a bond that will last their lifetime. They are closest during the fawn's first year. The fawn learns from her mother the lay of the land; where the best feeding spots are, where to seek shelter and where the best escape routes lie. *New York*

January 19

Male fawns will leave their mothers and wander away from her home range. They may not venture far and may even return as mature bucks. The likelihood of their breeding with their mothers is slim. Deer mortality and the passing of years both work against this possibility. Of course, it could happen, but the population dynamics are such that it so rare it probably has little impact on the genetics of the herd.
New York

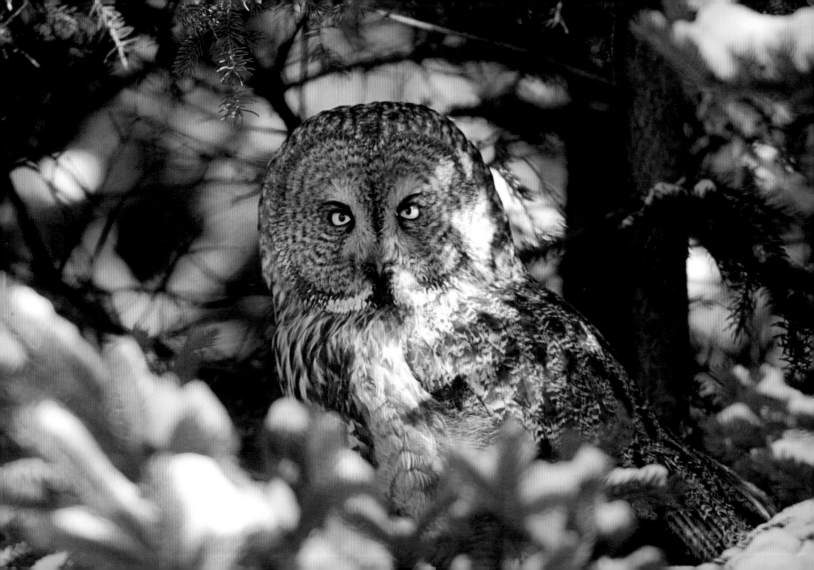

January 20

Great gray owls are the largest owls of North America. They are confined for the most part to the boreal forests. Every seven to ten years, winter conditions in their range create a situation where there are too many owls and too little prey. The owls will migrate south into more urban areas in search of food. *Ontario*

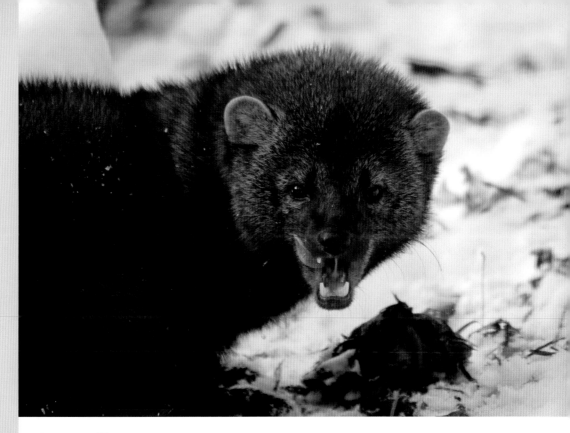

January 21

In many locations in the Northeast and Eastern Canadian provinces fishers are being reintroduced to parts of their former range. Fishers are a major predator of porcupines and are helping to control their numbers once again. Porcupines can be very destructive to forests and to human structures. *New York*

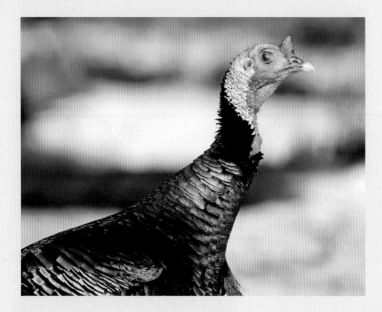

January 22

Lynx are cats of deep snow and as a result seldom have an opportunity to hunt whitetails. Exceptions occur at the extreme northern edge of the deer's range and in the Northern Rockies of the United States and the Southern Rockies of Canada, where their ranges overlap. Moose calves, mule deer and young elk also fall prey to lynx. *Ontario*

January 23

White-tailed deer country is also ideal country for wild turkeys. While the deer have proved able to recolonize many parts of their range where they were hunted out, the wild turkey has needed a bit of help. Turkey reintroductions have been generally successful and the birds are now well established in most of their former range. *Ontario*

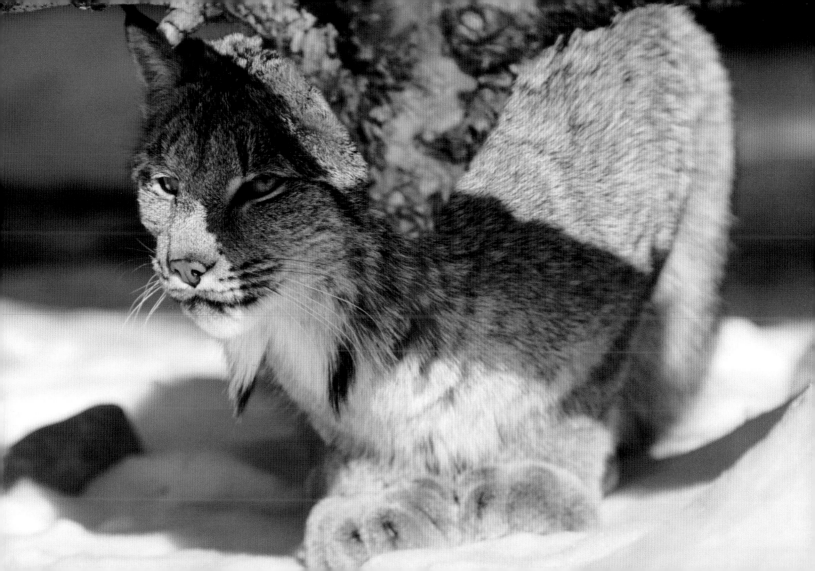

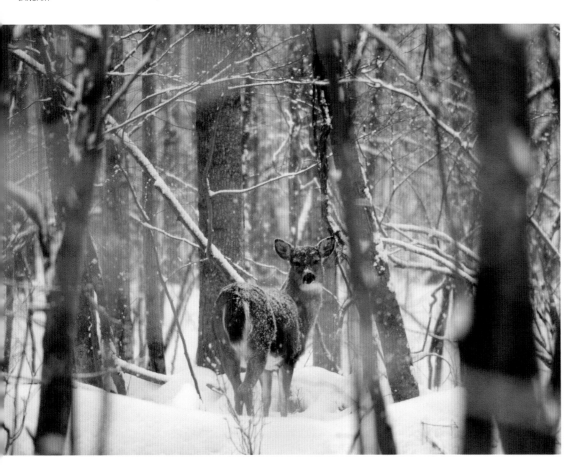

January 24

A healthy deer of any species is so well insulated that snow will not melt when it lands on its body. The deer's coat keeps the heat in. If the heat is escaping and does melt the falling snow, the animal is not in good condition and is unlikely to survive the winter. *Ontario*

January 25

Like many large animals, the deer has a metabolism that slows down in the lean times of winter. This is sometimes referred to as a state of semi-hibernation. Deer move about less and the development of the foetus is much slower. The arrival of warm weather and fresh plant material speeds up everything. *Ontario*

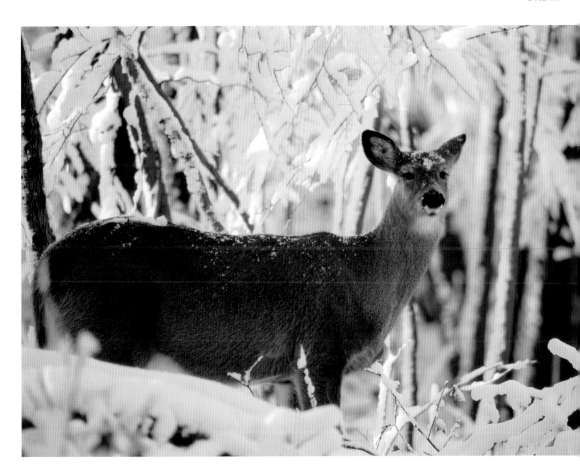

January 26

The most widespread member of the canine family is the red fox. It is found naturally in Europe, Asia, Africa and Central and North America. It has been introduced into Australia and New Zealand for sport. *Ontario*

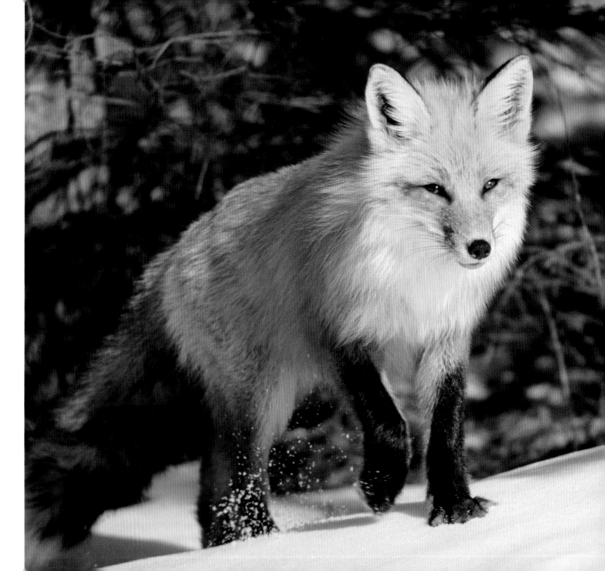

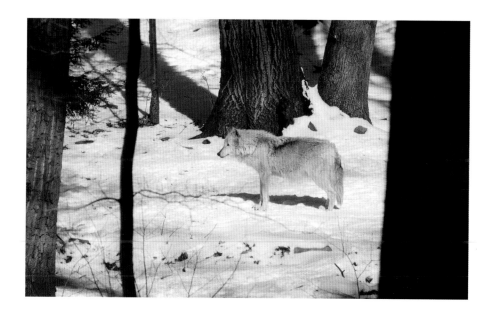

January 27

The gray wolf is the major predator in the deer's world. Wolves were once the most widespread of any large predator. Possibly, only the lion exceeded them. (The so-called American lion was merely a larger version of the African lion and likely the same species.) Today wolves may claim the title as they range from Spain to North Africa, Eurasia to North America. Lions are now confined to Africa, south of the Sahara and small remnant population in India. *Ontario*

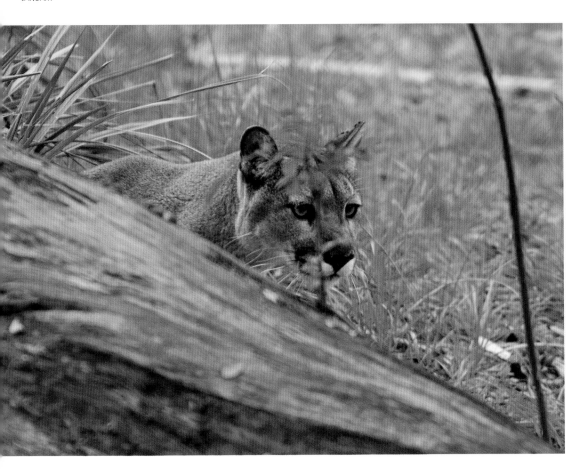

January 28

There are fewer than 100 wild Florida panthers. A subspecies of cougar, the Florida panther is protected by the Endangered Species Act. One of their main prey species is white-tailed deer.
Florida

January 29

Black vultures behave like their African namesakes, cleaning up carrion — in this case, a white-tailed doe killed by a car. Each day about one million animals (not counting insects) are killed on North America's roads. In some states, cars are the main "predators" of deer. *Florida*

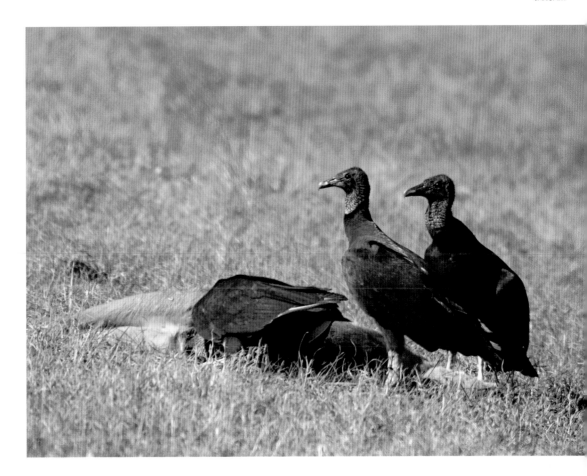

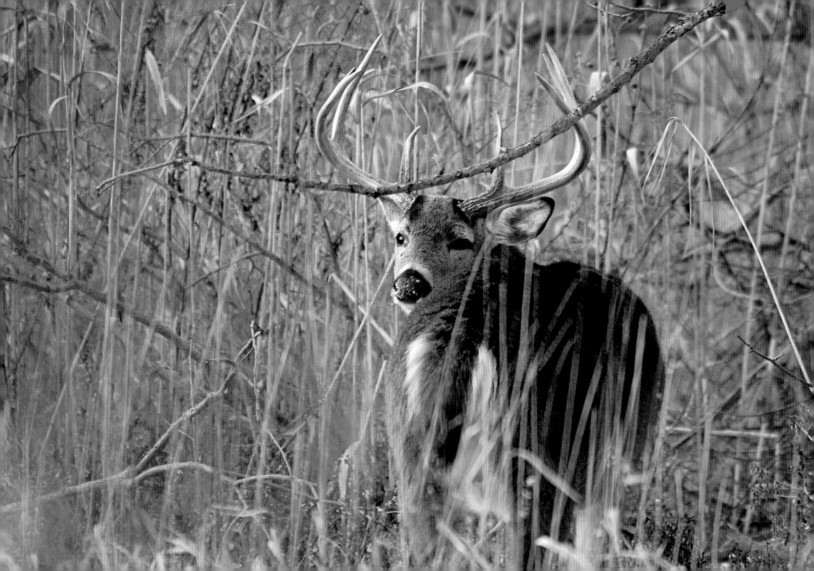

January 30

The tail of the white-tailed deer reflects its habitat preferences. Ungulates living in the open grasslands often possess white rumps, which are clearly visible when they flee an enemy (pronghorns and mule deer). Ungulates living in forests prefer to hide and advertise their location. White-tailed deer use both kinds of habitat. The white underside of their tail is hidden by the tail's brown surface, but when the tail is raised they expose a white "flag" to alert others of danger. *New York*

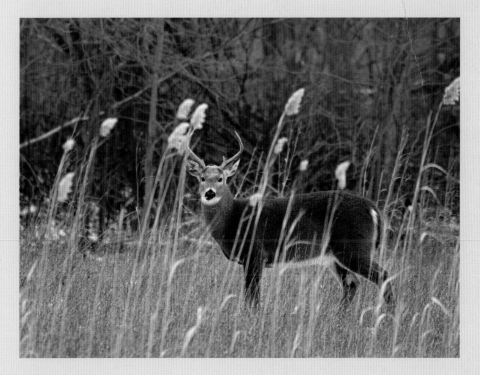

January 31

There is a tendency to overestimate the size of animals seen in the wild. Deer seem larger when seen at a distance than when encountered in a zoo or park where you can walk beside them. *New York*

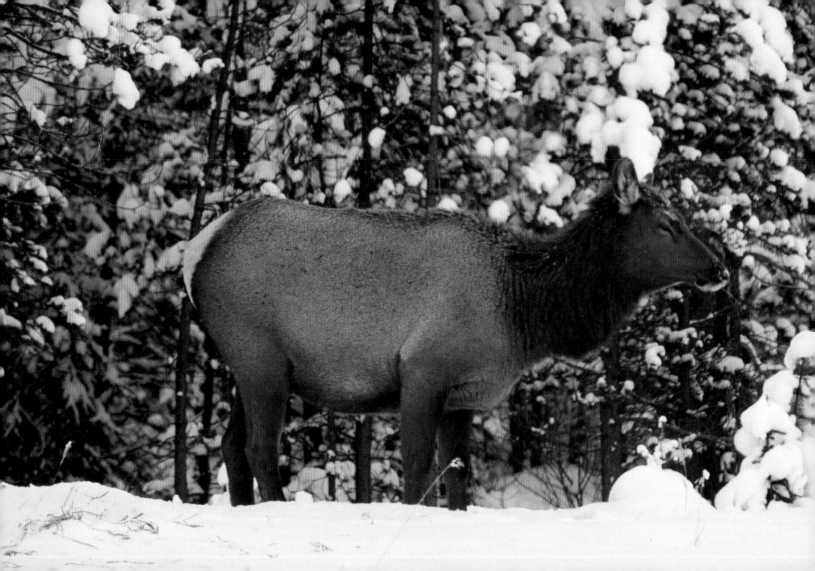

February 1

Wind can be more deadly than cold temperatures to any wildlife. Moose and deer seek out stands of conifers when the wind is blowing. The air beneath the conifers may be colder than the air outside the stand, but the wind chill is far less under the protection of these trees. *British Columbia*

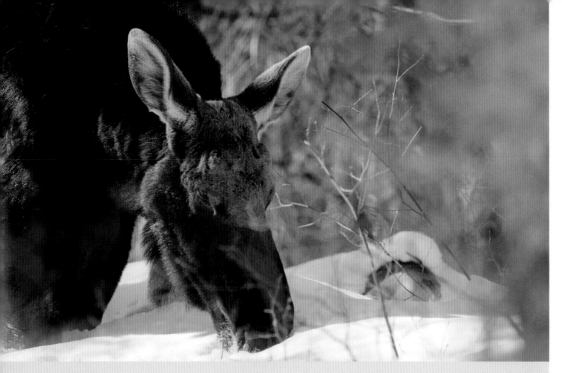

February 3

Snow depths of up to 2 feet (50 cm) are no obstacle to a moose but will slow down wolves, allowing the moose to escape. When the snow depth exceeds 2 feet (50 cm), the advantage switches to the wolves. The deeper snow slows down the moose and impedes their travel. Ice-crusted snow that supports wolves but not moose is especially dangerous for these large animals. *Ontario*

February 2

Winter in moose country provides about as much fresh water as summer does in a desert. Indeed, for all intents and purposes, there is no water available to them. Moose solve the problem by eating snow. If you have ever held snow in your hand in an attempt to melt it you would learn two things. It takes a lot of heat (energy) to melt snow and you get very little water for your effort. That moose can afford to swallow and melt enough snow to meet their needs is a testament to how well suited they are to their environment. *Ontario*

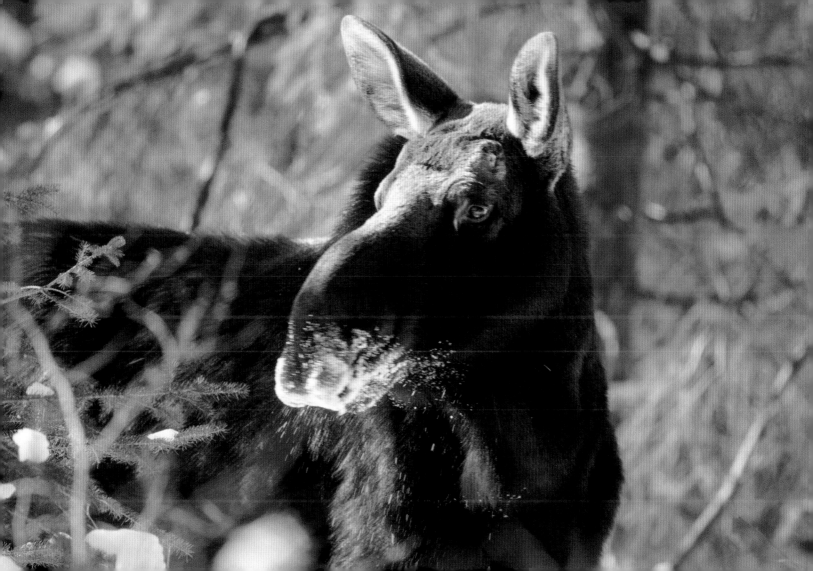

February 4

During winter thaws, white-tailed deer will venture out onto southern-facing slopes. There is less snow here and they may gain access to new feeding areas. *Ontario*

February 5

The deer family is broken into to two broad categories, Old World deer and New World deer. The New World deer are represented in North America by mule deer, white-tailed deer, moose and caribou. Elk are the only North American members of the Old World deer group. "Old World" refers to deer from Eurasia and "New World" refers to deer found in North America. The classification is based on physical and behavioral features, not location, and are not especially helpful because moose are found in Europe and elk are found in North America. *British Columbia*

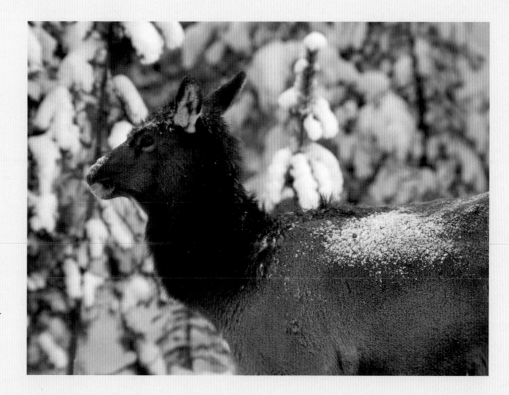

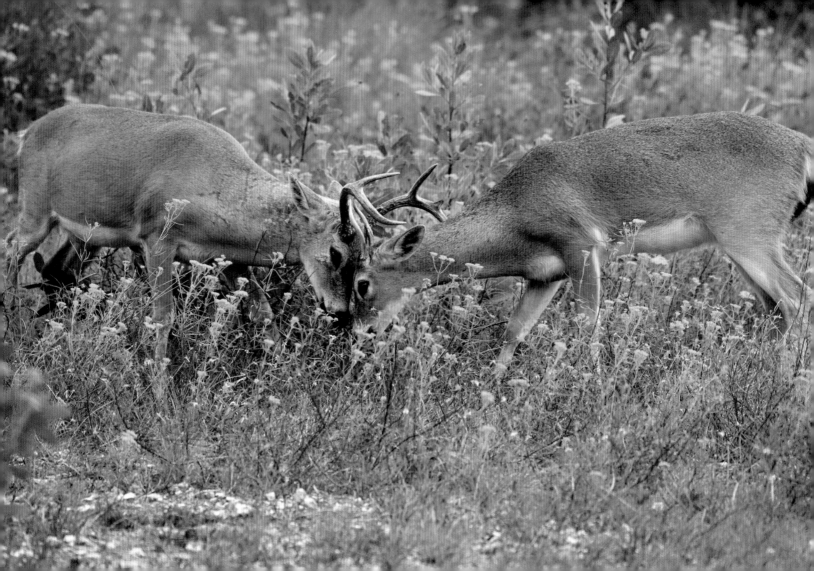

February 7

Mule deer typically have twins. By February the fawns are almost as big as their mother but still rely on her to teach them how to survive, especially in winter. Their blue-gray winter coats help protect them from wind chills. *Alberta*

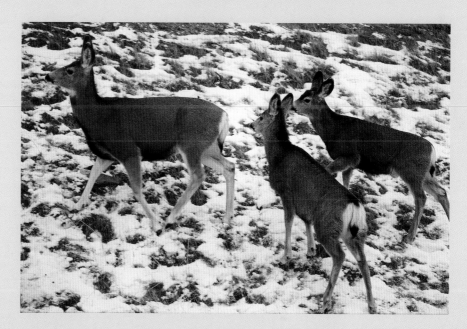

February 6

Key deer are the smallest race of white-tailed deer in North America. Adults range in size from 45 to 75 pounds (20–34 kg). A buck may reach just under 3 feet (less than 1 meter) An adult Key deer is about the same size as a yearling doe from the Northern States. *Florida*

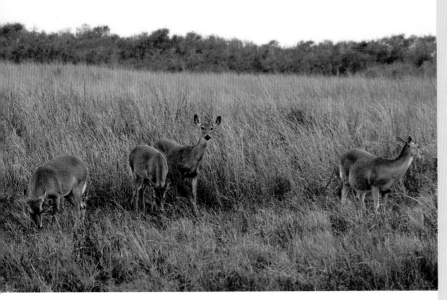

February 8

Whitetail does reach puberty when they are six to seven months of age, or when they weigh about 80 pounds (36 kg). This does not necessarily mean that they will breed in their first year. Other factors, especially the available amount of food and cold air, may prevent the young does from ovulating. *Texas*

February 9

Along the Gulf Coast, whitetail bucks still retain their antlers. The rut is over and young bucks will play-fight with other bucks. Antler size is not a very good indication of age. These two are both young, but whether they are three or four years old cannot be determined by their antler size. The number of points also has little relevance to age. Antler size is determined by the quality of the food available and by genetics. *Texas*

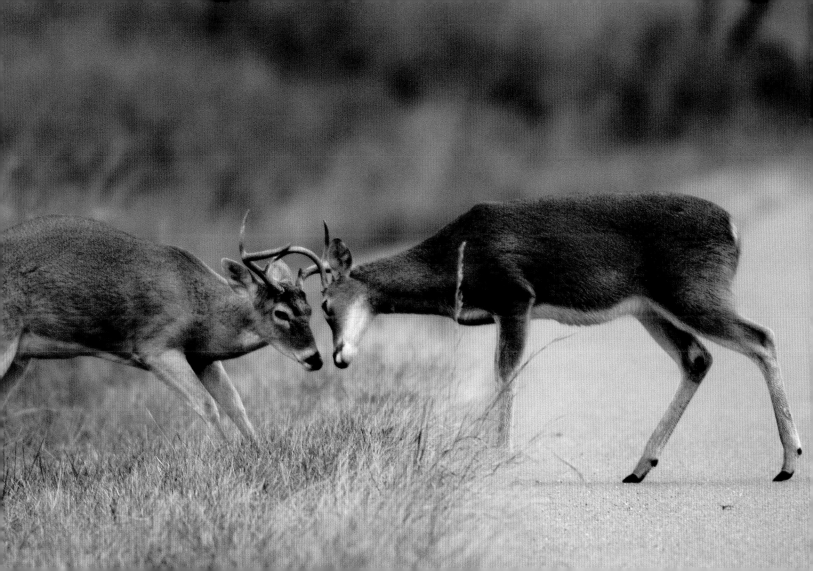

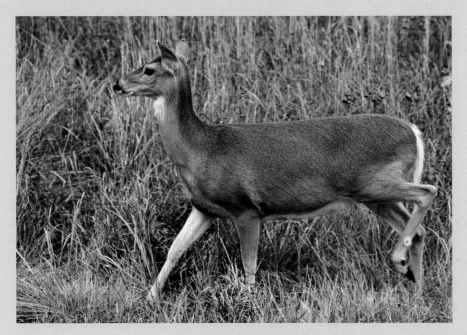

February 11

Along the Gulf Coast from Texas to Florida, and up the Atlantic coastline to the Carolinas, alligators prey on deer. Alligator numbers have bounced back since the mid-1900s because of their protected status. Today they are common enough that some controlled hunting and trapping of wild gators is allowed. *Texas*

February 10

This body language of this doe suggests she is alert but not yet alarmed. The ears are attuned to a disturbance (my camera's shutter) and her head is up. She is prepared to run if need be. If she were really alarmed, her tail would be raised and she would be in full flight. She may very well snort or stomp the ground to alert other deer that there is something to be concerned about. *Texas*

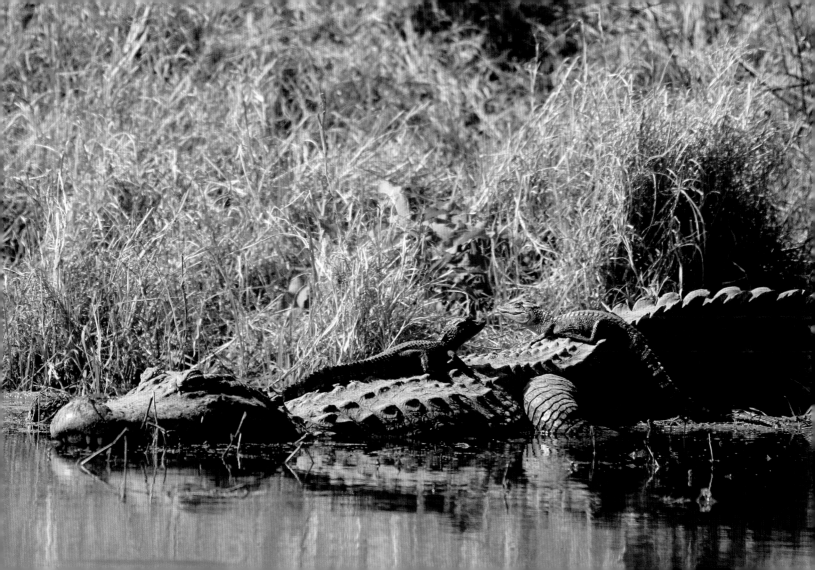

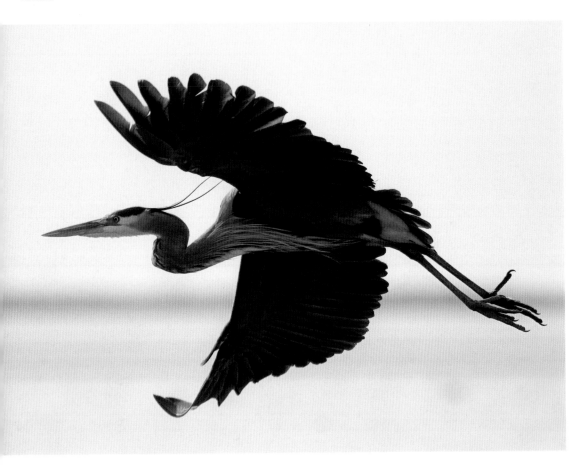

February 12

Great blue herons are migratory. Many congregate along the Gulf Coast, mixing with local non-migratory populations. At one time they too were hunted. Great blue heron decoys from the late 1800s and 1900s are now popular collector's items. *Texas*

February 13

Long-billed curlews are shorebirds and are common along the Gulf Coast in winter. However, in the spring and summer they feed far from shore, on insects and baby birds in the grasslands of the arid west. Even in the winter they are likely to be found feeding on southern prairies. *Texas*

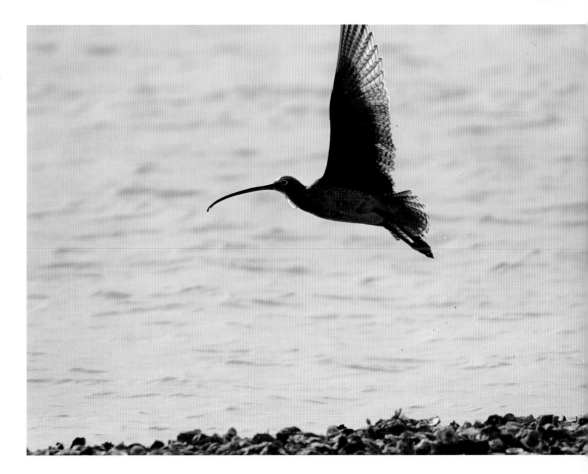

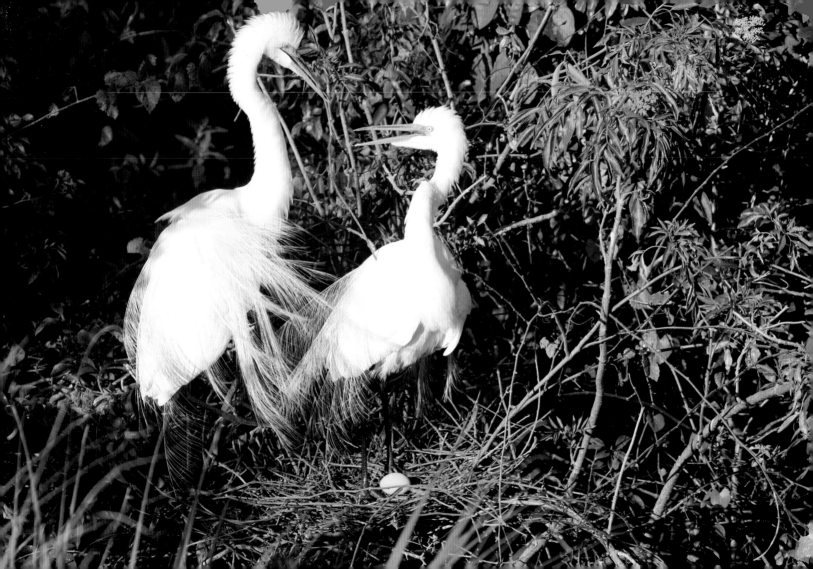

February 14

Once hunted nearly to extinction by plume hunters, the great egret has made a successful comeback. The plumes are at their most beautiful during the breeding season. Recently the great egret has been expanding its range, reclaiming areas in which it once bred. *Texas*

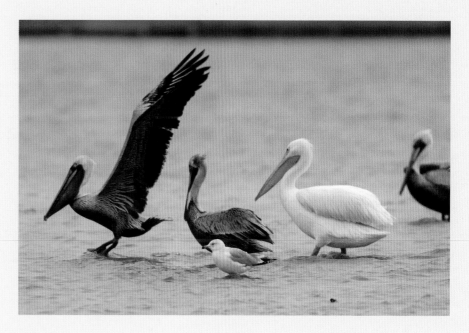

February 15

Along the Gulf Coast it is possible to see both North American species of pelican during the winter months. The brown pelican is resident and feeds on fish it catches by diving into the shallow coastal waters. The white pelican is a migrant; it nests on prairie lakes from the Ontario-Manitoba border north to the Northwest Territories and west to the Rockies. *Texas*

February 16

White-tailed deer are opportunists, very well adapted to take advantage of any niches that are open to them. During the last ice age they were confined to a small region of the west coast — present-day California — and were not very common. Larger herbivores such as giant bison, American camels, llamas, several species of horses, mastodons, mammoths and others dominated the ecosystem. With their disappearance, the white-tailed deer suddenly expanded in numbers and range, quickly filling the vacancy left behind by these mega-herbivores. *Texas*

February 17

Wild turkeys are our largest species of upland game birds. Their numbers have greatly increased thanks to reintroduction efforts by state and provincial wildlife managers and hunting organizations. Today they occupy most of their original range. These are Rio Grande wild turkeys. Their range extends from Nebraska, Texas and into Mexico. *Texas*

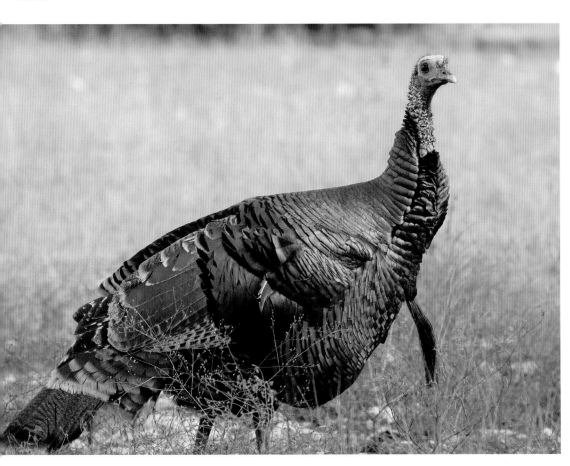

February 18

Rio Grande wild turkeys spend the early winter months feeding separate flocks of males and females with young. In February the males leave their flocks and begin to seek out open areas for their courtship displays. *Texas*

February 19

Male wild turkeys put on quite a display aimed at impressing females and intimidating males. When puffed up, the breast and back feathers shimmer with iridescent flashes of purple and bronze. The tail feathers expand into a peacock-like display, the skin of its featherless head becomes a brilliant blue and the wattles a vibrant red. All in all, an impressive sight. *Texas*

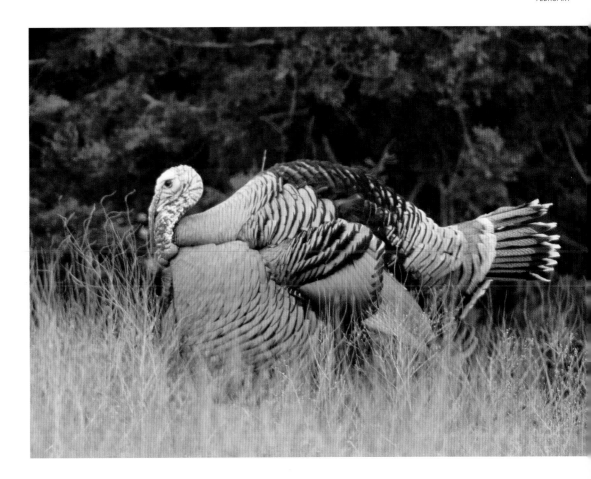

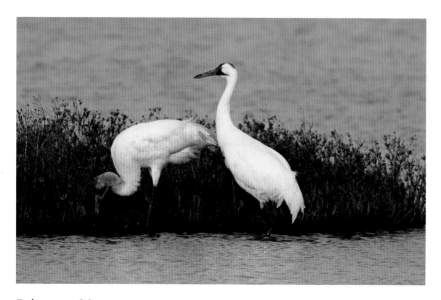

February 20

Whooping cranes once nested in the Gulf States but they were hunted almost to the brink of extinction. The only wild nesting colony that survived was in Canada's Wood Buffalo National Park in the North West Territories. A major effort has been made to bring the species back from the brink of extinction. Aransas National Wildlife Refuge in Texas is key to their survival because it provides a safe haven for the species in the winter. Year round the refuge also supports deer, bobcat and other wildlife. *Texas*

February 21

Whitetails do not seem be at all inhibited by water. They take to it readily, placing it as another obstacle between them and their pursuers. This doe, alarmed by the photographer, stopped running a few meters into the bush and looked back to see if I was going to follow her in. I did not — the water served its purpose. *Texas*

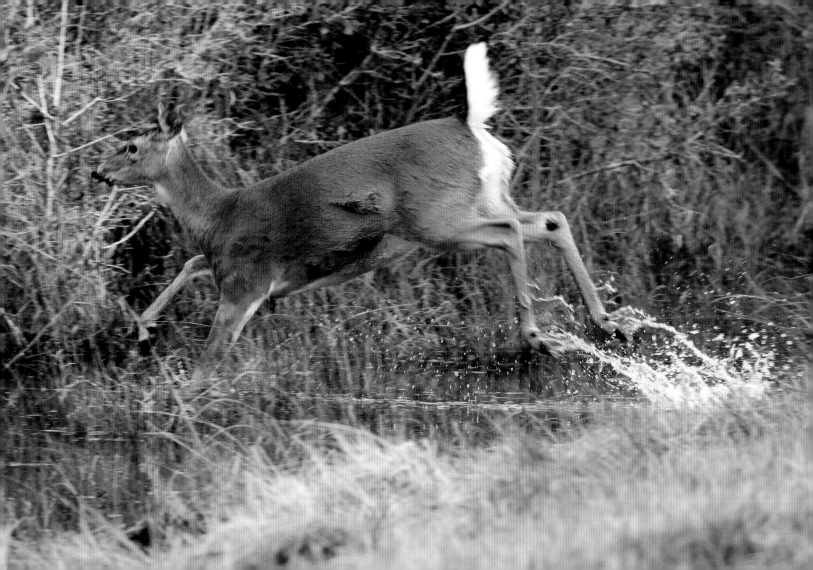

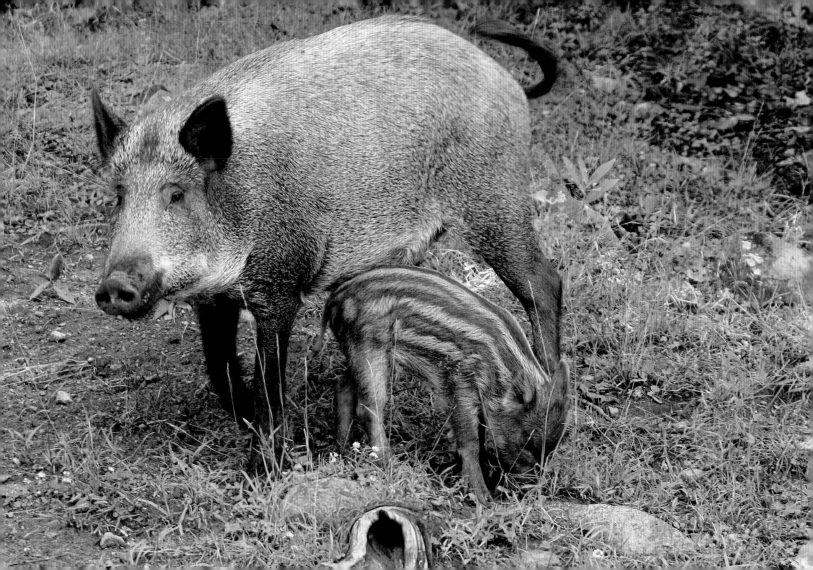

February 23

One of the reason wild hogs are such a threat to native wildlife is their ability to breed twice a year. Deer and bear breed only once and produce only two to three young. Wild hogs reproduce twice a year and will have between four and eight young. Females are able to reproduce when they are between six and ten months old. *Georgia*

February 22

Wild hogs are descendents of of introduced European wild hogs and domestic pigs that escaped to the wild. The two have interbred. While valued as a game animal, wild hogs are also perceived as alien pests. Wild hogs compete with deer, black bear and wild turkey for food. Their rooting in the soil destroys habitat as well. In addition, hogs are omnivores, which means they eat meat, unluckily for the birds eggs, hatchlings, snakes and other small animals that cross their path. *Texas*

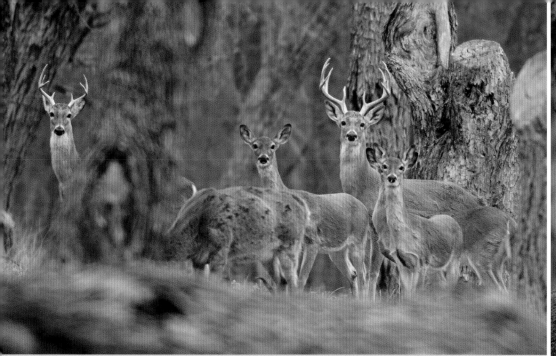

February 24

The survival rate of fawns, as with virtually all young animals, is quite poor. Six out of ten fawns survive their first two weeks, but by the end of summer only three are likely to be around. Predators such as coyotes, bears, bobcats, lynx, wolves are only part of the problem. Parasites — ticks, deer flies, mosquitoes, liver flukes and roundworms — are also a problem. Fawns that survive until February have gotten over a major hurdle in their lives. Their chances of living to reproduce are quite good unless they are under-nourished or ill. *Texas*

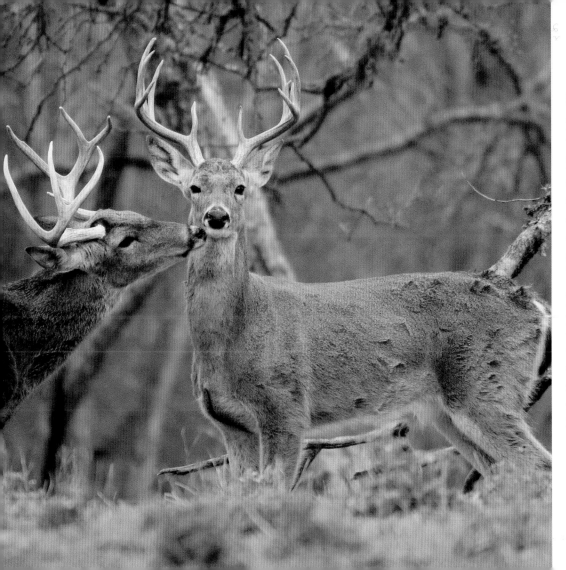

February 25

New World deer split from Old World deer in the late Miocene between 12 and 9 million years ago. These is some dispute as to which group moose and caribou belong. The general characteristics of New World deer are all found in whitetails. The digits are relatively long and end in long pointed hooves, Males have a pendular penis. New World deer specialize in exploiting the cell contents of plants and process their food rapidly. There are very conspicuous glands are their hind legs. *Texas*

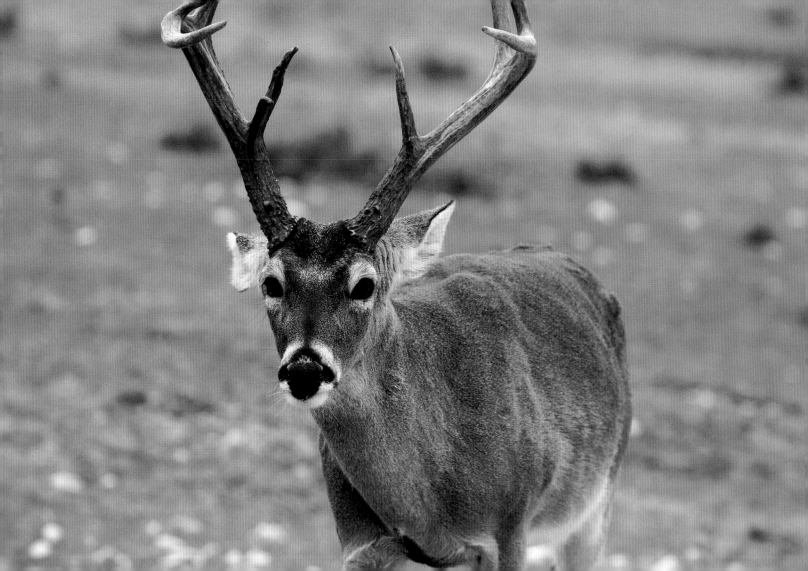

February 26

Texas white-tailed bucks often appear to have larger antlers than deer found farther north. In fact, they are not especially large but tend to look larger because Texas whitetails are smaller bodied than northern whitetails. *Texas*

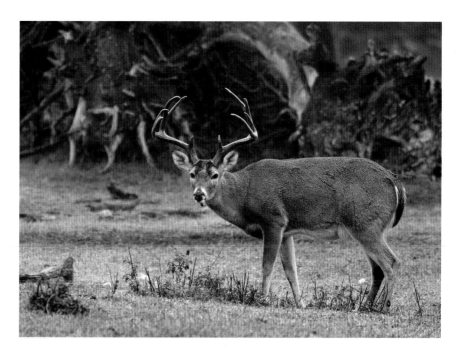

February 27

In warmer regions white-tailed deer seldom leave their home range and even if they do, they usually return to them in short order. *Texas*

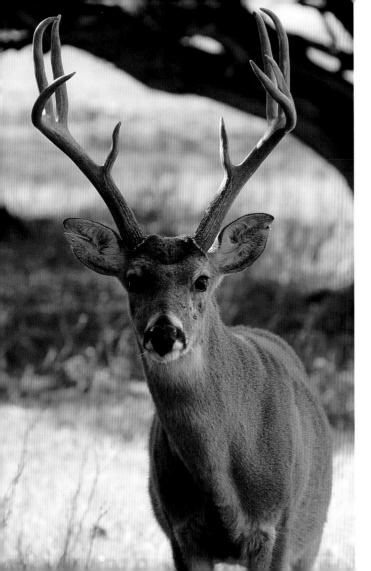

February 28

White-tailed deer racks are sometimes referred to as "high horned." This buck supports such a set of antlers. The growth tends to be more vertical (upward) than the more typical horizontal (semi-circular) whitetail antler.

Texas

February 29

Ospreys migrate from all over North America to the Gulf of Mexico. Some fly as far south as the coast of South America. Resident ospreys will begin nesting next month. Non-residents will follow the warming temperatures north to where they were first hatched. Osprey numbers have increased since the 1970s due to greater controls on pesticides.

Florida

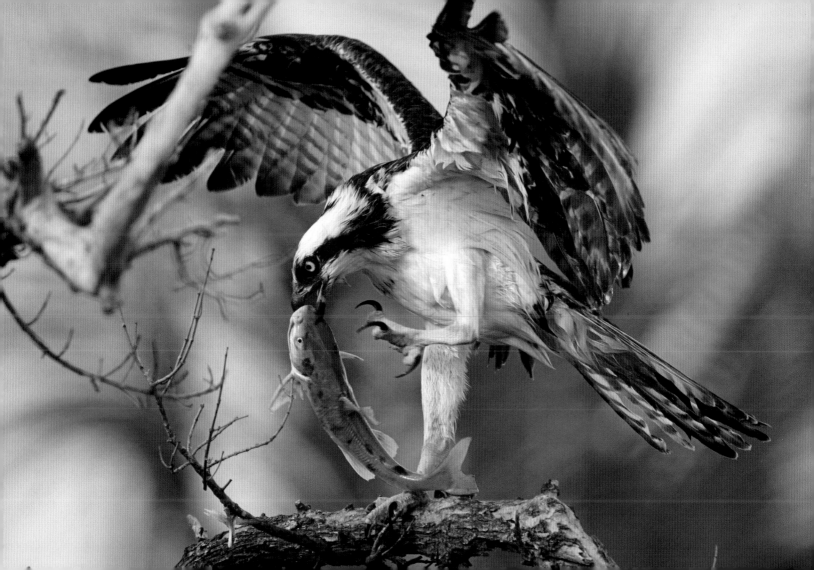

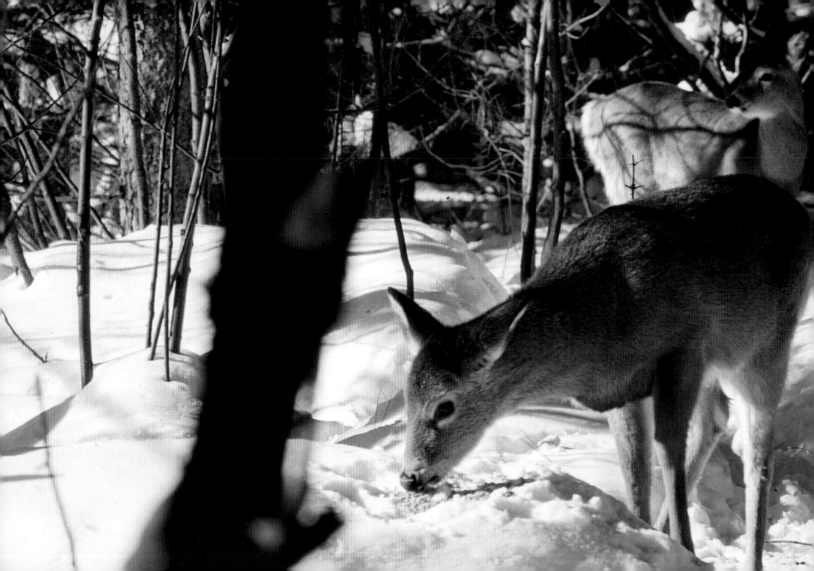

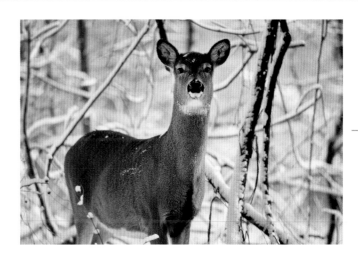

March 1

In Ontario, white-tailed deer were virtually eliminated from the southern region of the province by market-hunting. Ironically, deer moving south from the logging areas, where they were largely absent only 150 years before, help to repopulate the province. The introduction of hunting regulations and set fall hunting seasons allowed the deer to breed and build up their numbers. Before this deer were shot year round. *Ontario*

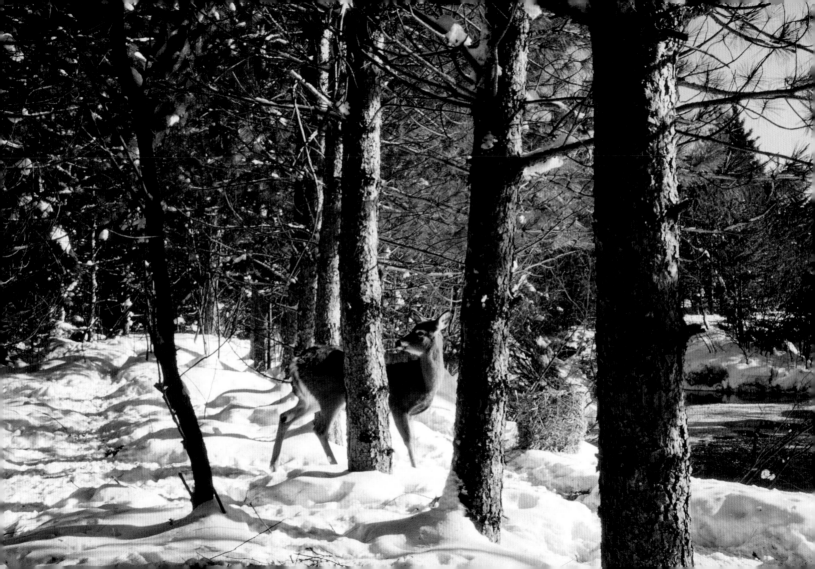

March 2

In the northern Great Lakes states and central Ontario white-tailed deer were absent or found in very limited numbers until the advent of logging in the 1800s. This created suitable habitat for the deer and they literally followed the loggers north. Today, with logged-over forests regenerating and growing out of reach, deer feeding has become an important activity to help sustain the herds. Deer feeding in the northern portion of their range is best confined (if done at all) to late February and March. This is when the does are most stressed by their winter diet. It also is the time when the foetuses start their growth spurt. *Ontario*

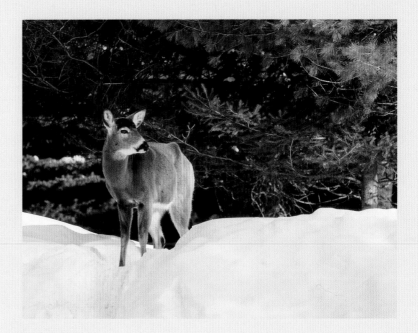

March 3

In the north, deer may travel several miles to deer yards when they sense an oncoming snowstorm. They will leave their traditional territories to make this trek. If a warm spell follows the snowstorm they may migrate back toward their home ground only to return when the next storm is detected. *Ontario*

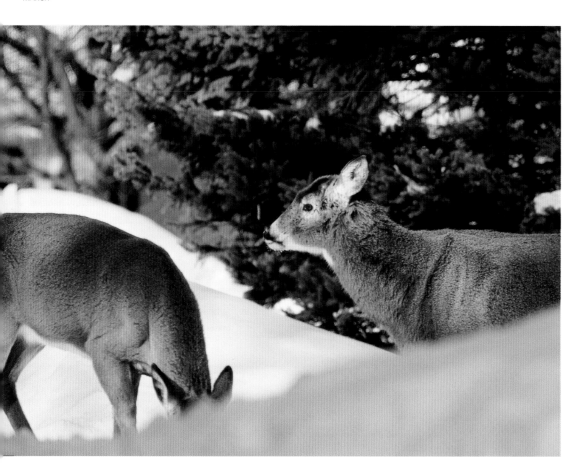

March 4

An advantage deer gain from yarding is the maintenance of clearly defined trails broken down by the herds moving about. If wolves appear, the deer can speed down these trails and escape. Such trails become death traps if they should ice over. Then the deer slip or are forced into deep snow where the wolves have the advantage. *Ontario*

March 5

In 1922 they numbered fewer than two dozen, but there are now about 800 Key deer centered on Big Pine Key in the Florida Keys. Other than automobiles, they have few enemies and are believed to have reached the carrying capacity of their range (the ability of this habitat to support them). *Florida*

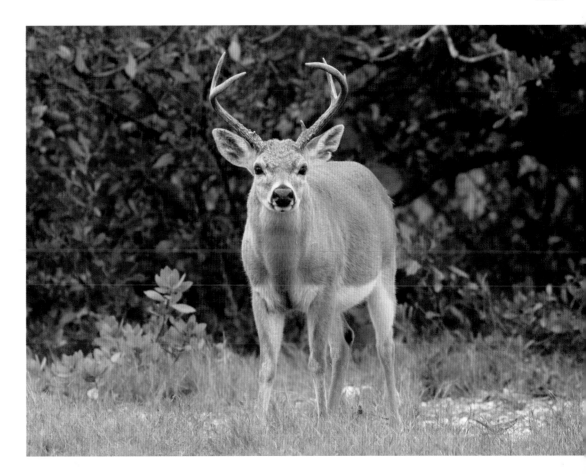

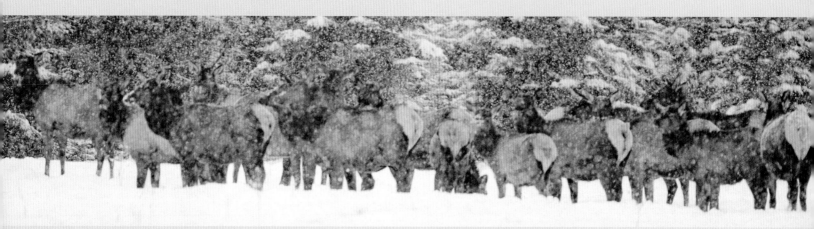

March 6

Elk are large enough to contend with moderately deep snows in winter. Living in herds helps the cows and fawns break trails. Cows and calves are more likely to survive winter than are the bulls. Bulls use up a lot of their fat (stored energy) during the rut and if they cannot rebuild these reserves in late fall they may starve to death. *British Columbia*

March 7

All deer are ruminants. Another ruminant we are all familiar with is the cow. Elk, like cattle, chew a cud. A cud is partially digested vegetation that is regurgitated from its first stomach, the rumen, for a good "chew" while the animal is resting. Then it is reswallowed and goes through further breakdown in the animal's other three "stomachs," the reticulum, omasum and abomasum. These elk are chewing their cud, resting on a ridge where they can keep an eye out for enemies. *Alberta*

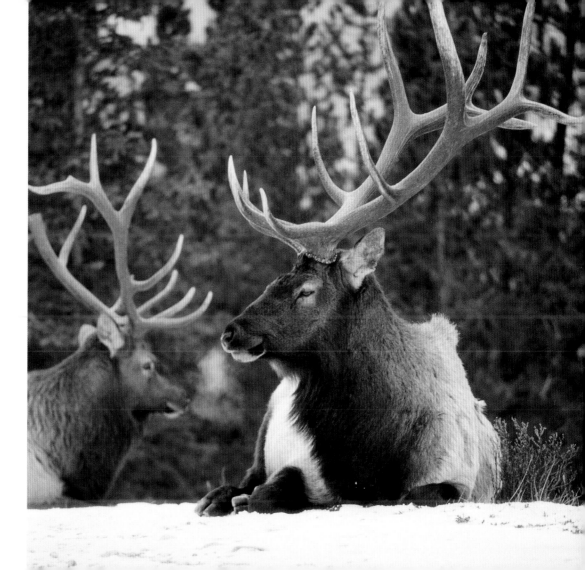

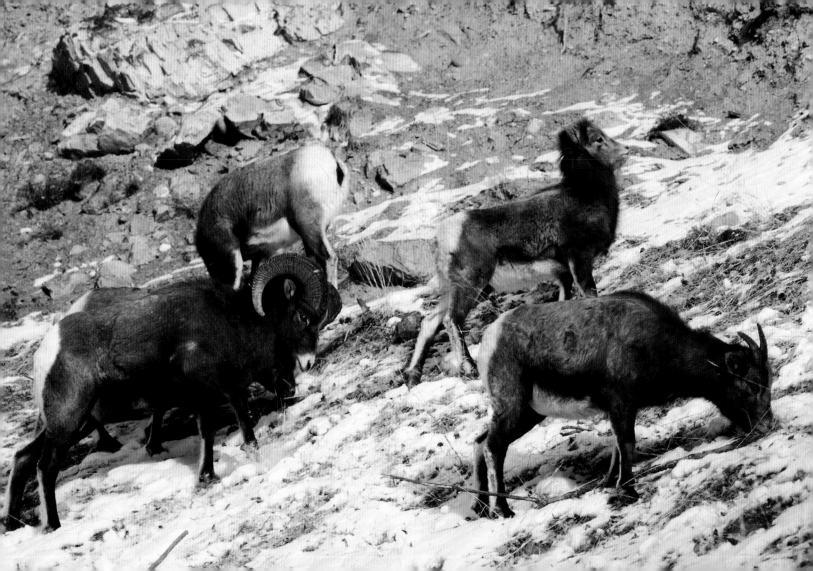

March 8

Bighorn sheep are survivors from the last ice age. They were once more widespread, occupying steep-sided river valleys such as the Missouri's, as far west as the Dakotas. There may have been two million in around the year 1800. They were hunted out of these areas and survived in their mountain strongholds. Intensive sheep management programs have restored them to much of their former range. Today there are over 35,000 bighorns in North America, up from fewer than 10,000 in 1960. *Alberta*

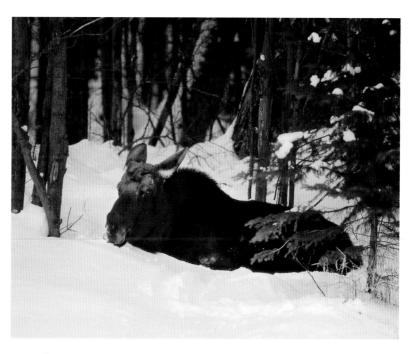

March 9

March can be a turbulent month in the northeast. Thaws can be followed by severe snowstorms. Moose still possess a full winter coat and will take shelter from the storms in conifer stands. Deep snow also helps to insulate them from the wind chill. *Ontario*

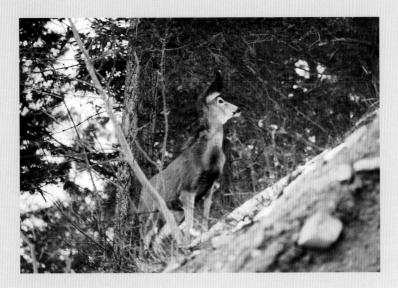

March 10

In the northern Rockies, mule deer have dropped their antlers. They will seek the windblown and south-facing slopes in order to escape being trapped in deep snow. *Alberta*

March 11

Mule deer antlers are different from the white-tailed deer's. A whitetail's tines do not branch but instead normally grow out of the main beam. A mule deer's fork and the tines also fork, giving the mule deer's antlers their characteristic "Y" pattern. *Arizona*

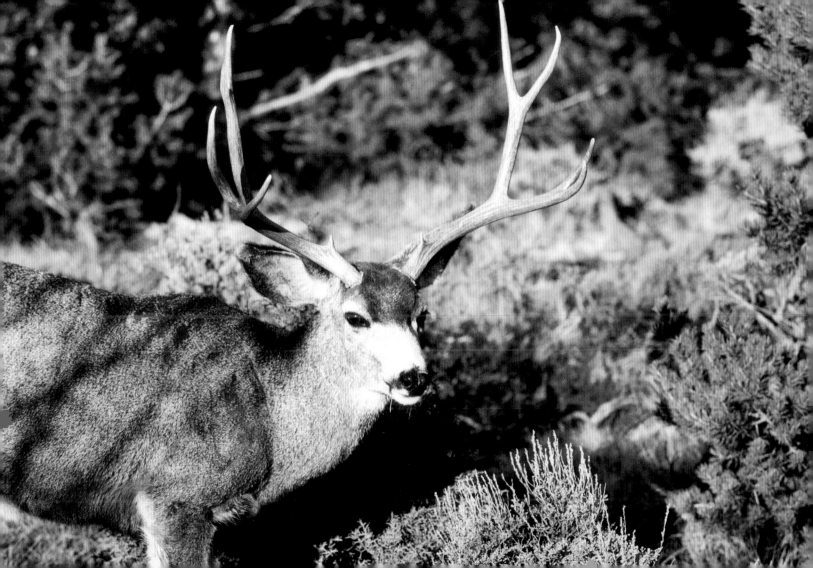

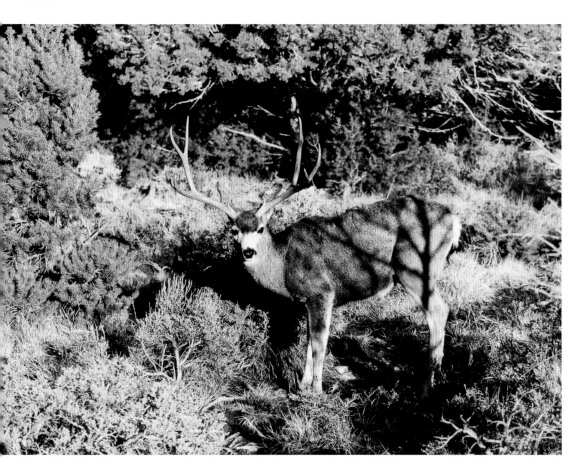

March 12

Mule deer numbers increased dramatically after the disappearance of the wolf, its major predator, in the continental United States. Some would say too dramatically! In parts of their range they literally ate up all of their browse, leading to massive starvation in the winter. Indeed, such events have spurred society's rethinking of the nature of wolves and their role in the ecosystem. *Arizona*

March 13

Mule deer are one of the youngest species in North America. They did not appear until the end of the last ice age. They are closely related white-tailed deer, and as the white-tailed deer has expanded its range in the past few decades, mule deer numbers have declined. Mule deer are better equipped to deal with wolves than are whitetails, but in the absence of this predator the white-tailed deer appears to be able to out-compete the mulies.

Arizona

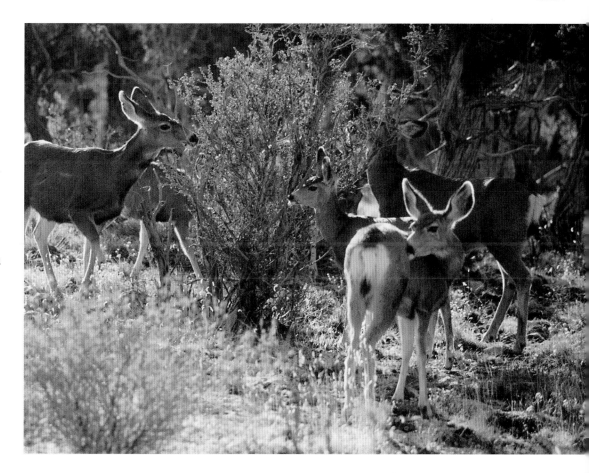

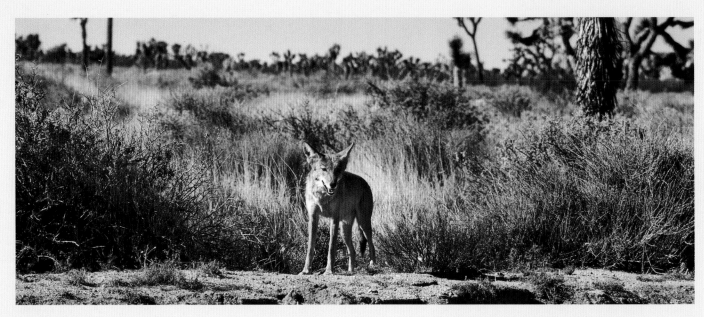

March 14

Coyotes benefited greatly from the rancher's hatred of wolves. As the wolf was eliminated, the coyote moved into the vacated range. Coyotes have been expanding their range since the mid-1800's. They seem able to exploit a wide variety of habitats from deserts to boreal forests. They also adapt to the available prey. Alone they will hunt rodents and small birds, but they will form packs to tackle large prey such as deer. *Arizona*

March 15

Javelinas or peccaries are not pigs. They are not even closely related to pigs. The fact that they look like pigs is an example of convergence. This occurs when unrelated species evolve similar features to meet their needs. Like pigs, they are omnivores and will eat small animals, however their preferred food is plant material including some cacti. There are four species, but only one, the collared peccary, is found in North America. While it is found in desert and scrublands here, it also inhabits rainforests. They live in herds of eight to fifteen animals. *Texas*

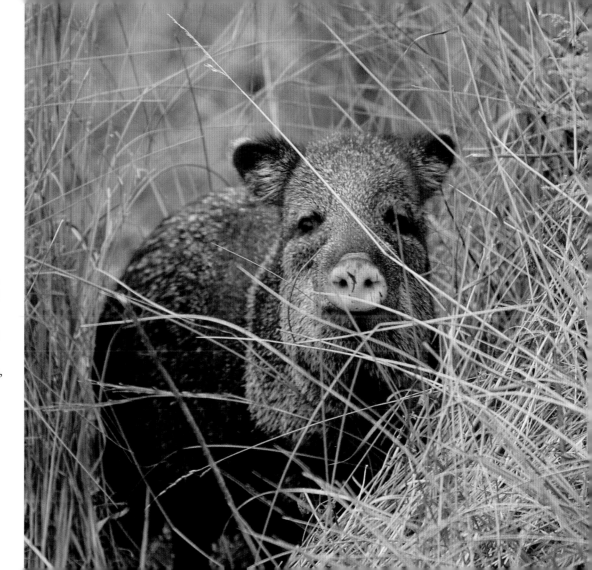

March 16

The diet of whitetails living on the agriculturally rich coastal plain of any of the Gulf of Mexico states is extremely varied. In the fall they eat the fruits of trees, oaks, dwarf palmetto, hawthorns and persimmons among them. In late winter and early spring, grasses make up part of their diet. In summer, twigs, leaves, tender shoots and many broad-leaved herbaceous plants form their diet. *Texas*

March 17

On the coastal plain, which is a rich agricultural area, resident white-tailed deer populations must compete with cattle, sheep and goats for browse. Squirrels, raccoons and wild turkeys compete for the crops of nut-bearing trees. Wild hogs are also major competitors. *Texas*

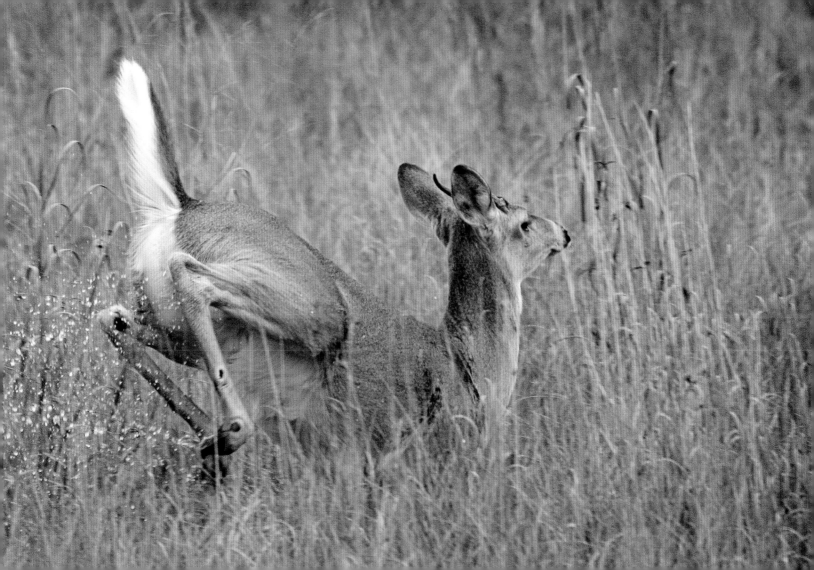

March 18

Nine-banded armadillos are invaders from South America. They first crossed over with the completion of the land bridge (we call it Central America) about three million years ago. They are confined to the southwestern states, except for Florida, where where the species was introduced. These armadillos have poor eyesight but are nonetheless effective predators on insects, small mammals and even snakes. They excavate and live in burrows that, once abandoned, may be taken over by coyotes, rattlesnakes or other animals. *Texas*

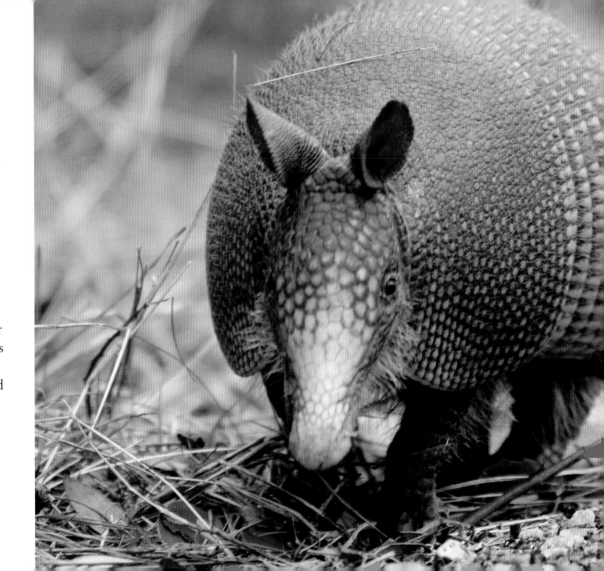

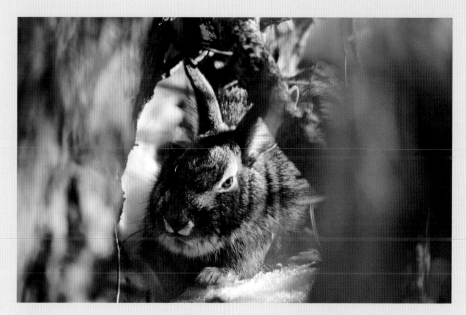

March 19

Cottontail rabbits are common throughout the white-tailed deer's range. Their droppings, like the deer's, are woody in winter. Cottontails, deer and moose conserve water by passing out faecal material that is very dry. In the cottontail's case it is sometimes re-eaten for its food value. A cottontail's droppings are about the size of your fingernail, whitetail's are about twice as large and a moose's is about the size of your thumb from knuckle to tip. *Ontario*

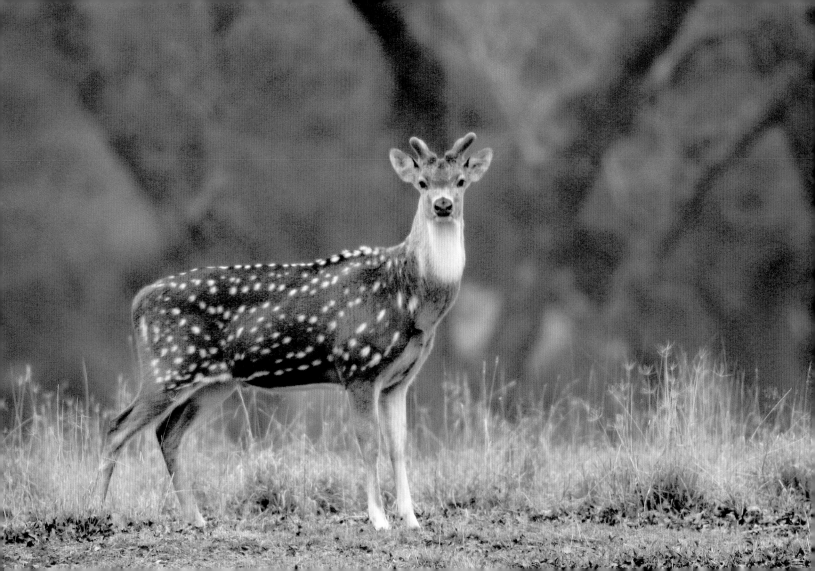

March 20

The introduction of non-native species of deer has occurred throughout the world. The North American white-tailed deer has been introduced to New Zealand and parts of Europe as a game animal. The Axis deer is an introduced species of deer found living wild in parts of Texas. Recent estimates put the population at around 40,000 animals. The species was originally found in India. *Texas*

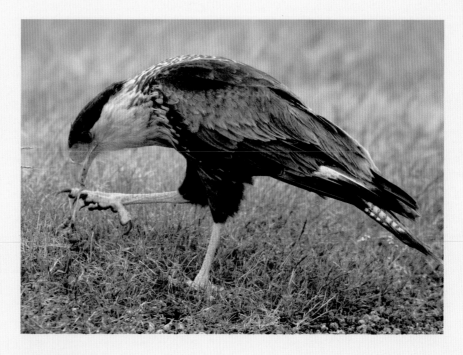

March 21

The crested caracara feeds on small animals and carrion. It often hunts by walking along on the ground searching out prey. It will dominate the larger turkey and black vultures that are present at carrion. The caracara is found in open prairies, and nests both in trees and on the ground. *Texas*

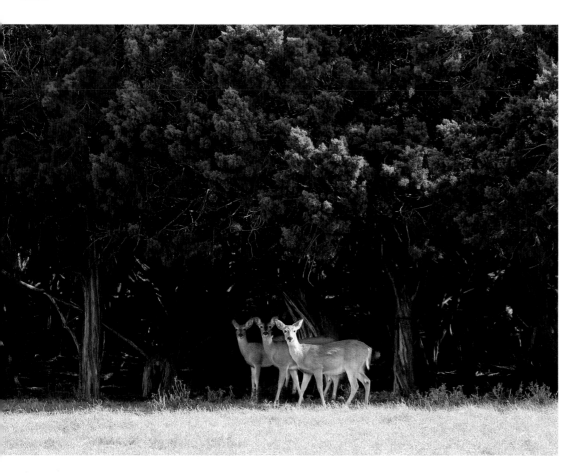

March 22

In Texas, whitetail recruitment rates (birth and fawn survival rates) average about half their potential. The reasons for this are poor range conditions, malnutrition and high predation rates on fawns. Most does have their first offspring when they are one and half years old. In good conditions, twins would be expected, but here the incidence of twins is below the national average. *Texas*

March 23

Despite their low recruitment rates, Texas has the largest white-tailed deer population (as befits the largest state south of Canada). There are over four million whitetails in the state. *Texas*

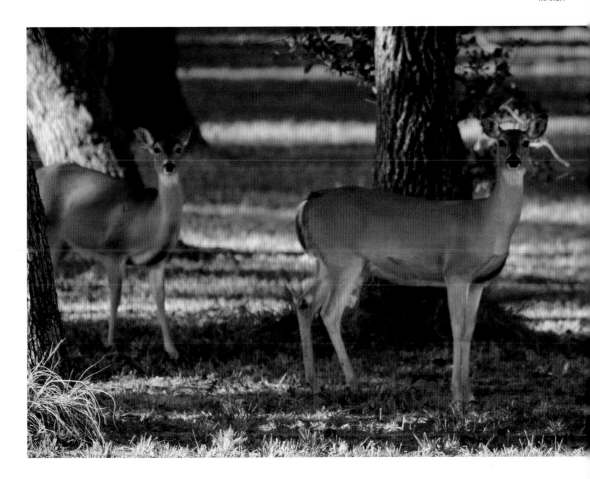

March 24

TOP The angle of the sun, as perceived by receptors in the deer's eyes, determines when it will grow antlers, shed velvet and lose antlers. Whitetails found in South America follow a mirrored pattern of those in North America. *Texas*

RIGHT By March, white-tailed bucks have shed their antlers across their range. Larger bucks usually drop theirs first. In the northern part of their range, antler-less males are often seen in January. *Texas*

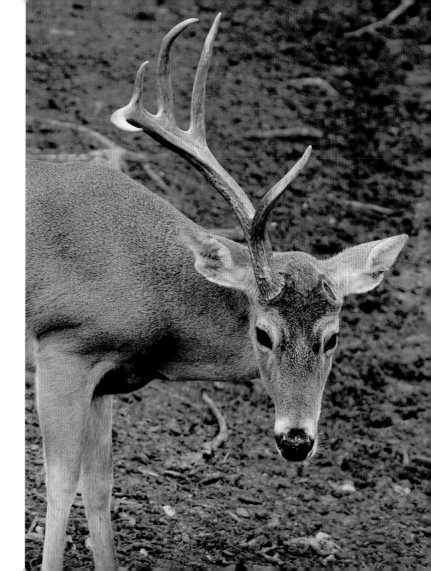

March 25

In the southern part of its range, the black-tailed jackrabbit may have up to seven litters. In the northern part, one to two litters are common. The black-tailed jackrabbit is able to exploit hot dry climates by being able to get most of the water it needs from vegetation. This gives it an advantage over mule and white-tailed deer in this habitat. *Texas*

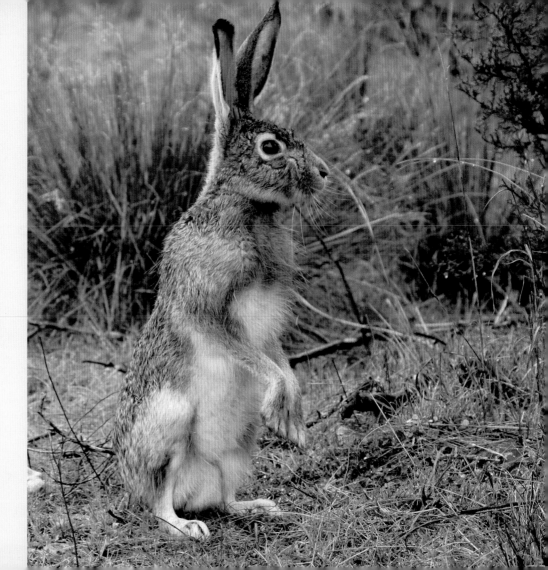

March 26

The moose is a concentrate feeder, feeding on clumps of coarse vegetation such as leaves, twigs, forbs — non-woody plants — and water plants as they come into season. This is unlike the behavior of a roughage feeder, which feeds on large quantities of the same food (for instance, bison and grass). In a forest setting, desirable foods are available in clumps of suitable habitat only at certain times of the year. Moose learn when the red maple leaves are at their best or when the water plants contain the most minerals, and move to these areas at the appropriate times. Moose usually feed alone or with their calves. *Ontario*

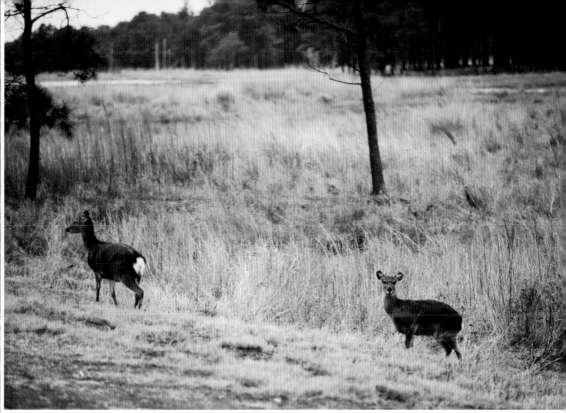

March 27

The Asian sika deer *(Cervus nippon)* a small species of oriental elk, has been introduced in the eastern United States, notably Assateague Island National Seashore and in parts ot Texas. *New Jersey*

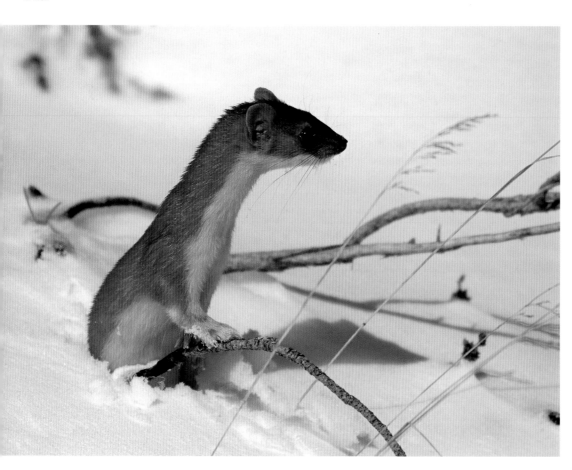

March 28

The long-tailed weasel is an active and efficient hunter all year round. In more northern parts of its range most turn white but brown-colored animals are by no means uncommon. I watched one hunt a Rocky Mountain cottontail once. The rabbit took off and headed for cover. There is nowhere a rabbit can go that a weasel cannot follow. I suspect it did not go well for the rabbit. *Colorado*

March 29

One of the first birds to nest in the north woods is the great horned owl. Owls begin courting in January and by February they are likely on the nest. The female shelters her eggs through snowstorms and bitter cold temperatures. The male is close by, usually in the dense cover of a pine tree. *Ontario*

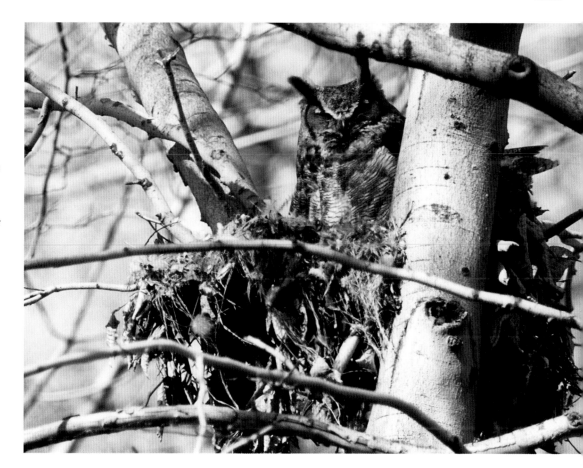

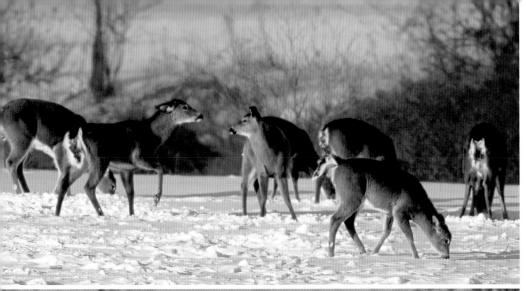

March 30

By late March the pecking order in the deer herd is well established. Laid-back ears and a mildly aggressive kick are all that are needed to move off a subordinate doe from a choice feeding spot. *Ontario*

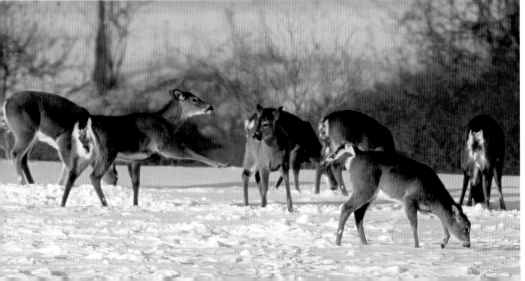

March 31

Whitetails will paw through snow to get to the last remaining seeds and grains left over from the fall harvest. By the end of March their resources are limited and their unborn fawns are making demands on the does' energy reserves. *Ontario*

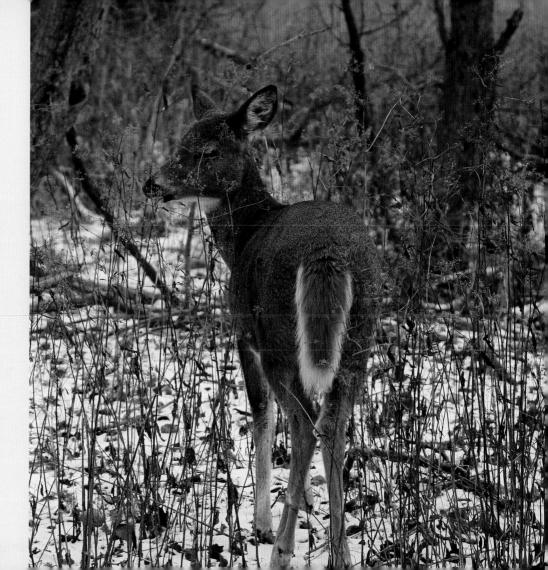

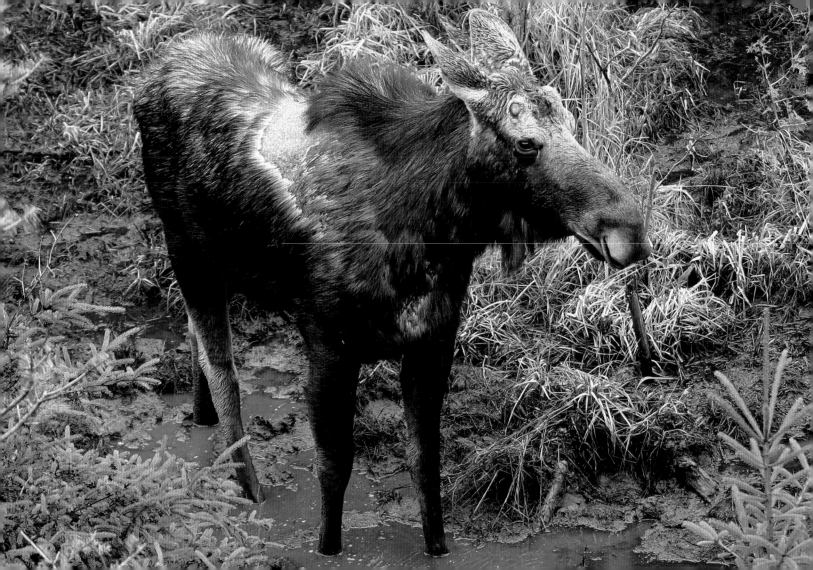

APRIL

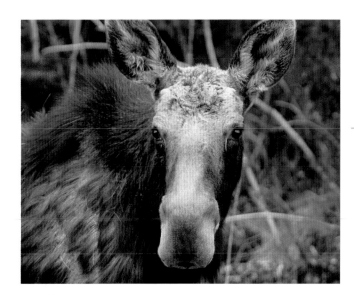

April 1

In Ontario's Algonquin Provincial Park, moose watching is a popular activity in April. Moose are drawn to the salt licks along the park's lone highway. The licks are not natural; they are pools where road salt applied to the road during the winter has washed off and collected. I once saw 48 moose in a 24-hour period. *Ontario*

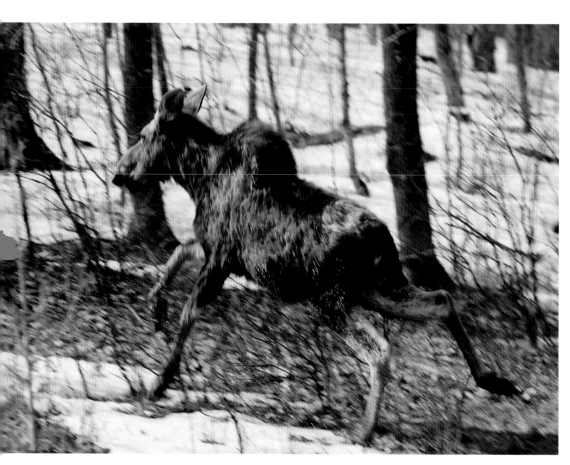

April 2

Moose infected by winter ticks will often scratch at the infestation to remove the pests. This removes the dark guard hairs of the animal's coat leaving it with a grayish appearance. Animals so afflicted are sometimes called "ghost moose." *Ontario*

April 3

A moose can easily tolerate 5,000 to 7,000 winter ticks but in bad years the number of ticks can exceed 50,000! Scratching often leaves the moose virtually nude. A sudden cold spell, very common in March and April, may kill hundreds of moose. *Ontario*

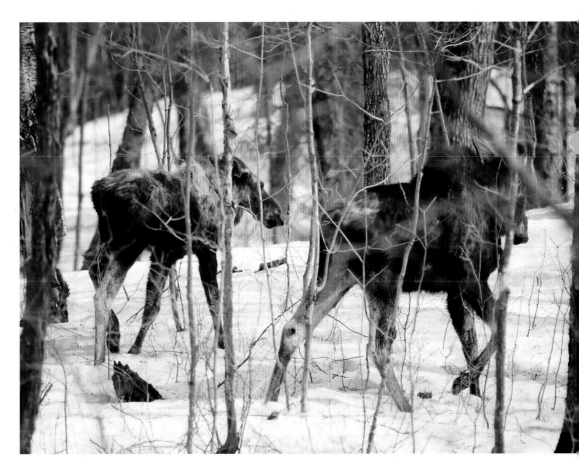

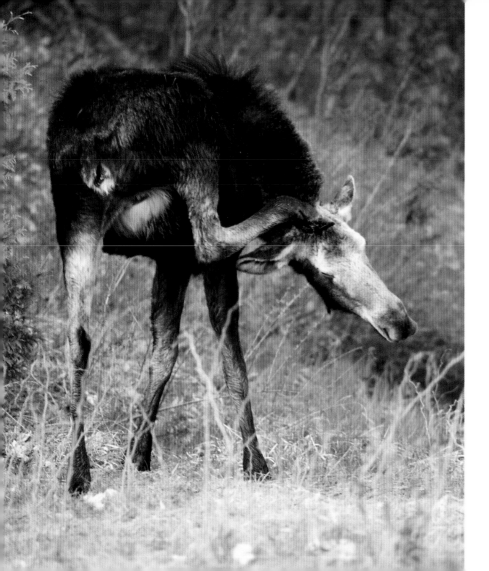

April 4

The winter tick *(Dermacentor albipictus)* is a skin parasite that on rare occasions can kill moose. The ticks fall off the moose in the spring, then mate and lay eggs. In the fall the pin-sized ticks climb up on the stems of weeds and grasses and attach themselves to a passing moose. Once on board, they burrow their heads beneath the animal's skin and engorge on its blood. Come March they are size of a quarter. *Ontario*

April 5

By now, if the snow is still deep, coyotes are getting desperate for food. They will have depleted the numbers of small mammals, many of which do not breed in February. Their best hope lies in winter-killed animals and animals weakened by starvation. Coyotes are easier to see at this time of year than most others, as they are actively seeking food even during the day. *Alberta*

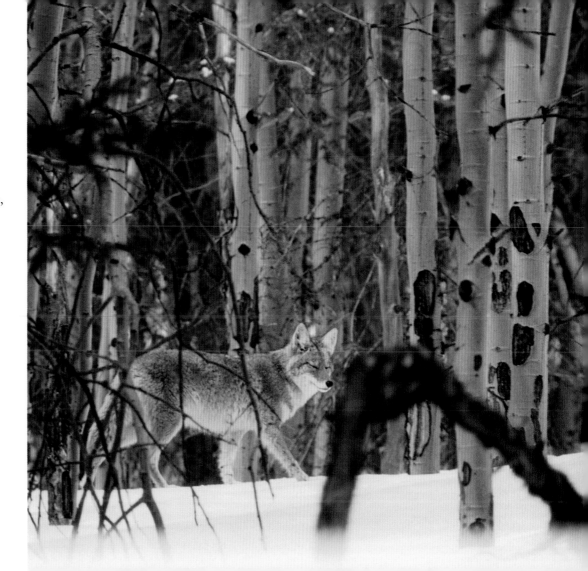

April 6

Wolves, unlike bears, are year-round predators on all forms of deer where their ranges overlap. Predators help control the population of their prey species and balance the ecosystem's resources. Studies have shown that when predators are removed from an ecosystem, the prey species (deer, for example) will overbrowse the available food. This leads to a crash in their population. On rare occasions, the scales tip to favor the wolf, and ungulate numbers begin to decline. In such situations, it is sometimes necessary to manage wolf numbers by trapping and hunting them. Airplanes and snowmobiles have been used to crop excessive wolf numbers.

Quebec

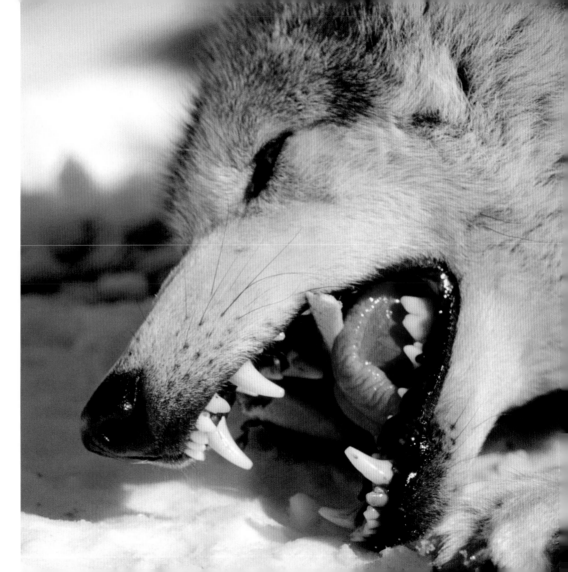

April 7

Wolf kills in winter are relatively easy to find. Many of the kills occur when the deer or the moose try to escape by crossing a frozen lake. It is not unusual to see ravens and bald eagles in attendance at such kills. This kill is a white-tailed deer. The wolves left it unattended during the day but will likely return at night for a final feed.

Ontario

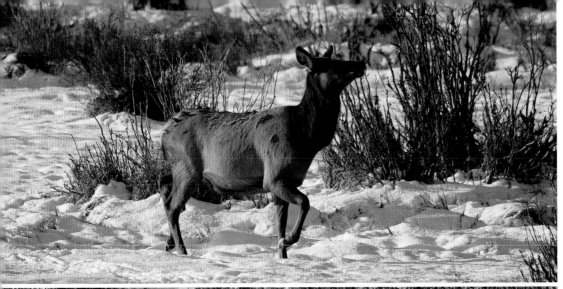

April 8

Wolf chases involving elk can cover a lot of ground because elk have a lot of stamina but so too do wolves. Elk cows tend to flee as soon as they spot a pack on the prowl. All things being equal, there is a good chance the cow will escape. But wolves are expert at exploiting mistakes and unexpected events. Deep snow may slow the cow or she may slip on ice. *Wyoming*

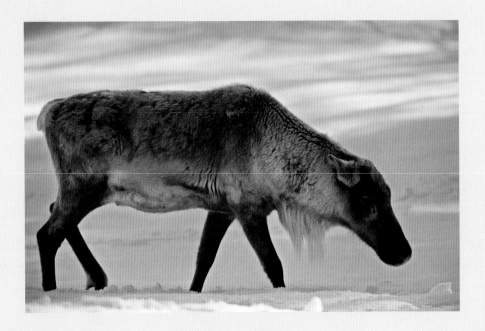

April 10

By early April, great horned owlets are ready to fledge. The parents will continue to feed them for several more weeks. The young face many dangers, especially if they fall to the ground where foxes may find them. *Ontario*

April 9

By April most caribou, male and female, have shed their antlers. These members of the deer family are our most northern deer and the only ones in which both males and females possess antlers. *Quebec*

April 12

The spring green-up arrives along with mixed herds of deer. Free of the confines of winter snows in the north, the deer herds are anxious to feast on the rich plant material appearing around them. Old social conventions break down and mixed herds are common. *Ontario*

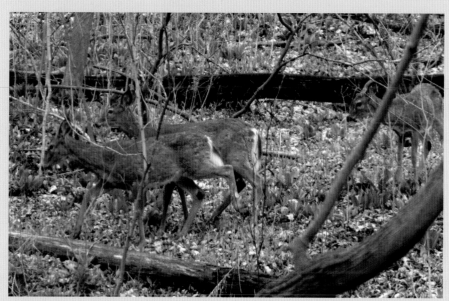

April 11

White-tailed deer have many predators. Bobcats, coyotes, wolves, black bears, lynx, cougar, alligators, grizzly bears, red fox (fawns), wolverines and golden eagles are all threats. *Virginia*

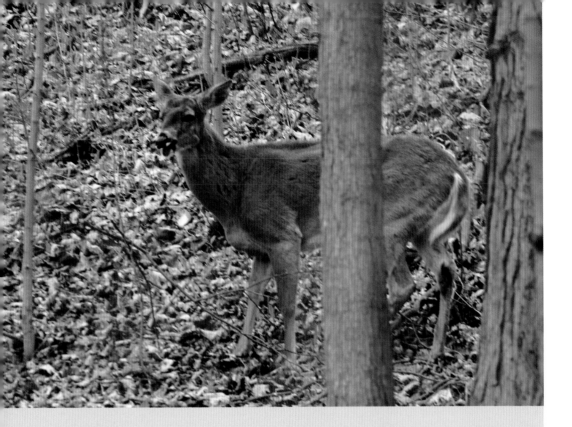

April 13

Black-crowned night herons are the most cosmopolitan members of their family. I've photographed them in Africa, Europe and Australia. Their arrival signifies the beginning of spring. In Virginia they are nesting by mid-March but in Ontario they do not begin to nest until April. *Ontario*

April 14

This buck was feeding with the does and fawns in the previous picture but he was more wary and alert and he followed behind the others. His antlers have not yet started to grow. *Ontario*

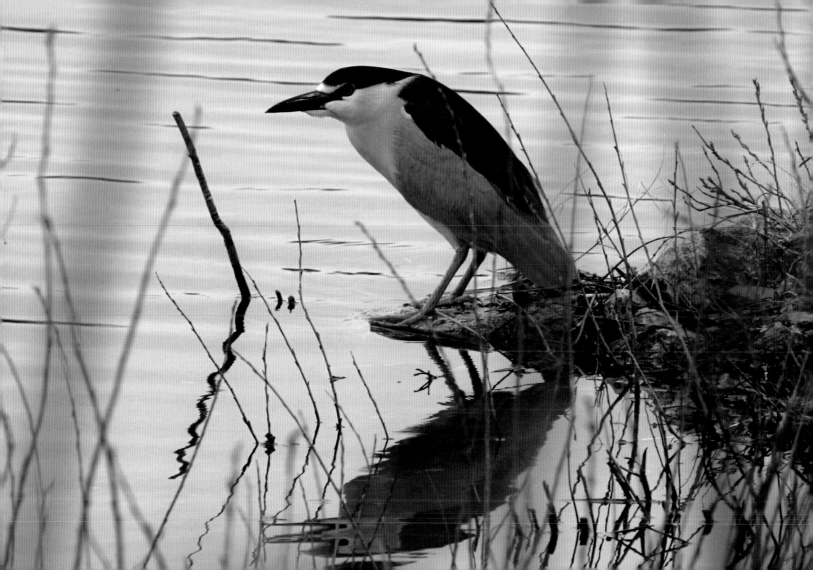

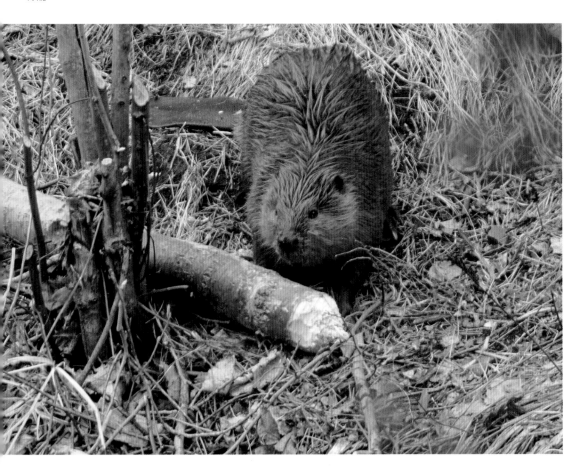

April 15

Beaver are an essential part of the deer's world. Even the tallest of deer cannot reach the top of most trees. By cutting down trees the beaver does two things: it creates wetlands for deer and moose to use and it creates new habitat for new trees to grow. *Ontario*

April 16

Cottontails reproduce very efficiently. Females will give birth two to four times a year, each litter having up to nine young. Fortunately for the ecosystem, predators are just about as efficient hunting them. Coyotes, great horned foxes, owls, weasels and a variety of other hunters prey on these bunnies. *Ontario*

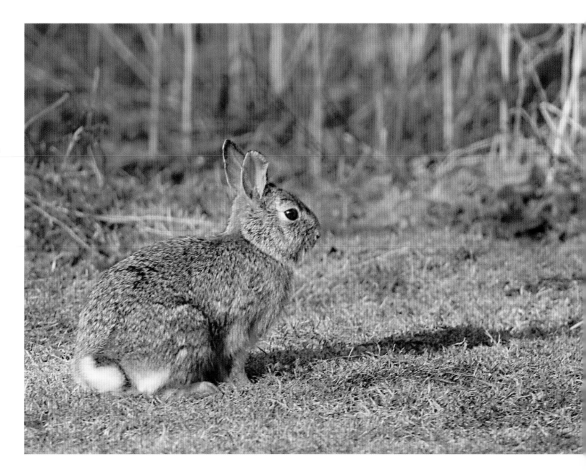

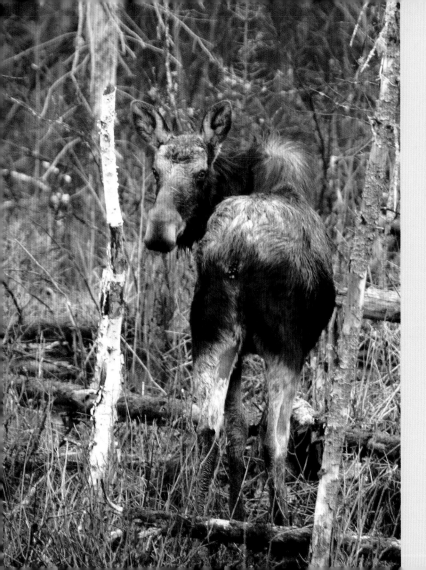

April 17

Moose use their long legs to run over obstacles such as fallen logs. This gives them a better chance of escaping predators, who with their shorter legs, cannot simply run over the fallen trunks. The moose's gliding stride uses much less energy than that demanded of wolves that have to leap over obstacles. *Ontario*

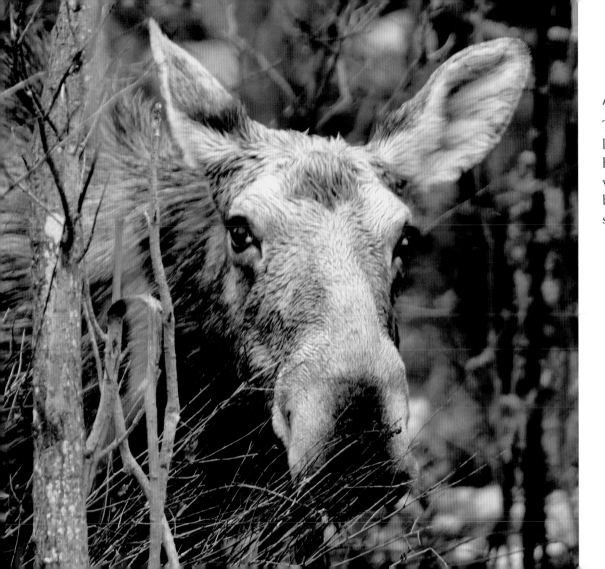

April 18

The eyes of the moose are located on the sides of the head, providing a good view to the side, front and behind, but only limited stereoscopic vision. *Ontario*

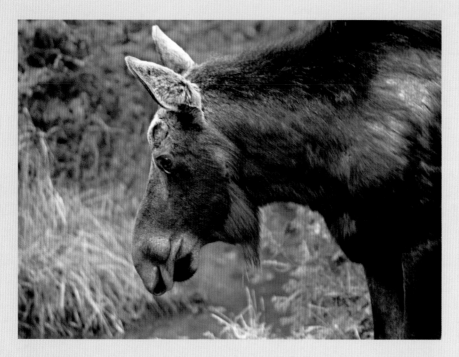

April 19

Pedicles are bony protuberances where the antlers develop. They may appear to be round bloody bumps on the head when antlers are freshly shed. However, before antler growth begins they are covered with skin and hair. *Ontario*

April 20

Moose rely on their long legs for defence. They can kick out effectively with both front and rear hooves. A wolf or bear kicked by one of these animals is certainly going to know it. The Ontario Ministry of Natural Resources documented at least one case in which one of the black bears in their study was killed by a moose's kick to the ribs. *Ontario*

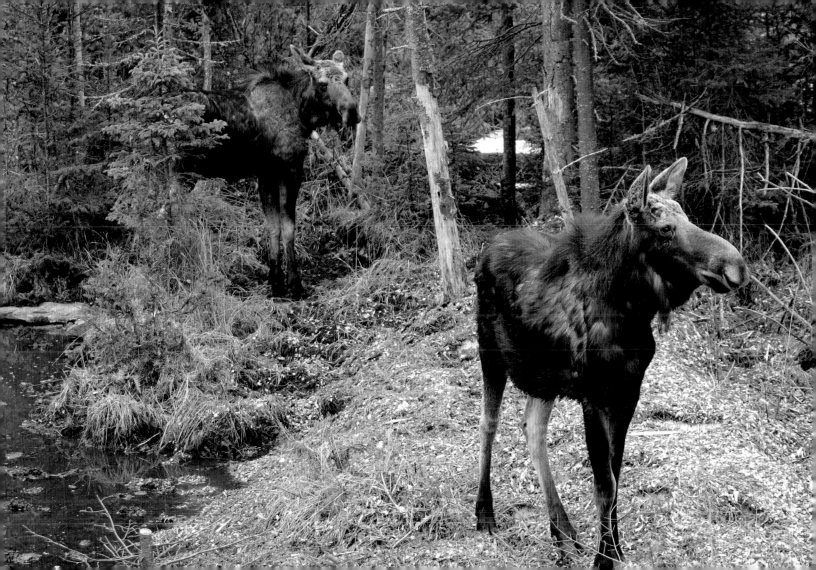

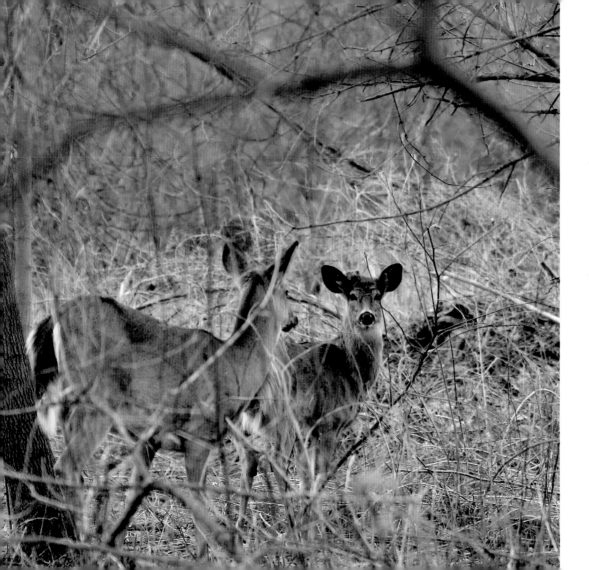

April 21

First-time mothers set up territories, which they will defend, adjacent to their mother's birthing area. They will move a little farther away when the next generation of their mother's fawns (their younger female siblings) give birth to their first fawns. This can crowd the maternal doe's territory, but fawn mortality tends to be high so overcrowding is rare. *Ontario*

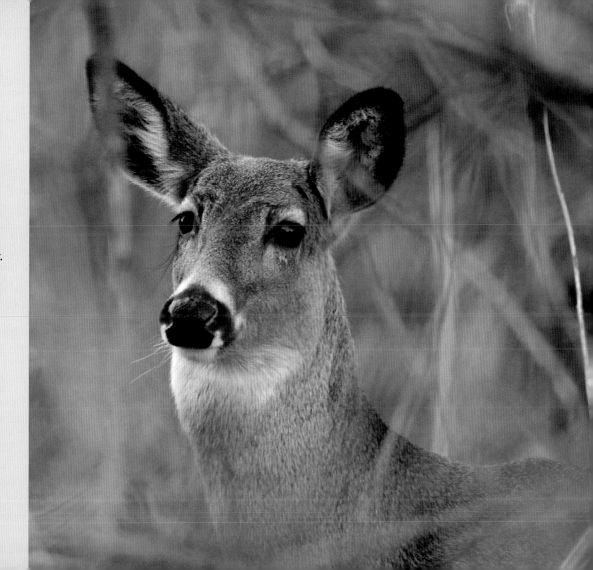

April 22

I recognize that beauty is in the eye of the beholder and is really a quality that humans, not animals, see in others, but to me this doe was a strikingly good looking specimen. Some does are not quite so pretty. She still has her winter coat on, which does help.

Ontario

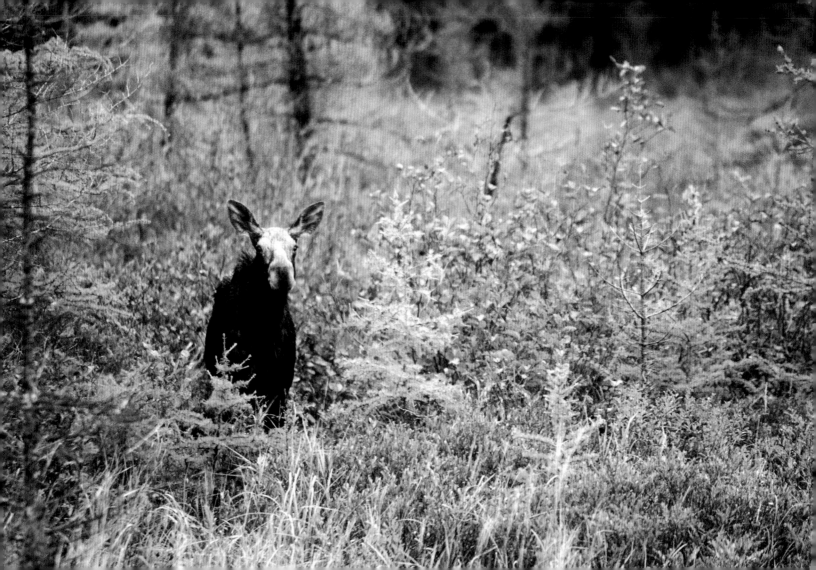

April 23

Seasonal home ranges of moose in North America range from .8 to 1.6 square miles (200–400 hectares). The size is determined by the amount of food resources available to maintain the animals.

Ontario

April 24

The woodcock is actually a member of the shorebird family. However, they are most often encountered in wet woods. They nest on the ground and are almost impossible to see. During courtship the male performs a high spiralling flight. A good friend helped band these birds. The process begins with the sound of the twittering flight. The bander then runs to the site and waits for the bird to descend back to where it started out from and into the bander's net. *Ontario*

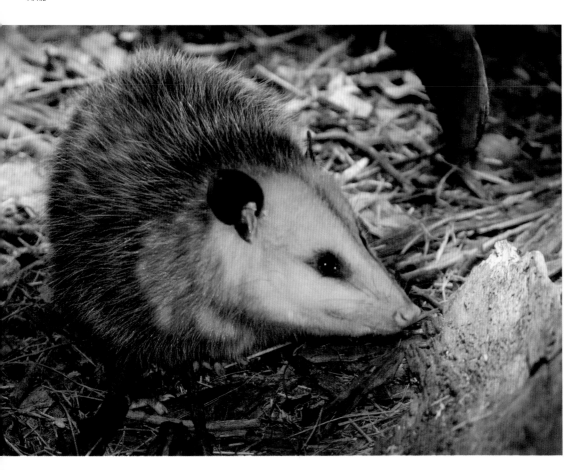

April 25

The opossum is North America's only member of the marsupial family. Like the armadillo, it is a migrant from South America. Unlike that animal, however, the opossum continues to expand its range. It is now found across the United States and in many of the Canadian provinces. It just barely survives northern winters. The secret to its success is its ability to reproduce twice a year; litters average seven but can be as many as thirteen babies. *Texas*

April 26

The black bear relies on the spring green-up for food. Up to 80 percent of a bear's diet is vegetative matter. Although it feeds on plants voraciously a black bear will not gain much weight. In the spring and summer, the bear's feeding simply maintains its weight. It will not begin to put on weight for hibernation until late in the summer or early in the fall. *Alberta*

April 27

While it will still be a month or so before this doe gives birth, the distance between her last year's fawns is already increasing. The yearlings are playful and often wander away. By the end of April there is so much new food available that the larger herds are beginning to break up as does return to their natal areas. *Ontario*

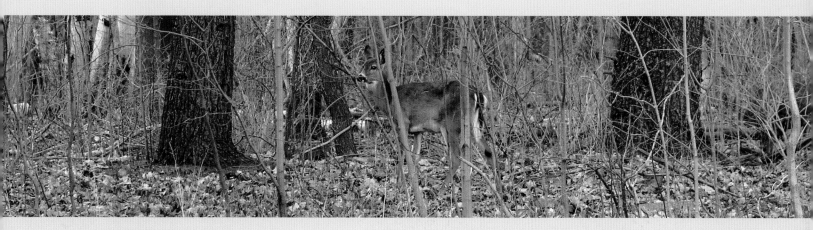

April 28

This yearling was quite a distance from its mother when I first noticed it. It wasn't quite sure about me and quickly retreated to join her again. One day, in the not too distant future, it will no longer be tolerated by her and will have to follow its own instincts. *Ontario*

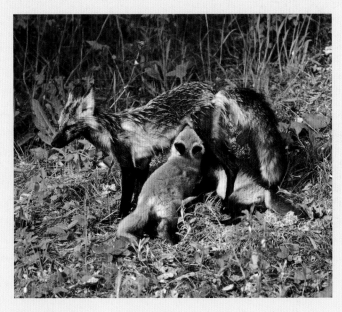

April 30

Elk drop their antlers in late March or early April. Immature bulls may even keep theirs until May. By the end of April, however, antler growth is well-advanced on the mature bulls. *Michigan*

April 29

Red fox come in many colors. This is a dark-phased one but her pups represent the genetic variation you sometimes see in fox families. These pups would have been born about a month ago, near the end of March, but are now just coming out of the den. *Ontario*

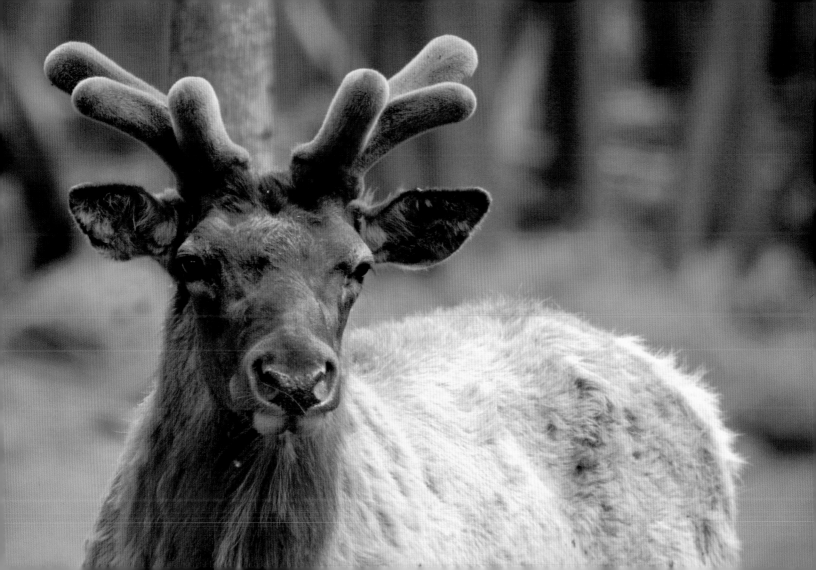

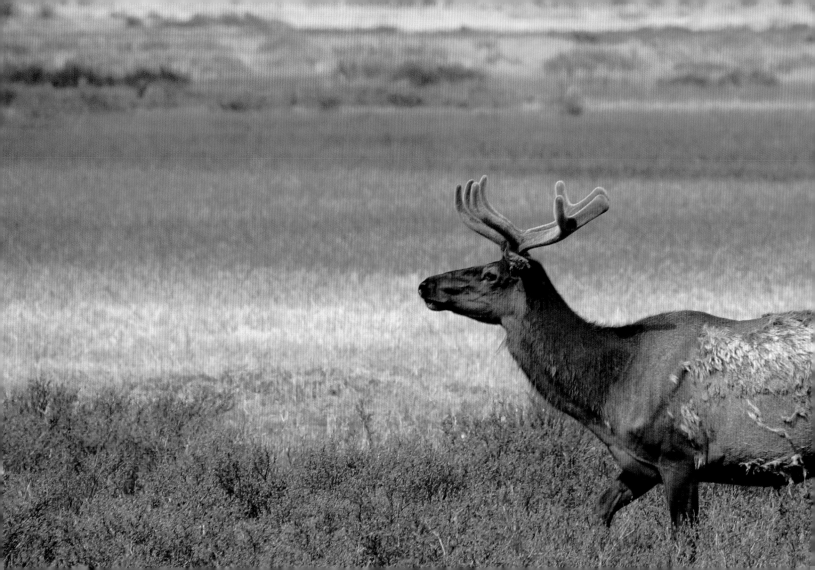

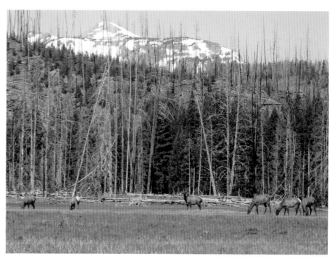

May 1

Elk are long-legged "cursors." When faced with a predator they escape by employing a strategy of rapid and sustained flight. They do not leap like whitetails or stand their ground like moose. The elk's strategy works best in open plains where there are few obstacles to overcome. Elk may attempt to chase off a pesky coyote but will not stand and face a pack of wolves or a bear. *Wyoming*

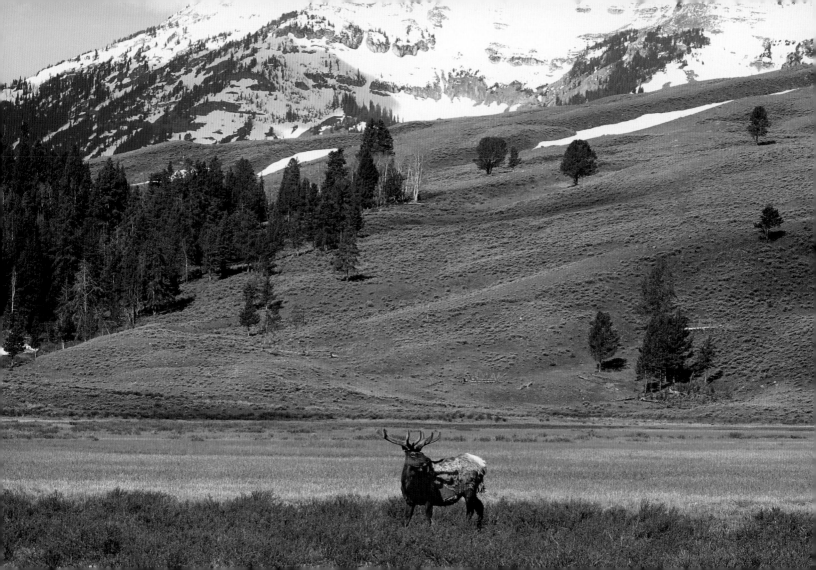

May 2

In the spring, bull elk are usually found alone or with only a couple of other males. Adult bulls are confident in their abilities to cope with predators. They select the areas that offer the best nutrients for their growing antlers.

Wyoming

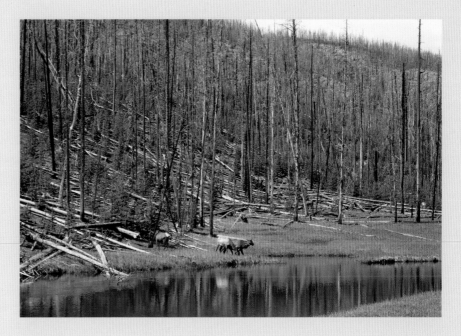

May 3

The fires that ravaged Yellowstone National Park in 1988 turned out to be very beneficial to elk and other large mammals. The amount of available grass for grazing was increased and the new growth forests provided reachable browse. Wildlife numbers are up and it is easier to see the animals as well.

Wyoming

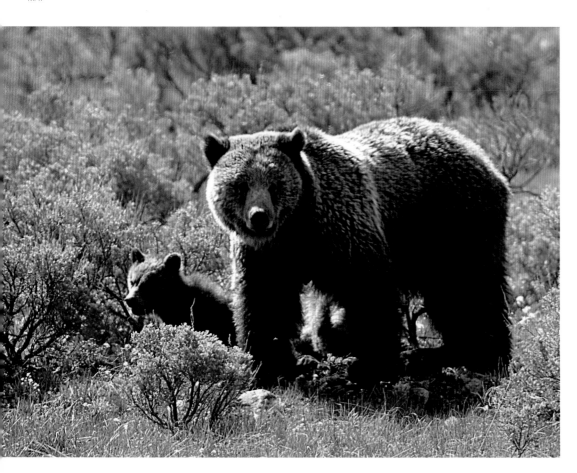

May 4

The diet of a grizzly depends on where that grizzly bear lives. Bears that live along the coast feed on salmon. Bears that live in an ecosystem where ungulates are not numerous get by on vegetation and insects. This bear lives in Yellowstone where ungulates are abundant, especially elk. Her diet will be composed mostly of meat. *Wyoming*

May 5

The spruce grouse forages both in trees and on the ground. It is often seen along roads that cut through wet spruce forests. It comes to the roads to get small stones that it will swallow and store in its crop. The stones are used to help grind up food. This bird can store up to 10 percent of its body weight in its crop. Digestion usually takes place a night when the bird is roosting. *Ontario*

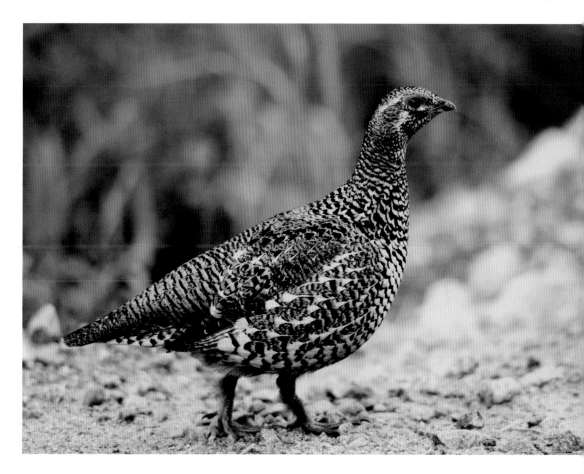

May 6

The sandhill crane's call is a distinctive one. It can be heard throughout the spring mating season well into summer. Mated pairs call back to each other constantly. Later, during the migration, calls are used to keep in contact with other cranes as they migrate south. This species of crane is one of the few that is not endangered. Huge flocks gather in the fall to migrate south for the winter.

Wyoming

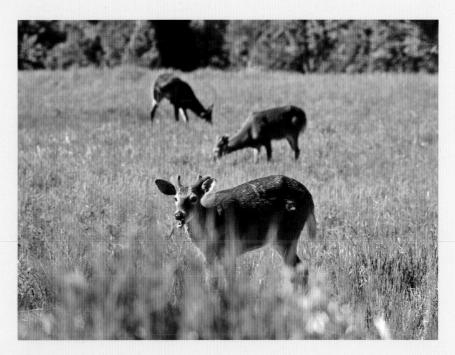

May 7

As their antlers begin to grow, white-tailed bucks will continue to congregate in small bachelor groups. There is no play-fighting and the bucks do not keep close company. The antlers are tender now and will bruise easily. *Ontario*

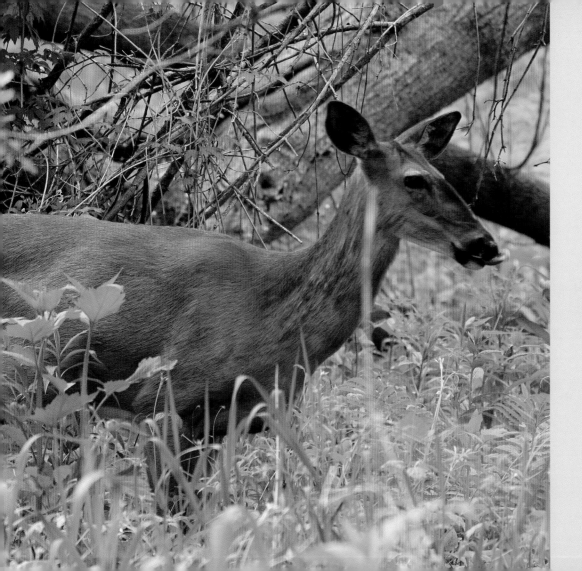

May 8

The white-tailed deer's range must meet two main criteria. It must be large enough to meet the deer's nutritional needs so that it can successfully reproduce. It must be small enough so that it can improve its probability of survival by possessing an intimate knowledge of its features. In general, a deer's territory seldom exceeds a radius of 1 mile (1.6 km). Deer living in better ranges will travel less; deer in poor range travel more. *Ontario*

May 10

As fawning time draws closer, does begin to spend time alone. Last year's offspring are chased away and are now independent. They may well join up with other yearlings and be encountered in small groups. In the fall, yearling females will join up again with their mothers and this year's crop of fawns. *Ontario*

May 9

White-tailed deer are most visible (from our point of view) in the early morning hours and in the late day. During most of the year they follow a fairly predictable routine. They will feed in more open areas at dusk and dawn and retreat to cover during the day. *New York*

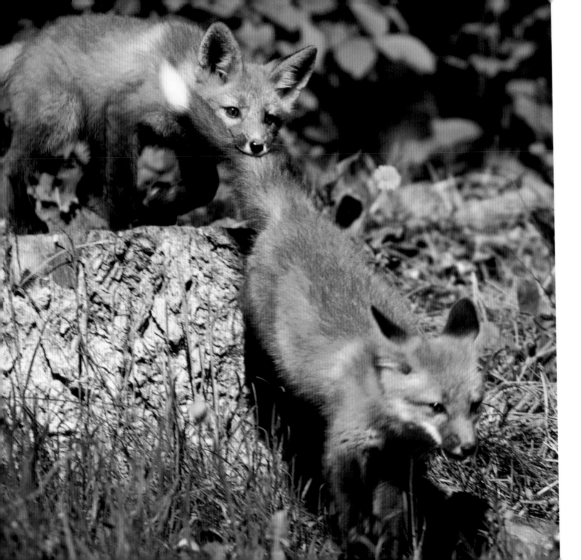

May 11

Red fox kits are noisy, playful critters in May. Both parents have a role in raising them, the male spending more time hunting than the female. Kits are most visible at this time of year. By July the same foxes that scrambled so readily in full view will become nervous and hide when approached. By August they will be gone, wandering up to 100 miles (about 150 km) in search of a vacant territory. Many do not survive beyond this period in their lives.

Ontario

May 12

Bald eagles are well known as expert anglers. They are often associated with locations where fish are available. They are also adept at hunting waterfowl. What is less well known about them is that they are scavengers. This one was waiting until wolves left an elk kill. Where wolves and bald eagles are around, watch the eagles. They will lead you to the wolves.

Wyoming

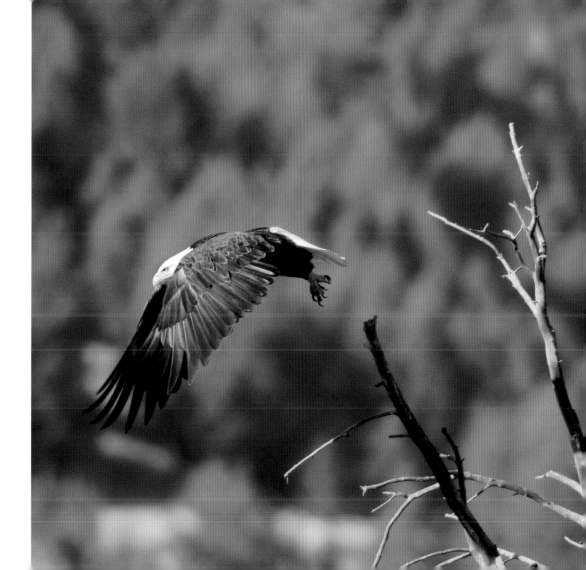

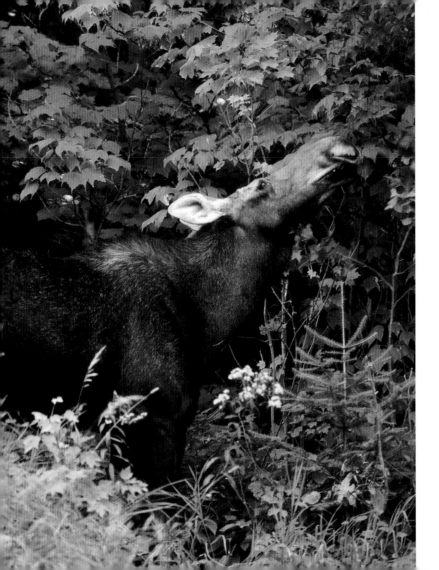

May 13

The name "moose" is an Ojibwa-Cree term meaning "twig-eater." The first large species of deer the Europeans encountered was the elk. In Europe the largest deer was known as "elk" but is in fact identical to North America's moose. Nonetheless, the name elk was given to the animal the native Americans called "wapiti." When the North American moose was finally encountered, it could not be called "elk" because that name was being used so it came to be known by the term we know it by today. Confused? It's simple, really. In North America a moose is the same animal as the European elk. An elk in North America is an entirely different animal. *Ontario*

Cast-off antlers are recycled. Weathering breaks them down to their basic nutrients, but before that happens, porcupines, mice, rabbits, hares and even the deer themselves (moose, in this case) will gnaw at the antlers for the minerals they contain. There is even a type of fly that will lay its eggs in the cast-off antler. The larva feed on the old bone. *Ontario*

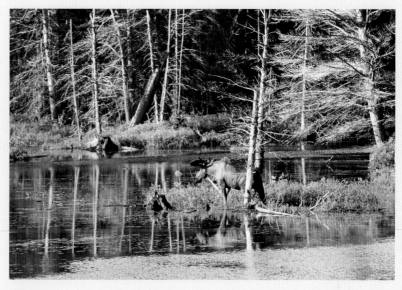

May 14

The three most important abiotic factors in forging the ecology of moose are forest fires, snow depth and cold temperatures. Forest fires create new feeding opportunities but most also leave sufficient cover for the animals. Snow depth limits moose competitors (especially white-tailed deer) and also provided winter insulation. Moose do not do well in warmer temperatures and will move northward if the climate warms. *Ontario*

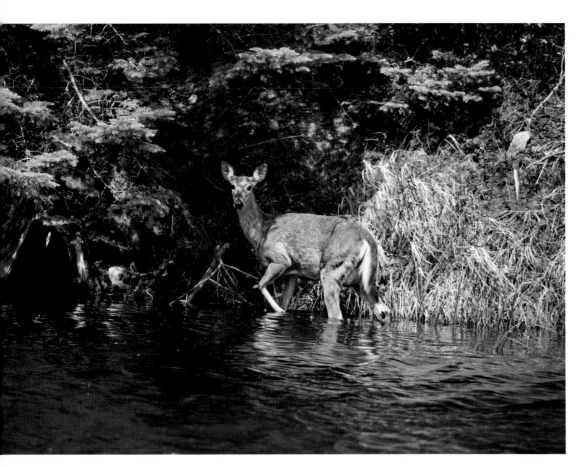

May 15

Whitetails will feed readily on water plants growing in shallow water. They also need to drink copious amounts of water on hot summer days. They are good swimmers and seem to have little fear of water.
Ontario

May 16

White-tailed deer when they flee usually flee downhill into cover. Mule deer flee uphill. Whitetails and mule deer are both short-legged "saltors," meaning they employ a strategy of leaps and bounds combined with outright running to escape predators. Both species try to put obstacles between themselves and their predators. *Ontario*

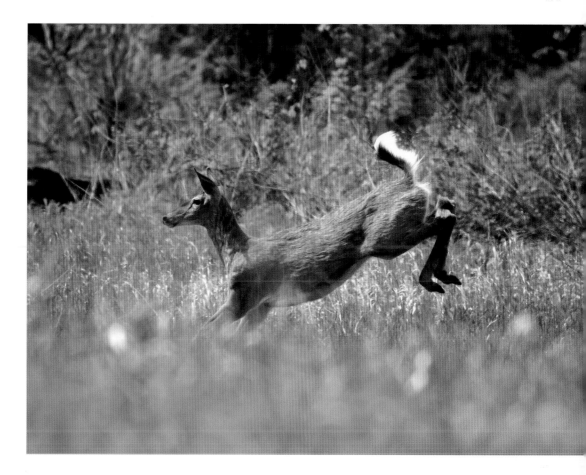

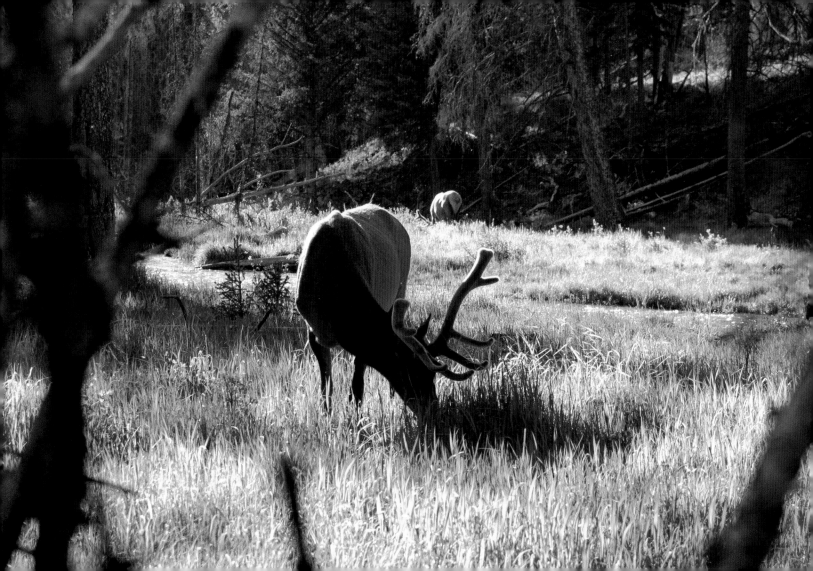

May 17

New spring growth is when a plant is most nutritious. It has not yet begun producing protective toxins to make it less attractive for wildlife. The spring green-up is an important source of food for wildlife after a long winter. *Wyoming*

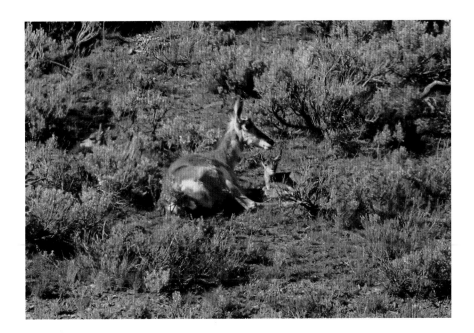

May 18

Pronghorn does leave the safety of the herd to give birth. Twins are common. The fawns are hiders. After nursing, the mother leaves them but is almost never out of sight of the spot where her babies lie hidden. *Wyoming*

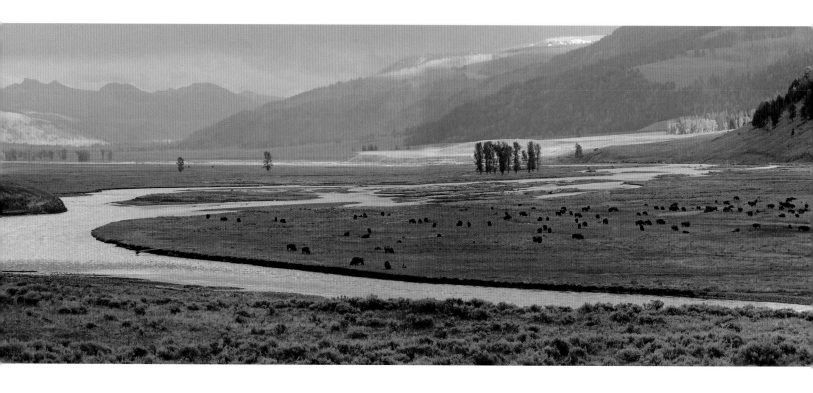

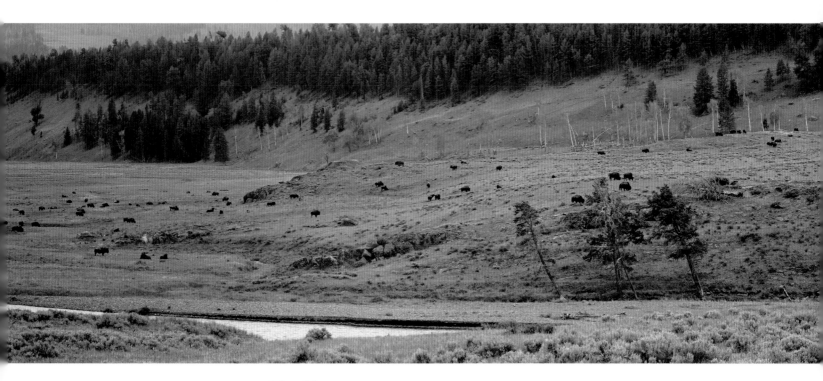

May 19

Yellowstone's Lamar Valley is known as the American Serengeti thanks to the large herds of ungulates that use it year round. The biggest concentrations of wildlife occur in the winter when elk return from their summer feeding grounds to shelter in the valley. *Wyoming*

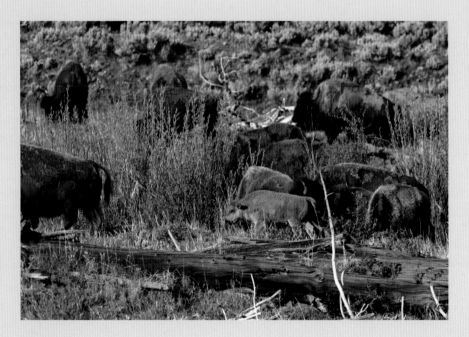

May 20

Bison calves join the herd soon after birth. They must be strong enough and fast enough to keep up with the herd as it searches for new grazing. *Wyoming*

May 21

These two young rams are enjoying a playful bout. Unlike antlers, horns can be used to calculate the age of animal. Horns do not fall off but continue to grow each year. The rate of growth varies with the season and this produces a "ring" when the growth is slower. These two rams are about three or four years old. They are old enough to be living away from the ewes and lambs in the company of adult rams. *Alberta*

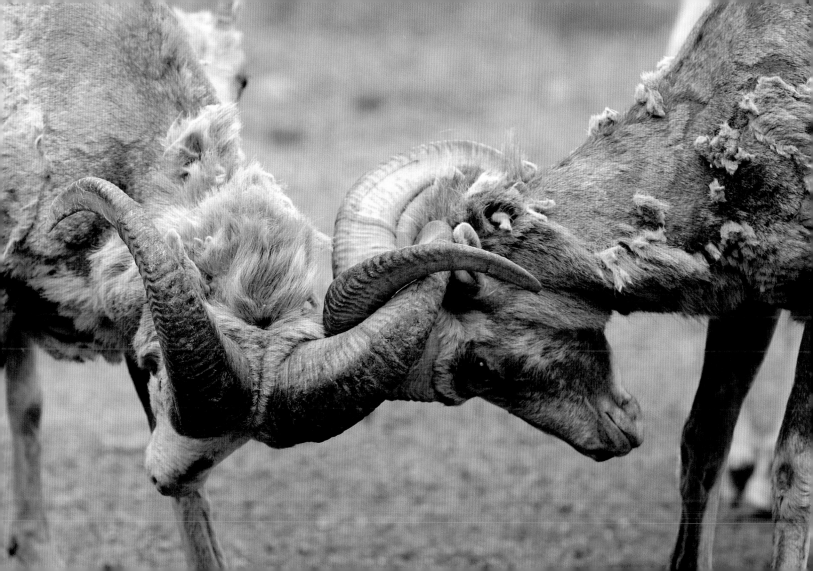

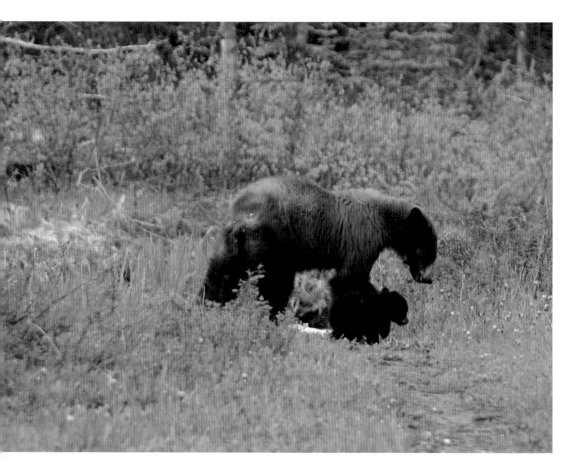

May 22

Black bears in the eastern regions of North America live up to their names: they are almost always black. In the more open country of the west, up to 40 percent of the population may be other colors, including brown, cinnamon, blue, white and chocolate. Nonetheless, they are all black bears. This brown black bear has one black cub and one brown cub.

Alberta

May 23

This black sow has three cubs, two black and one brown. All bears can climb trees but for the cubs in really is a matter of life and death. Male black bears will prey on the cubs if they get a chance. The cubs' best hope of survival is to scoot up a tree too thin to support a mature male bear. Wolves also prey on black bears of all sizes. *Alberta*

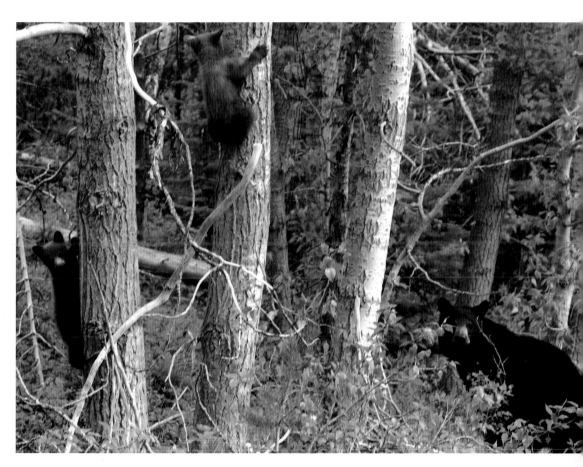

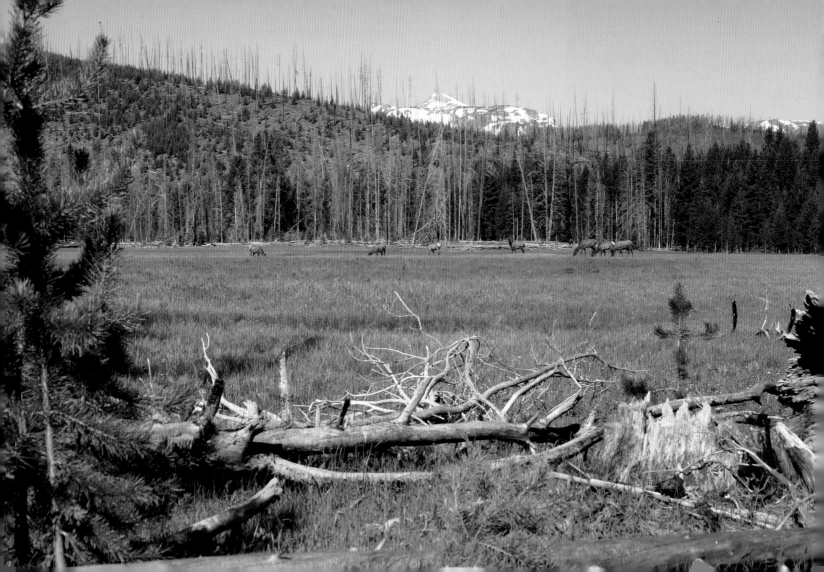

May 24

Elk country is often a mixture of open meadows or prairies, mountains, and fairly open forests. Elk rely on their vision to spot predators and will move off once they spot one.
Wyoming

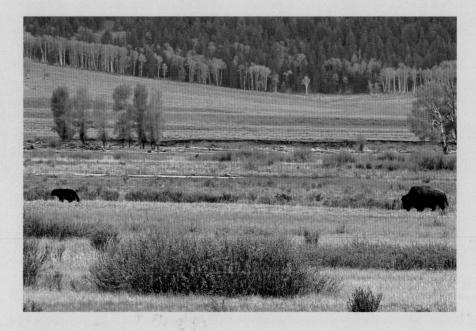

May 25

Bison are grazers and in the spring they may well wind up sharing a patch of their pasture with a black bear. Black bears are omnivores and will also prey on bison calves. Just to be on the safe side, a bull bison escorts the black bear away from the area. *Wyoming*

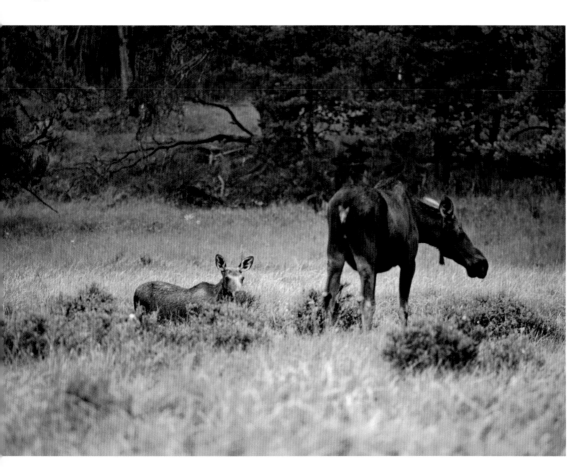

May 26

In late spring before she gives birth to her next calf or calves, the cow will aggressively discourage her calf from hanging around her. The yearling will follow her mother for a few days after but usually keeps at least 100 yards away. Gradually the distance grows. Males become more independent sooner than the female yearlings. *Montana*

May 27

The tail of the mule deer, like the tail of the white-tailed deer, reflects its habitat preference. Mule deer are found in more open country and as a result, they can keep an eye on each other. An alarmed mule deer's backside is visible for all to see. But it is just as true of a mule deer that is relaxed in feeding. It signals to other deer that it is safe to relax and feed too. *Alberta*

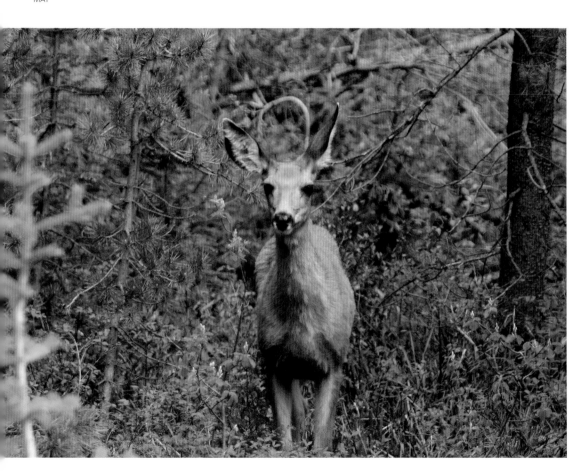

May 28

Mule deer rely on the ears and eyes to detect an enemy. They will try to sneak away unseen, whereas a white-tailed deer will often choose to rely on lying still and going unseen by their hunters. *Alberta*

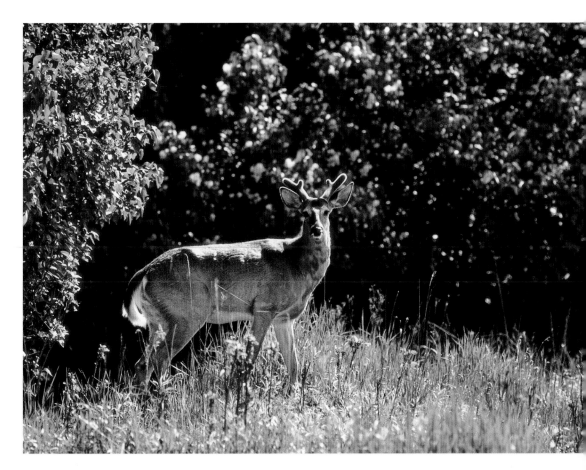

May 29

Antlers are the fastest
growing bones in nature. A
healthy white-tailed buck's
antlers will grow half an
inch (1.25 cm) per day.
By mid-summer a well-
nourished buck will sport
a fully grown set under a
velvet covering. *Ontario*

May 30

White-tail fawns in the north are born in late May or early June. The further south the deer are found, the later in the year fawning takes place. Deer in the southern states are born in July. Gestation is about 200 days. This pregnant doe was only hours away from giving birth to twins.

Ontario

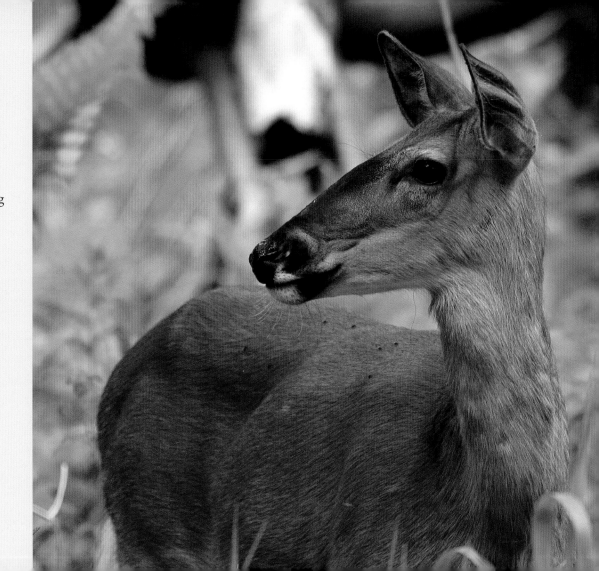

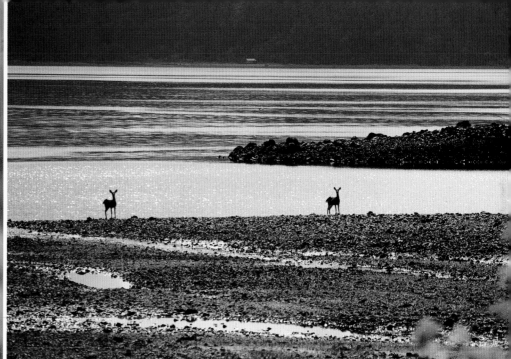

May 31

Black-tailed deer will feed on the tidal flats looking for vegetation washed up along the shore or exposed by the receding tides. They will also swim from island to island seeking out the food they like. Coastal black-tailed deer are also known as Sitka deer, not to be confused with the introduced sika deer. *Washington*

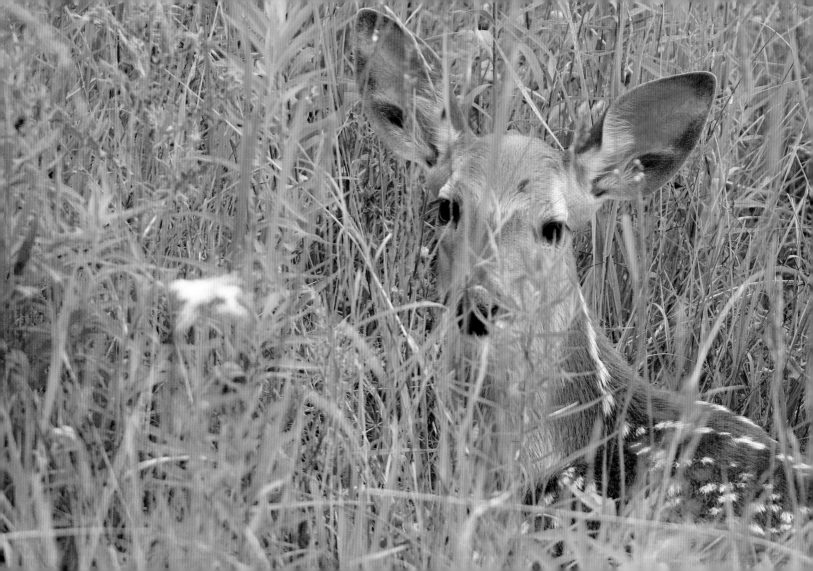

June 1

White-tailed fawns are "hiders." They rely on concealment and a lack of scent to escape the notice of predators when they are newborn. Their mothers will visit them two or three times to nurse them and then wander off to feed. Does will attempt to distract a predator and even become aggressive with smaller hunters such as red fox. *Quebec*

June 2

This doe is seeking a secluded place to give birth. It selected a small island in the middle of a fairly shallow river. Given that this doe's range was in the middle of a large cosmopolitan city park, it was probably one of the best sites that it could choose. Researchers that had radio-collared another doe found that she used a location in a lumberyard several times to give birth.
Ontario

June 3

Cow moose will seek out isolated places to give birth to their calves. A willow-lined stream near Alaska's tree line would be a good spot. However, grizzlies often feed or rest in these willow forests, and this cow is taking no chances. She knows the danger that could lie hidden here.

Alaska

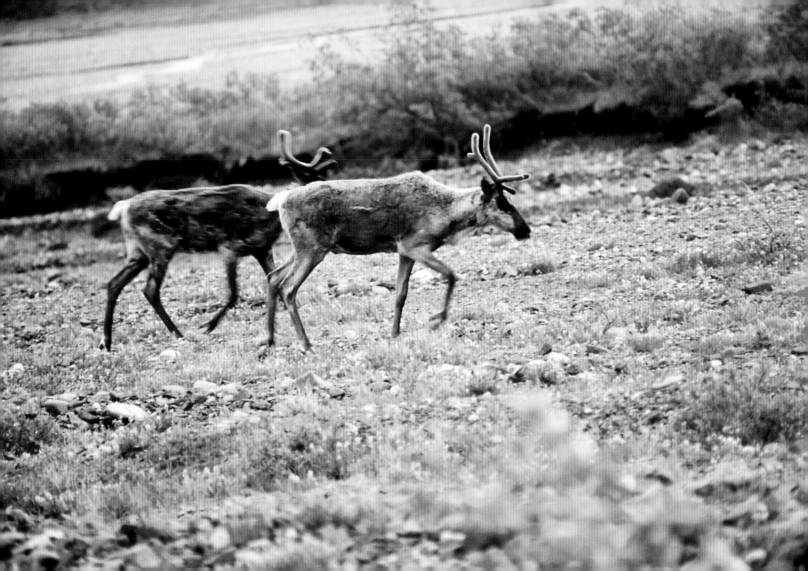

June 4

Caribou are always on the move. In winter, herds that favor the tundra in the spring and summer move into the boreal forests to the south. Mountain caribou migrate up and down mountains with the seasons. Woodland caribou do not migrate so much from one range to another but are instead always moving about within their home range looking for food. *Alaska*

June 5

Elk are alone when they give birth. They leave their herd and seek a sheltered place. In Yellowstone one favored area is the sagebrush-covered Swan Flats. This is great place for a nature lover to watch an ecosystem in action. *Wyoming*

June 6

A young elk calf can walk within an hour or two of its birth but it is not yet able to outrun a wolf or grizzly. The mother leads it a short distance away from the birthing spot after eating most of the afterbirth. She also ingests the calf's urine and feces to reduce telltale odors. The calf needs to exercise a bit too before it will be fed. *Wyoming*

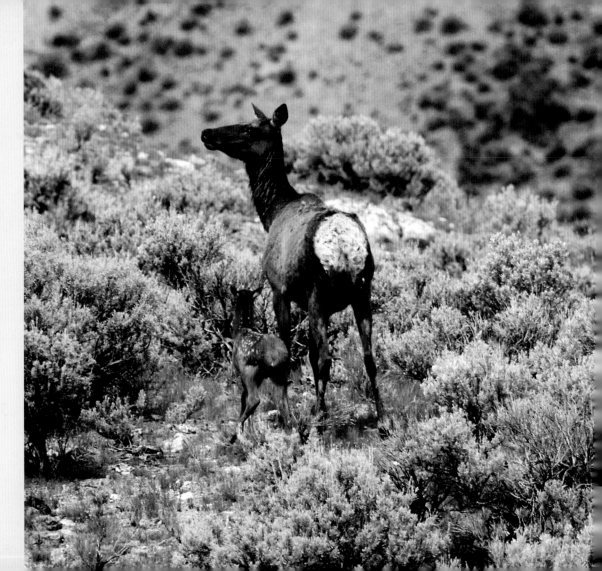

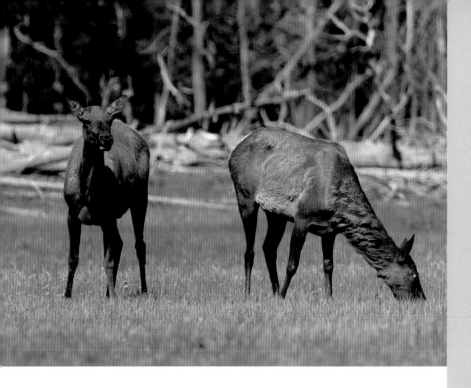

June 8

The elk calf is a hider. Once fed it seeks a safe place to bed down and hide. Deer fawns are also hiders. Moose and caribou calves are followers. Elk calves will hide for about four days after birth. Then they too will follow their mothers and bed near them. *Wyoming*

June 7

These elk cows have given birth and have left their calves hidden in the sagebrush or the forest. They are not far way from their babies and will keep track of the location. Should a predator appear they will try and distract it, leading it away from their babies. *Wyoming*

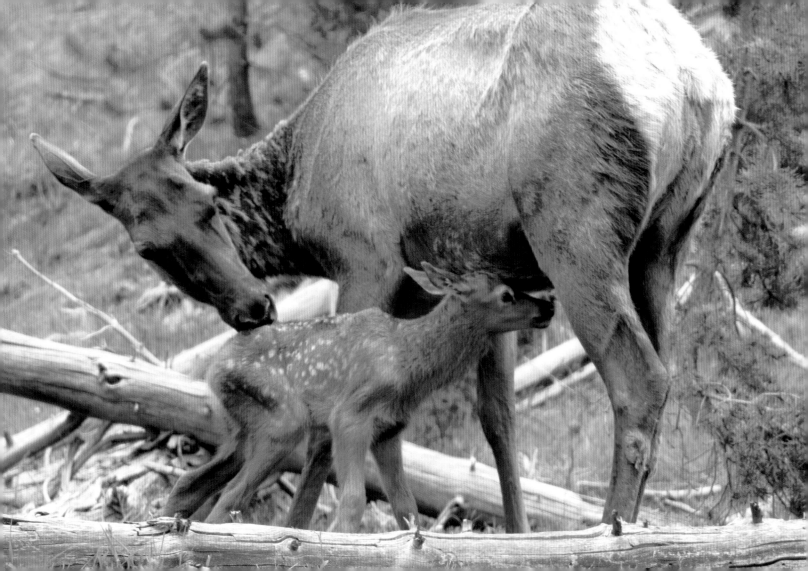

June 9

In Yellowstone most elk calves are born in a three-week period from the end of May to mid-June. The cow will nurse her calf only a few times during the day, perhaps as few as five or six times (caribou nurse ten times a day). She calls to her calf and the calf emerges from its hiding spot to feed. The cow ends feedings abruptly. *Wyoming*

June 10

The grizzly sow (to the right) has found and killed a calf elk. The cow is unable to defend her calf as she would put her life at risk. The sow grizzly has two cubs of the year (born in January, and quite small) and she needs the nutrition the calf represents to produce milk to feed her cubs. She comes to this calving area every year and hunts for the newborn elk hiding in the sage. By the time the tourist season arrives in mid-June the calves are too fast and too mobile for her to spend much time here, so she moves on. *Wyoming*

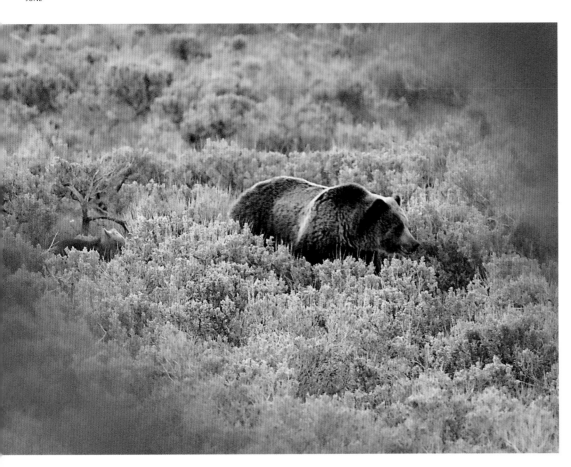

June 11

After feeding on the calf, the sow leads her cubs to a pool of water. Typically, she, like most predators, will drink after consuming her kill. The cubs are too young to eat meat but they will mouth the carcass and play with it. In the process they will begin to be weaned. *Wyoming*

June 12

Elk calves can keep up with the herd when they are sixteen days old. Both deer and elk offspring use the "hider strategy" of lying still and hidden for the first few days of their lives to avoid detection by predators. Moose and caribou offspring employ the "cursorial strategy" of trying to outrun the enemies soon after being born. As soon as deer fawns and elk calves are developed enough, they too will become cursorial and flee from their predators. Of course, other cows have calves too, so it not unusual to see cows with similarly aged calves keeping company. *Wyoming*

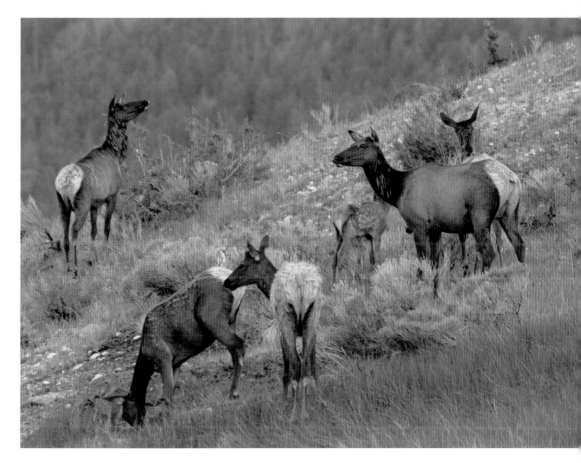

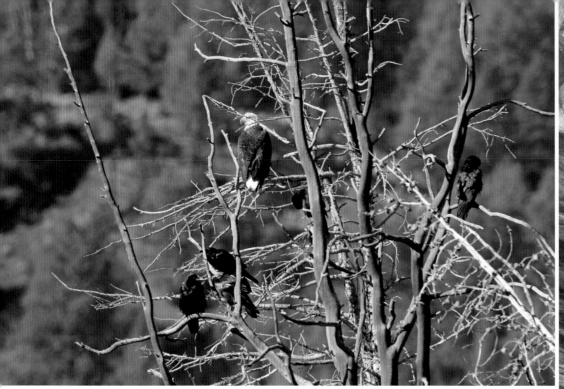
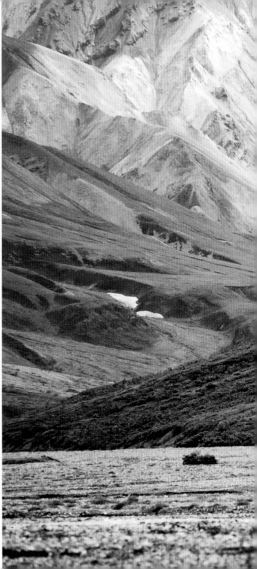

June 13

The sight of a bald eagle in a tree with ravens in attendance means there is carcass about. If you are hiking the backcountry, it is wise to beware. In Yellowstone some animals die of old age, starvation and disease but since the reintroduction of wolves such events are less likely. Grizzly bear numbers have increased as well. Watch the ravens! A carcass can mean that bears, wolves or both are in an area. *Wyoming*

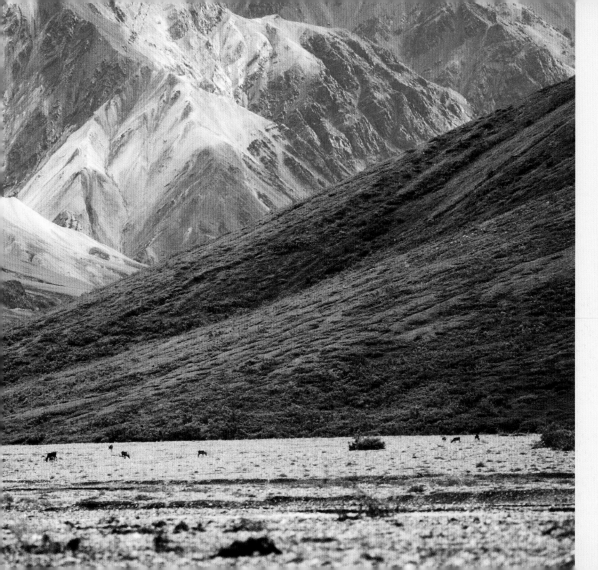

June 14

Caribou are constant wanderers. They move constantly seeking fresh pastures. Lichens and grasses make up much of their diet. Lichens are extremely slow growing, so once an area has been grazed it may be some time before the herds return to that part of their range. Of all the members of the deer family, caribou occupy the largest territories. *Alaska*

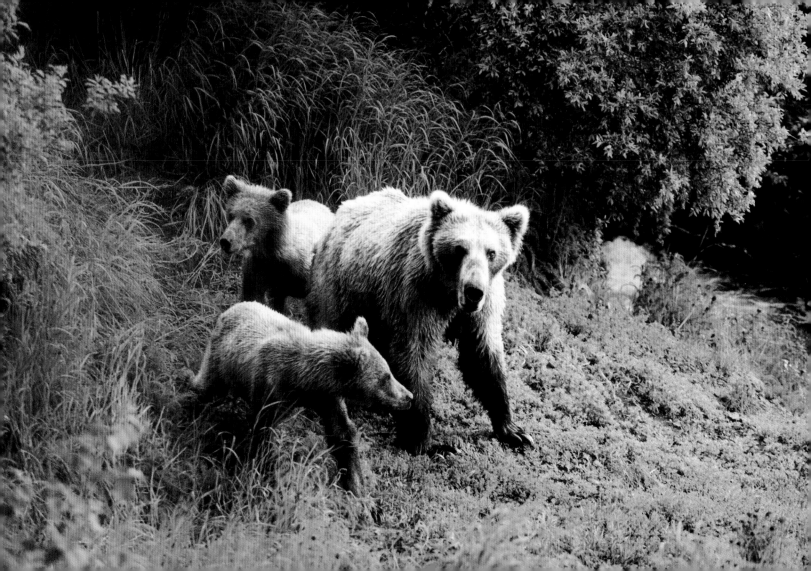

June 15

Grizzly bears on the Pacific Coast are known as brown bears. They are the same species, but coastal bears are much larger thanks to a rich diet of salmon. These are yearling cubs. *Alaska*

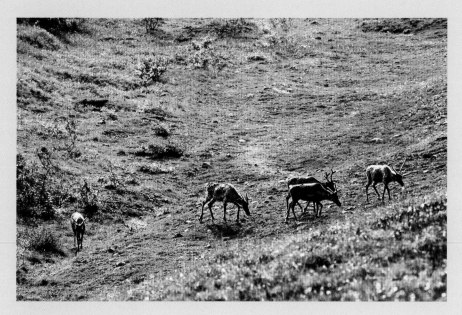

June 16

Caribou also migrate to escape predators. Their winter grounds usually support high concentrations of wolves, the herd's main predator, but in the spring the wolves are having their young too and as a result are less mobile. Unlike the caribou's calves, a wolf's pups cannot follow the group for several weeks. A single wolf needs to kill eleven to fourteen caribou a year to meet its needs. *Alaska*

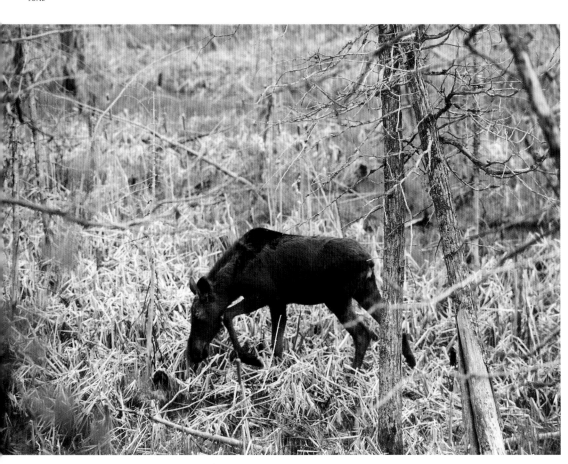

June 17

In early June it is very common to encounter a single yearling moose. These are the youngsters that were driven off the month before by their mothers. By now they are independent of her and wander on their own. This is a healthy development, because the newborn calves attract predators such as bears and wolves. The yearlings are much better off not being near the new arrivals. *Ontario*

June 18

Cows tend to use the same area of their range to give birth. Islands are preferred where they are available. Bears appear to have knowledge of these areas, and will seek out newborn calves during the birthing season. *Ontario*

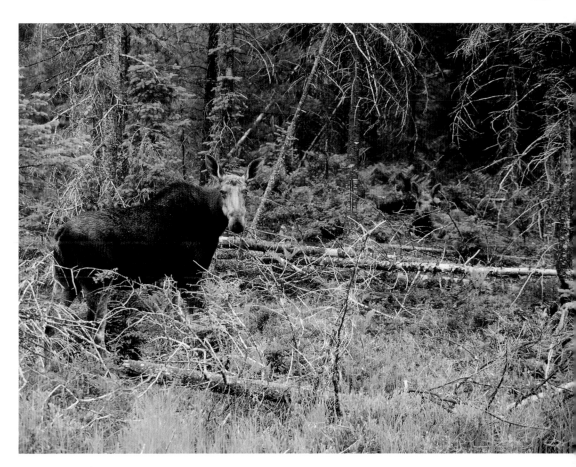

June 19

This moose appears to have survived an attack by a predator. Either a wolf or a bear may have caused the wound. They are the only two predators large enough to attempt such an attack where this photo was taken. Although it was still bleeding, the wound did not seem to hamper the moose. Perhaps days later the leg would stiffen and the predator would find this cow easier prey. Wolves have been known to follow a wounded animal for hours and even days as it slowly bleeds to death. *Ontario*

June 20

This sow grizzly/brown bear has cubs of the year following her. This will be their first trip to the salmon river she uses. They are in their most vulnerable period of their lives. The annual salmon run attracts large numbers of bears and while most are well fed and have little interest in the cubs, a boar might seek them out. If the cubs die, the female will come into heat and give the male a chance to breed. *Alaska*

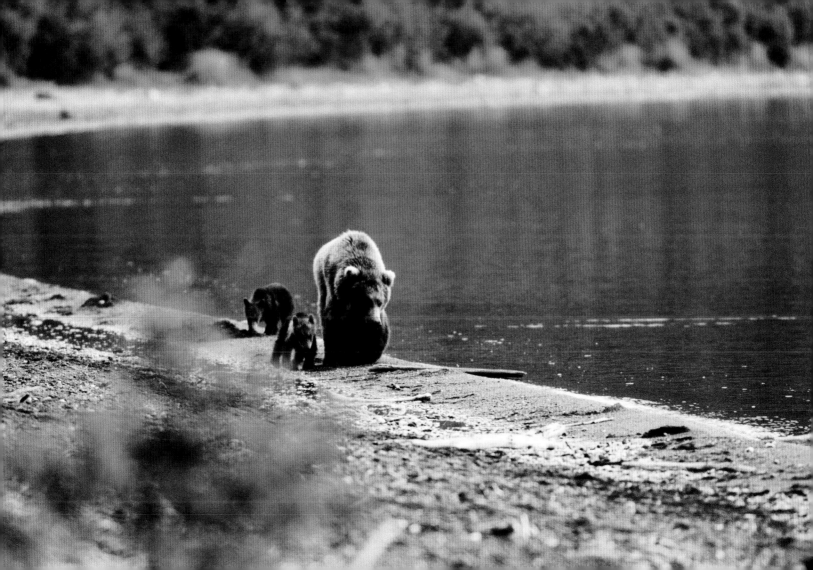

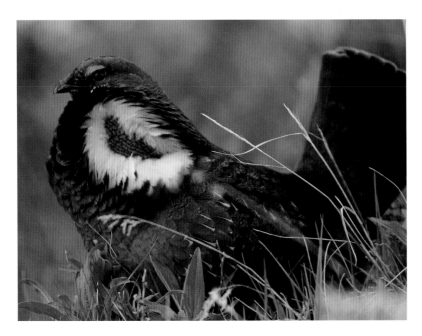

June 21

Blue grouse are found in coniferous forests and forest-grassland habitats in the western United States, most often in stands of ponderosa pine and Douglas fir. They also like habitats that include aspens. This male is displaying in the hopes of attracting a hen. *Wyoming*

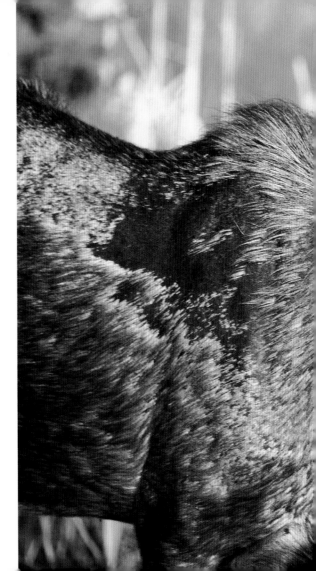

June 22

Even in June moose continue to frequent roadside "salt licks." Consider the difference in the development of these two animal's antlers. The kneeling bull's have begun to palmate but the younger bull's are still just "bulbs." Note that this this is not the usual way moose drink. This position leaves him very vulnerable to predation. *Ontario*

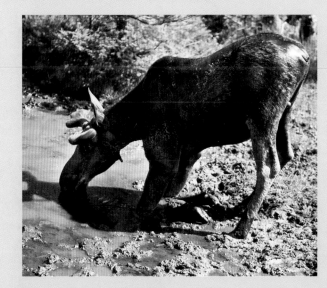

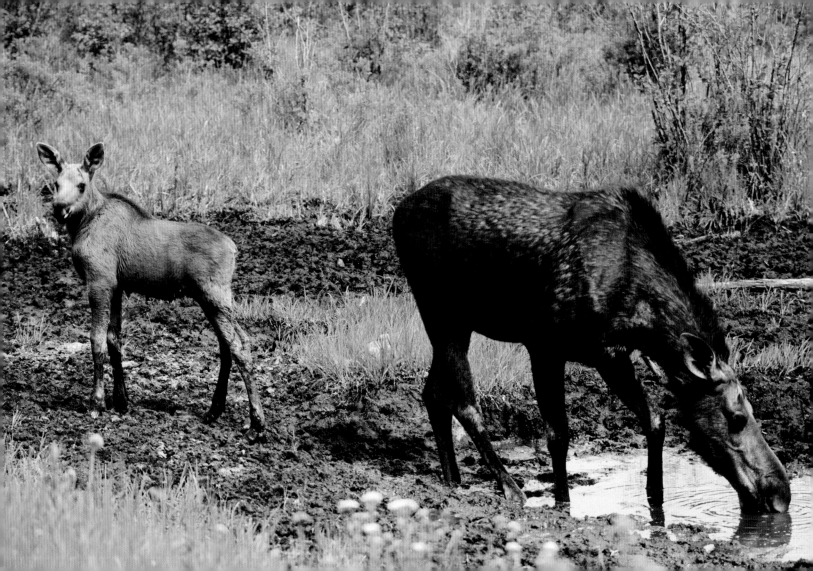

June 23

Calves grow rapidly. They will increase from their birth weight of 22 to 35 pounds (10–16 kg) to well over 260 pounds (120 kg) in the next four to six months. *Ontario*

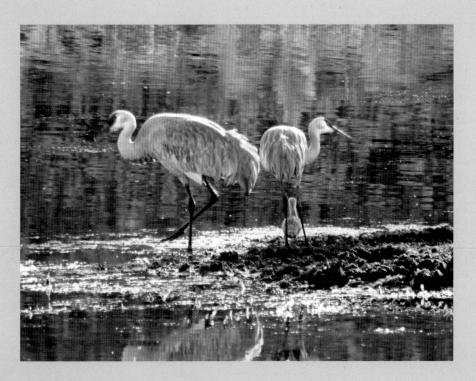

June 24

Sandhill cranes will nest on small floating islands in the middle of lakes or ponds. I was surprised to discover, though I probably should not have been, that both the adults and chicks can swim. *Wyoming*

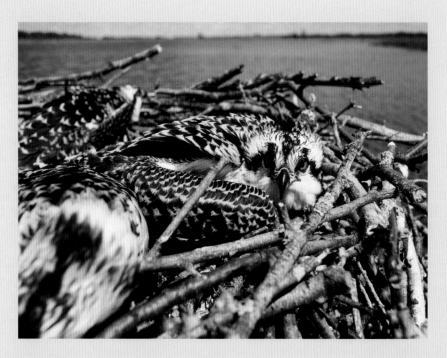

June 26

Antler growth in all deer begins under a layer of skin known as velvet. The thickness and size of the velvet varies with species and races. Under it, blood vessels deposit minerals (calcium) that will form the antler. Most species begin growing antlers in early spring. Antler size depends on genetics, available food, soil quality, available minerals and the health of the individual animal. *Wyoming*

June 25

Osprey chicks are well camouflaged and when left alone in the nest while their parents are out fishing they will lie flat and unmoving. In Florida and along the Gulf Coasts osprey chicks have already fledged but in Ontario they are still weeks away from that stage. *Ontario*

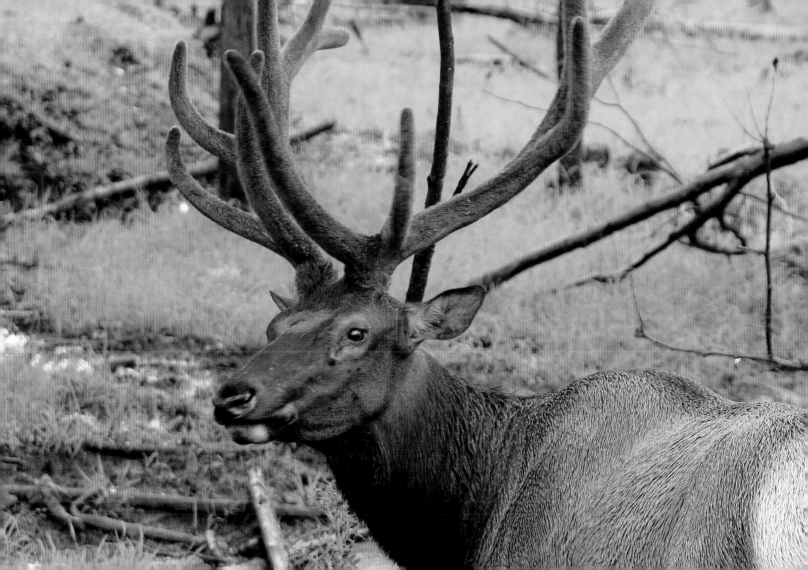

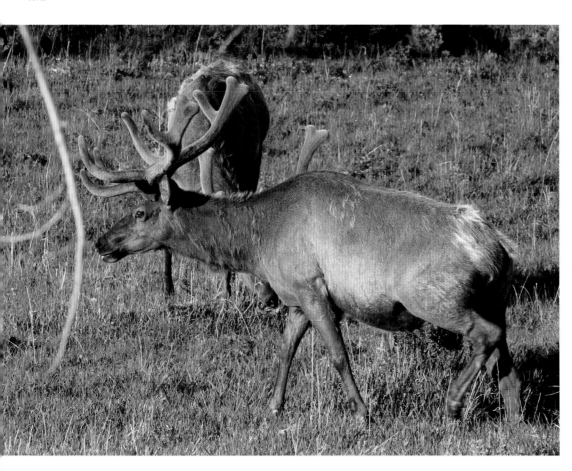

June 27

Elk feed readily on new grass. Grasses rely on silica to make themselves less appealing to most herbivores. Foliage, on the other hand, is protected by chemical and mechanical means (for instance, thorns) against browsers. In the spring, new foliage lacks these defences, and grass has not yet become toughened with silica. As the grasses harden, elk turn their attention to browse as well. Bison are better equipped to feed on grasses throughout the year. *Wyoming*

June 28

These are black-tailed deer. Note how their tails resemble the whitetails' tail. California blacktails are genetically most closely related to white-tailed deer, from which the species evolved, and the most distantly related to mule deer. *California*

June 29

Paleo-Indians who depended on agriculture viewed the white-tailed deer as a major predator on their crops. Deer could consume a large part of their maize crops; in lean years that could tip the balance between survival and death. Because of this, they killed newborn fawns and pregnant does in the spring and hunted deer year round. An added benefit of hunting deer was the meat and skin the animal provided. *Ontario*

June 30

There are several wild calls that evoke the feeling of nature. The howls of a wolf pack as it rendezvous with its pups is one. The bugle of a bull elk echoing off the mountain peaks in the fall is another. Neither of those is as familiar to most people as the call of the loon. Its calls, some melancholy and others almost lunatic, echo across most northern lakes. *Ontario*

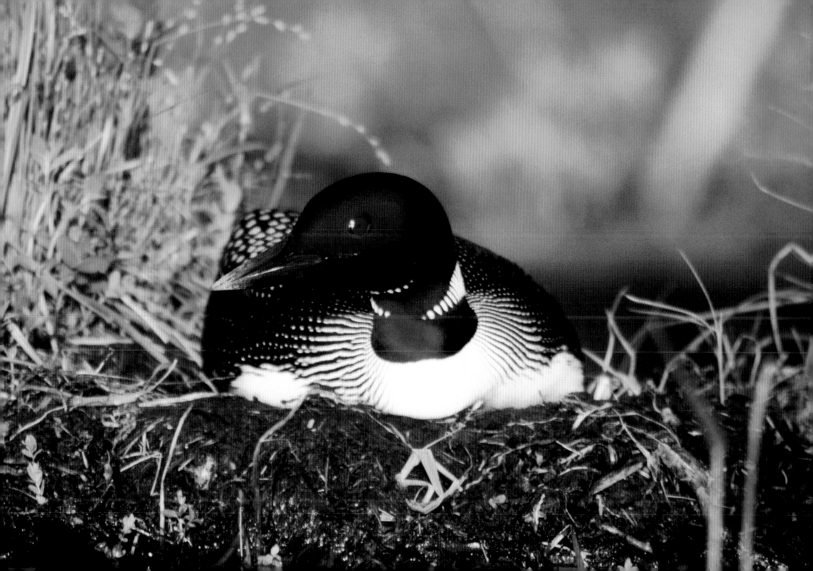

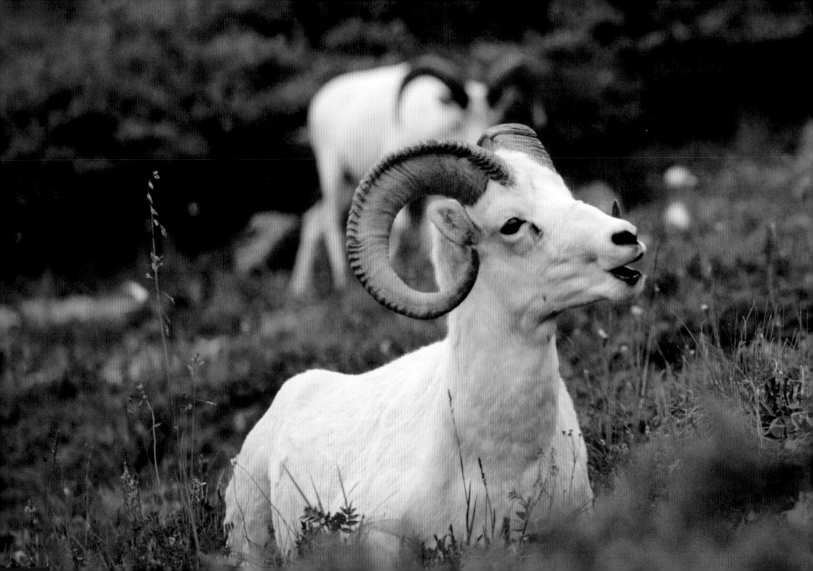

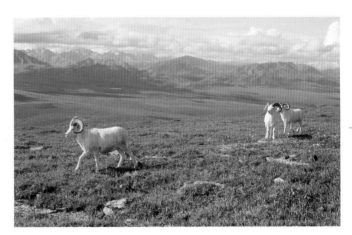

July 1

Dall's sheep are also known as thin-horn sheep. They are a more recent arrival in North America than the bighorn sheep. Bighorns, which have heavier and thicker horns, arrived here before the beginning of the last ice age and are today found south of the glaciated regions, Dall's sheep arrived during the last glaciation event and are confined to north of the icefields. As the ice retreated, the thin-horn sheep moved south and the bighorns moved north. As yet the two species have not met. *Alaska*

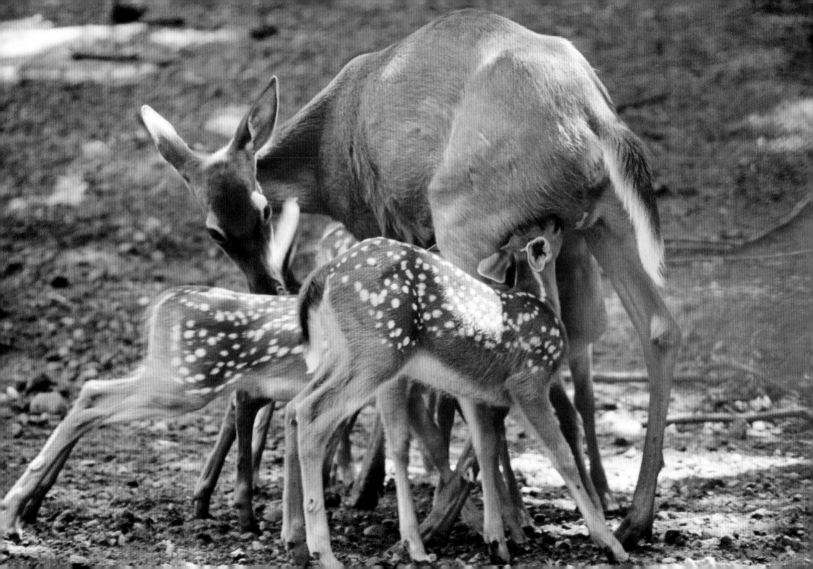

July 2

Twins are common among whitetail births. Triples and even quadruplets are known but are rare. *Ontario*

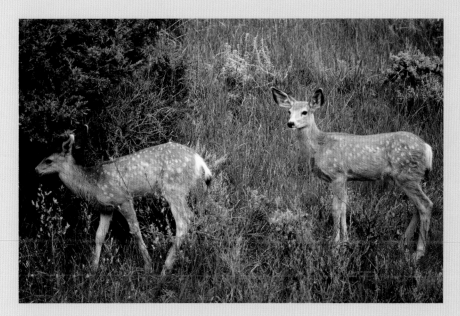

July 3

Twin births are also common for mule deer. In general, young deer born with spotted coats are "hiders." Whitetails and mule deer fawns spend more time hiding than do elk calves. There is an advantage to this in that it makes them less vulnerable to predation. However, many fawns of both species die in their first few days due to severe weather, disease and to predators such as bears and coyotes. *North Dakota*

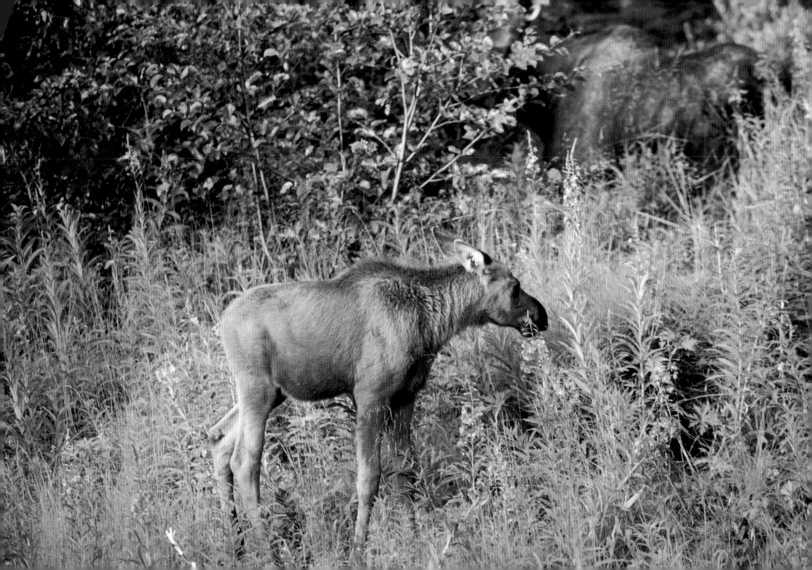

July 5

Elk typically have only one calf, and twins are rare. They will loose their spotted coats as the summer passes. *Wyoming*

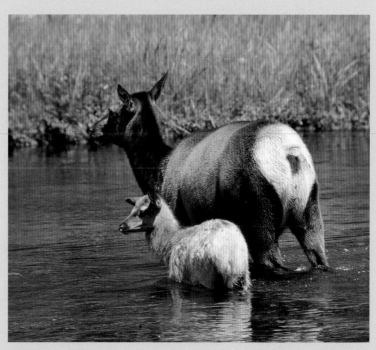

July 4

Twins in moose are common, but most have only one. In a growing population that is colonizing new territory, twins will be seen quite frequently. In areas where the moose population is at or near capacity single calves are more common. This is a result of the nutritional capacity of the range. *Alaska*

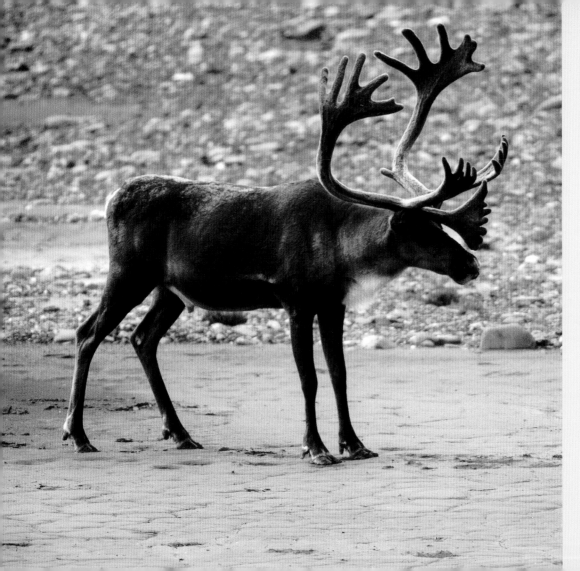

July 6

By July the bull's antlers
are almost full-grown.
Caribou bulls have the
largest antlers of any deer
in comparison to their
body size. Yes, a moose has
bigger and heavier antlers,
but the ratio of body size
to antler size in moose is
not as extreme as it is in
caribou. *Alaska*

July 8

Caribou typically have only one calf. Calves are born in the early spring when harsh conditions still exist. Wind chill is a major cause of calf mortality. By July the calves have begun to grow their first set of antlers. *Alaska*

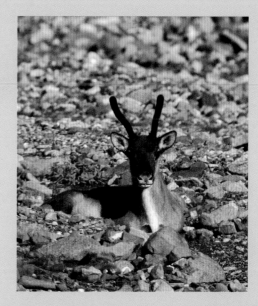

July 7

Anyone who has ever spent a day on the tundra knows that flies are, to say the least, abundant. Pity the poor caribou. There are bloodsucking mosquitoes and blackflies to rob it of its energy. Botflies to burrow through the hide and live just below it. Nostril flies lay their eggs in the animal's moist nostrils. Refuge from many of these pests can be found on the cold fields of snow that persist into summer or on windswept gravel beds. *Alaska*

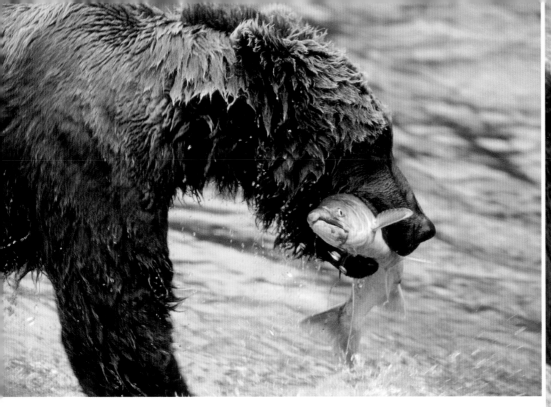

July 9

The relationship between bear, fish, forest and deer is a complex one. Bears carry the salmon into the woods to eat them. They deposit their droppings in the forest as well. Both these activities enrich the soil and provide nutrients for the trees. The deer eat the trees. DNA studies of trees, even some distance from the salmon river, found evidence of salmon in the trees. *Alaska*

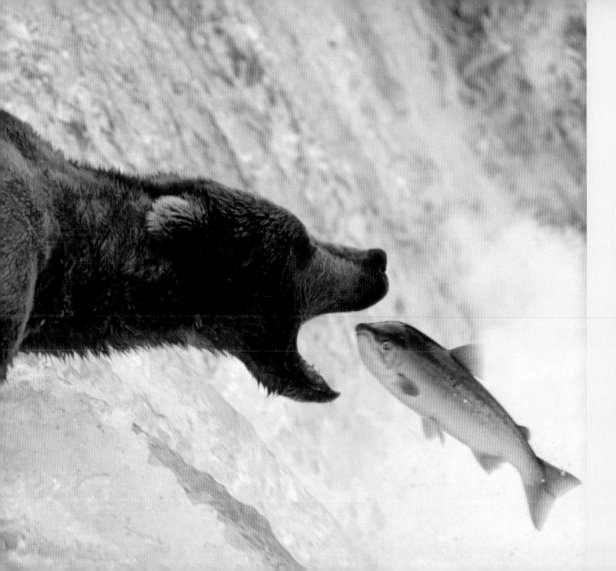

July 10

Salmon run at different times of the year. This looks like a sockeye salmon that is either about to commit suicide or the unluckiest fish in the world. In fact, at Brooks Falls, Katmai National Park and Monument, the brown bears know where the best spots are for fish to get up the falls. They simply stake the area out and wait for the fish to jump into their mouths. *Alaska*

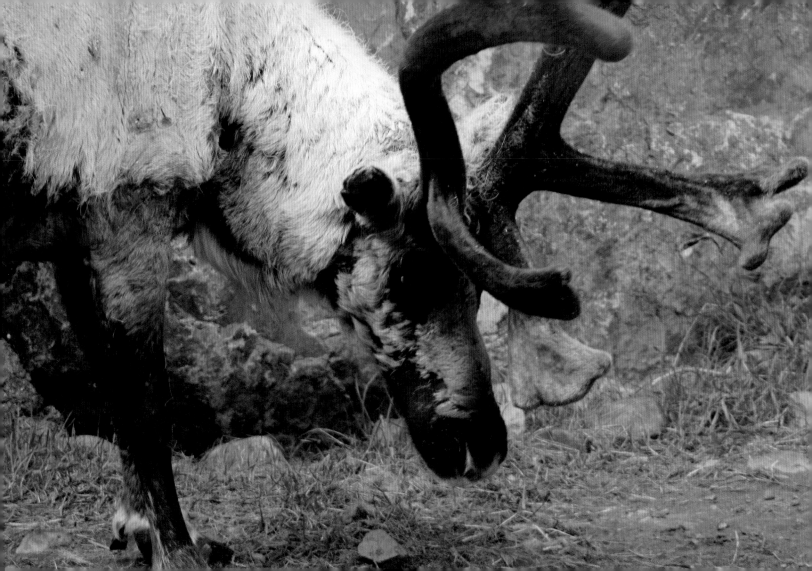

July 11

Caribou have large, concave hooves that splay widely, giving the animal support in snow or muskeg. They are also used to paw through the snow to obtain food. When danger is near and the caribou is fleeing, scent glands located at the base of the ankles deposit a scent that is carried by the air alerting other caribou.
Alaska

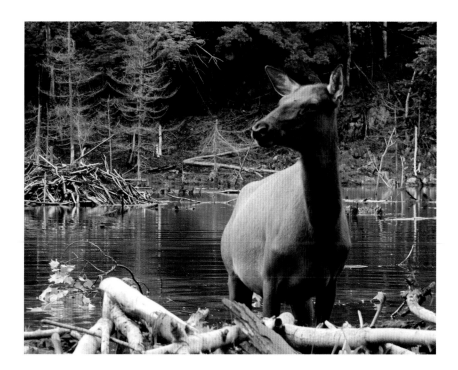

July 12

Manitoba has a herd of about 7,000 elk centered around Riding Mountain National Park; elk were once common on the prairie here but survived only in aspen parklands. Neighboring Saskatchewan has 15,000 elk. *Manitoba*

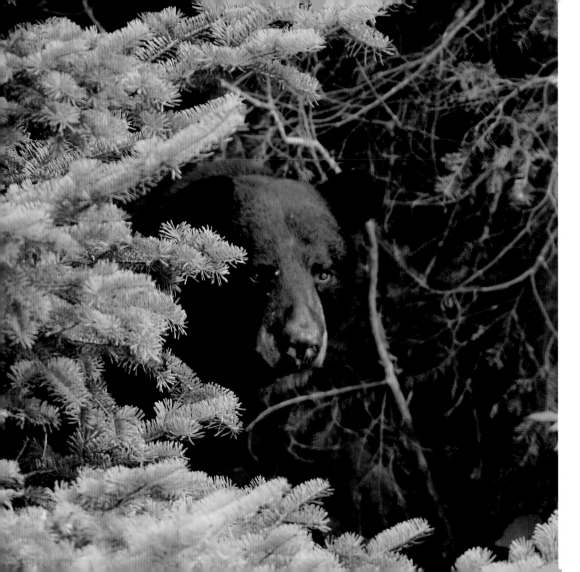

July 13

Black bear are superbly suited for life in the forest. Their color provides excellent camouflage. Much has been written about how the grizzly has kept the black bear confined to the forest, but it now appears that black bears also keep grizzlies out of the forest. They are much better at using the forest's resources than their larger relatives. *Ontario*

July 14

By mid-July the calf moose's coat is starting to turn brown. It will still nurse, but it is also now feeding on browse and water plants like its mother. *Ontario*

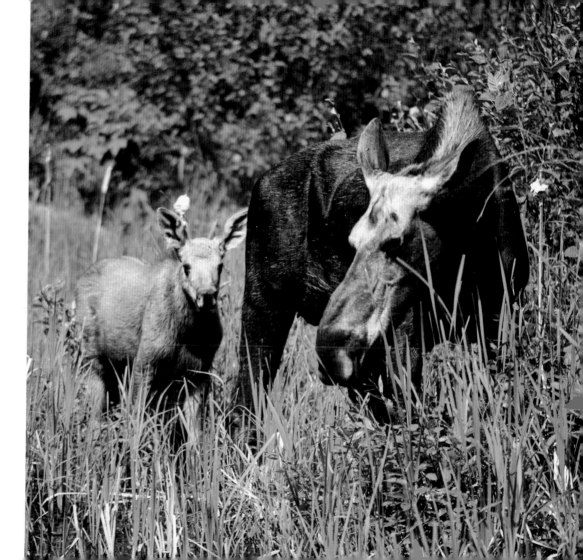

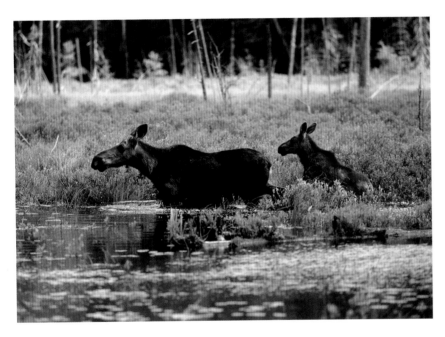

July 15

Moose calves follow their mothers within hours of being born. It is essential that the cow moves her offspring away from the birthing spot and its telltale odors. Calf moose can swim quite well within days of their birth. They will follow their mother wherever she goes. Should a calf get lost or separated it is certainly doomed. No other cow will accept it and nurse it. *Ontario*

July 16

A cow moose will vigorously defend her calves against any predator. There are many examples of a cow chasing off a grizzly or a black bear. Even packs of wolves think twice. Nevertheless, a cow with twins is at a distinct disadvantage. In the hubbub of charges, feints and battle, one calf usually finds itself separated from its mother. Usually this leads to the calf's demise. *Ontario*

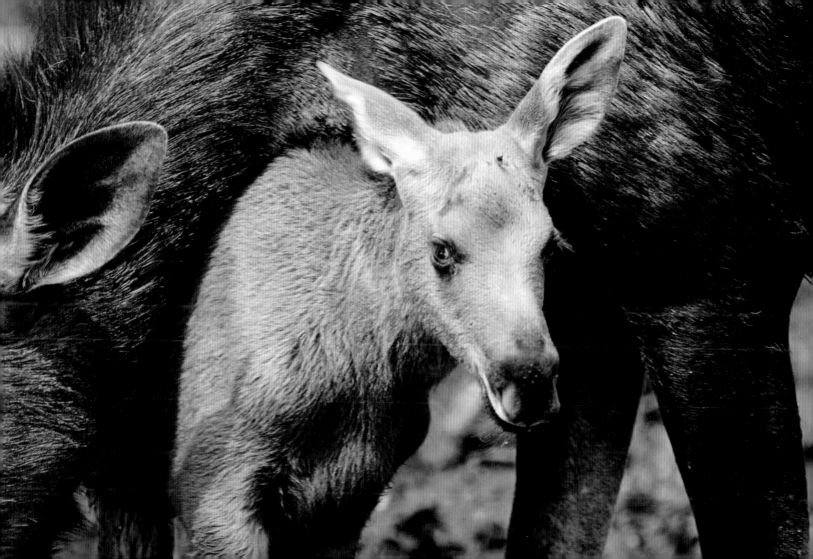

July 17

The brain worm (*Parelaphostrongylus tenuis*) is a parasite carried by white-tailed deer. The deer have lived with this parasite for a couple of million years and have adapted to it. Moose have been exposed to it for several thousand years. They die if infected. The parasite's eggs pass out in a deer's droppings. The eggs hatch and the larva invades the foot of a passing snail. The snail climbs up onto a leafy branch where a moose may ingest it. This disrupts the parasite's lifecycle and instead of migrating into a deer's nasal passages, it migrates into the moose's brain. *Ontario*

July 18

Reintroductions of elk have been going on in the east for sometime now. Pennsylvania was one of the first states to succeed. Elk are also well established in Michigan's Upper Peninsula, and some have even swum across to Ontario. Ontario's most recent attempt at elk reintroduction has also had success. Today there are about 500 animals in the province. Michigan has between 800 and 900. Pennsylvania has about 800.

Ontario

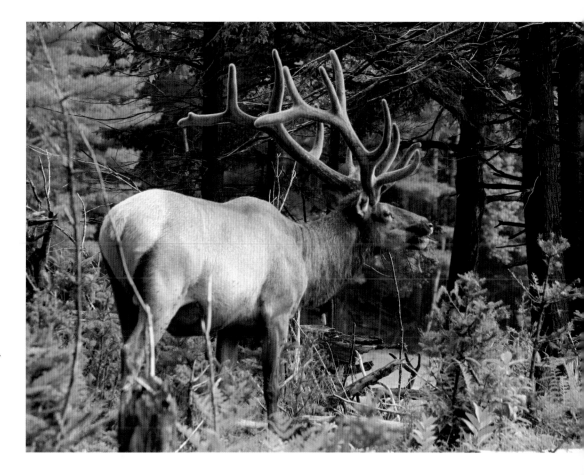

July 20

Unlike elk, bighorn sheep and bison, mountain goats suffered little habit loss or a decline in population numbers. They inhabit the highest reaches of the mountains, where even sheep seldom venture. *Montana*

July 19

The antelope jackrabbit is known for its long antelope-like leaps. It is found in the deserts of the southwest, especially Arizona. It has a major advantage over mule deer in that it is not tied to water sources. It gets all of the moisture it needs from vegetation. The large ears serve as a means of controlling its body temperature. On hot days it exposes them to the breeze, which cools the animal's body. On cool days and at night it keeps the ears laid back on its body to conserve warmth. *Arizona*

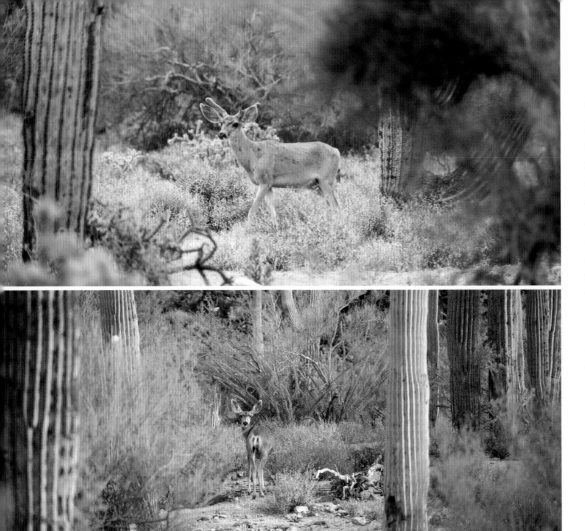

July 21

Mule deer in desert areas are tied to available water resources. In the Saguaro desert, water is abundant during the summer monsoonal rains that sweep in from the Gulf of Mexico. Mule deer are wide ranging at that time, but in the winter months when there is very little precipitation the deer are tied to springs and artificially maintained water holes. *Arizona*

July 22

Mule deer are "stotters." Stotting is a gait that mule deer employ to advertise how fit they are to a predator. It says, "Do not bother with me, I am too fit to catch." The deer lift off on all four feet at once, literally bouncing off the ground. It takes a lot of energy and the animal must be fit to perform it. In fact it takes about thirteen times more energy than flat-out running does.

Arizona

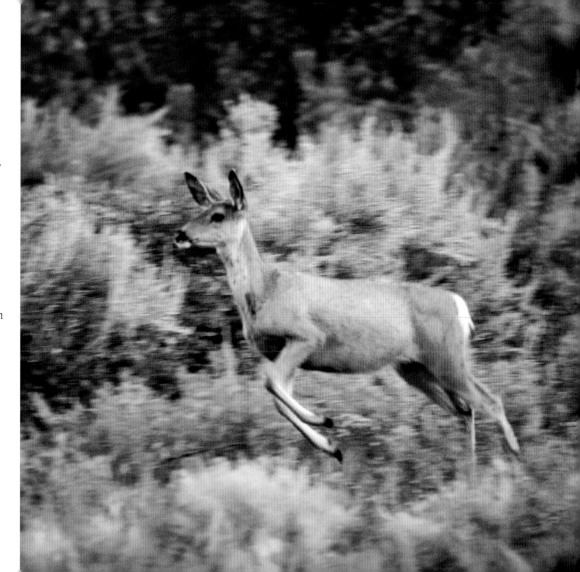

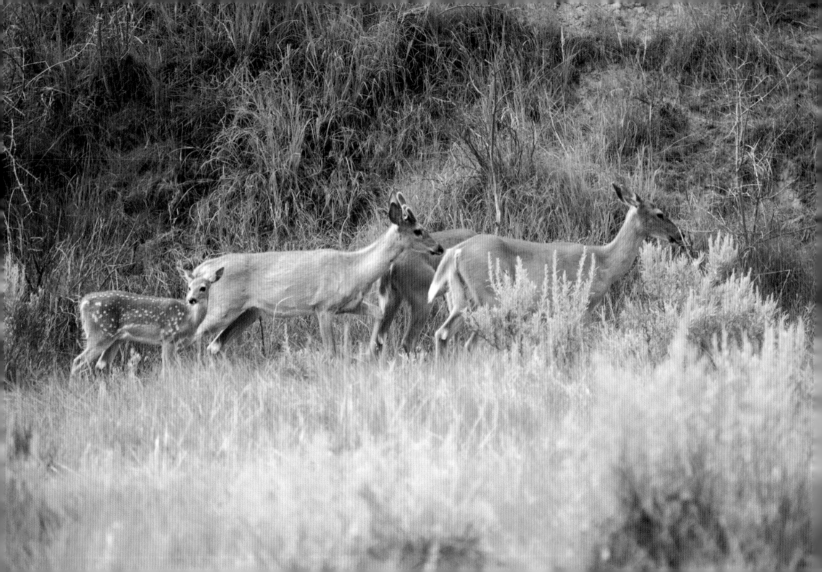

July 23

White-tailed deer tolerate a wide variety of climate conditions ranging from the subtropics of Florida to the cold snowy winters of the Northeast. White-tailed deer live in Central and South America as well.
Ontario

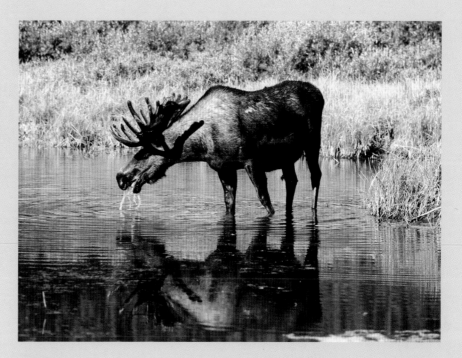

July 24

The Shira's or Yellowstone moose is the smallest of the four races. It generally has the smallest antlers and body size. Bulls average 816 pounds (370 kg). Breeding may be either serial (brief pairing of a bull and cow with the bull moving on to a new mate) or harem breeding. *Wyoming*

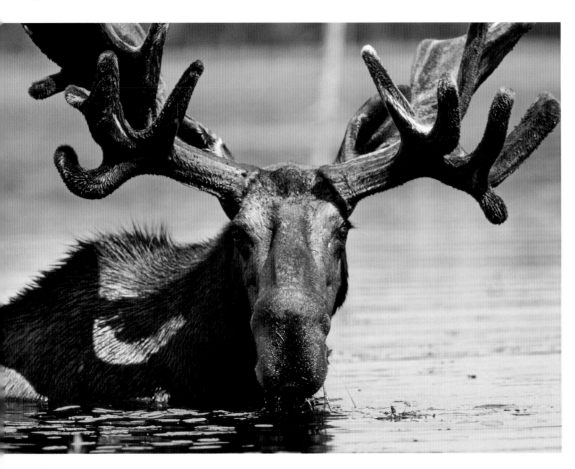

July 25

One of the most exciting ways to watch moose is from a canoe. In the spring and into mid-summer the animals will feed on water plants. Sometimes, as with this bull, a quiet paddler can get quite close. Note the white patches on the antlers. This is where the velvet is beginning to dry up. *Ontario*

July 26

Mule deer browse on a variety of vegetation depending on where they live. Green leaves and twigs, the younger the better, are a staple especially in the spring, but they will also feed on grasses, herbs, weeds, blackberries, raspberries, vines, grapes, mistletoe, mushrooms, ferns, and even cactus fruit. *Ontario*

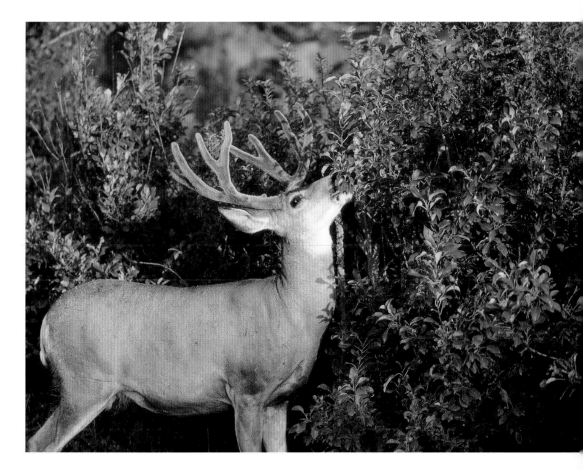

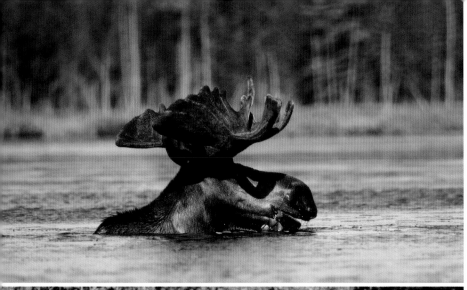

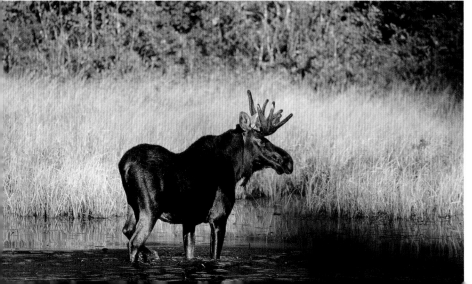

July 27

There are four races of moose in North America, each with a defined range. Ranges do overlap somewhat, so there is some interbreeding. The four races are Shira's or Yellowstone moose (Wyoming, Idaho, Montana, southern Alberta and British Columbia, and introduced into Colorado), Eastern or Taiga moose (Maine and Nova Scotia westward into Quebec and Ontario, introduced into Newfoundland), Northwestern moose (northern Michigan, western Ontario, Manitoba westward to central British Columbia, the Yukon, Northwest Territories and Nunavut) and the Alaskan/Yukon moose (Alaska, Yukon and northern British Columbia). See map on page 14. The four races are pictured here: Eastern moose *(top left)* Ontario; Northern moose *(bottom left)* Manitoba; Alaskan moose *(right)* Alaska; and Shira's moose *(far right)* Wyoming.

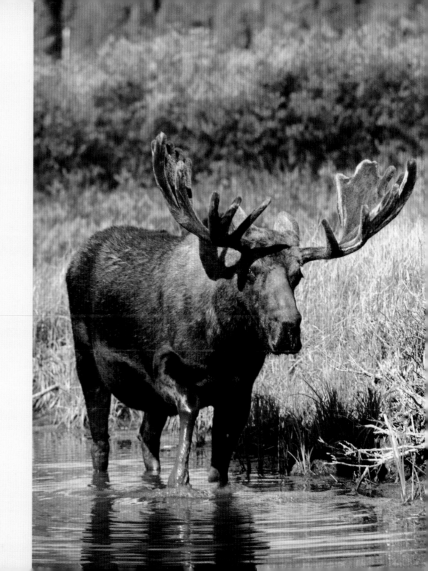

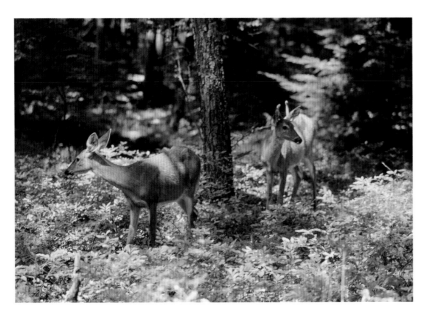

July 28

Sitka deer are a smaller race of black-tailed deer. They tend to have a shorter face than their more southern relatives. These deer are very vocal animals, likely because they live in temperate rainforests where sound conveys information better than sight. Their repertoire of sounds includes bleating, baaing, and grunting. Researchers have identified at least twelve different signals that Sitka deer use. *British Columbia*

July 29

There are still a few places where elk inhabit their old prairie haunts. These animals were resting in a pond when I came across them in Fort Niobrara National Wildlife Refuge. There are approximately 350 bison and 100 elk. They represent the great herds that once roamed the Great Plains. *Nebraska*

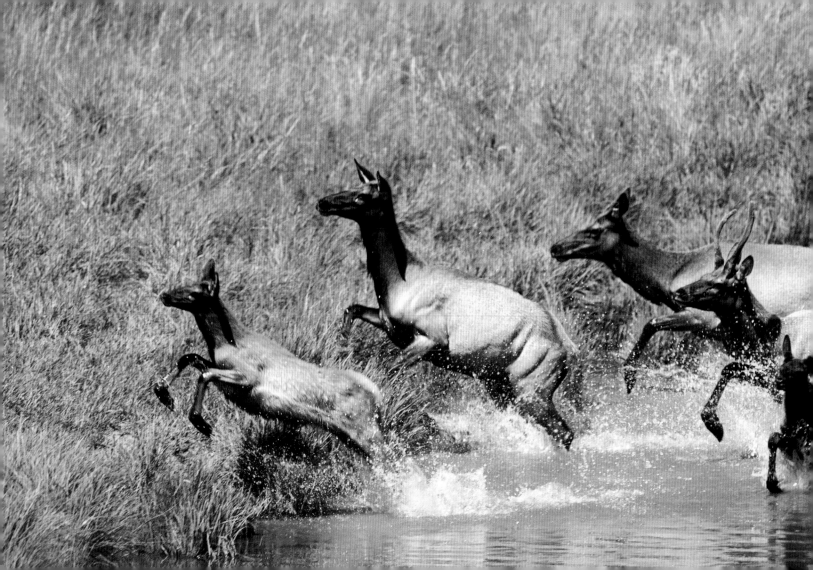

July 30

By the middle of summer, the whitetail's antler growth is well along. The antlers are still sensitive to bumps, so the bucks tend to be harder to find. *Ontario*

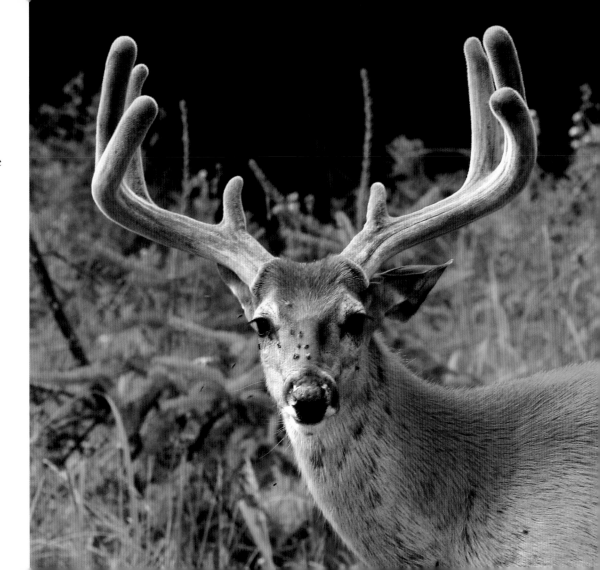

July 31

White or albino whitetails are rare but do occur. Some populations, especially those where predators have been eliminated, will contain numbers of deer with this genetic trait. In the wild, white deer are very conspicuous and are soon discovered by predators. *Nova Scotia*

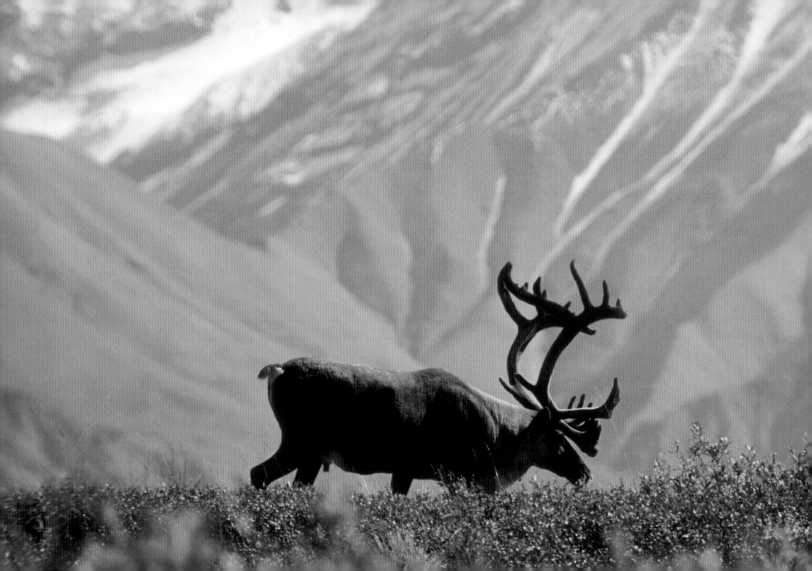

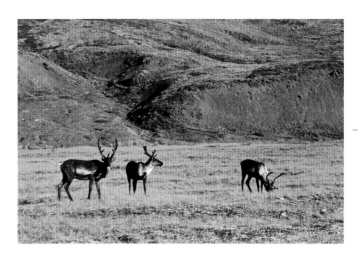

August 1

The world population of caribou is around five million animals. The Eurasian subspecies is called reindeer. Both caribou and reindeer are considered to be the same species. The seven subspecies are barren ground *(Rangifer tarandus granti)*, Svalbard *(R.t platyrhynchus)*, European *(R.t. tarandus)*, Finnish forest reindeer *(R.t. fennicus)*, Greenland *(R.t. groenlandicus)*, woodland *(R.t. caribou)* and Peary's *(R.t. pearyi)*. *Alaska*

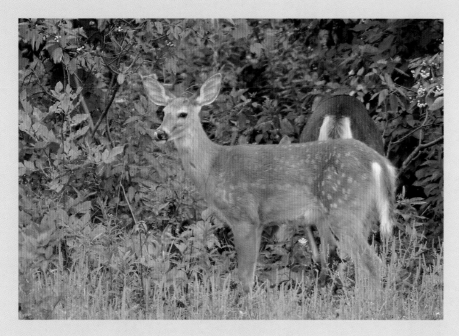

August 3

In summer, deer disperse to low densities, and that is why often just a doe and her fawn(s) or a single buck will be encountered. They tend to use relatively small areas. As fall approaches, the deer begin to congregate in small female herds. Typically, the adult females are related. Doe fawns will stay in the area in which they were born. They socialize with their mothers as adults. *Montana*

August 2

This two-month-old whitetail buck will not enjoy the benefits of its mother's home range. Males are not tolerated by the adult bucks, especially in the rut, and are forced to keep on the move. Even so, they will not wander far from the place they were born. After the rut they will associate with more mature bucks and in the winter may even yard up with their mother's herd. *Ontario*

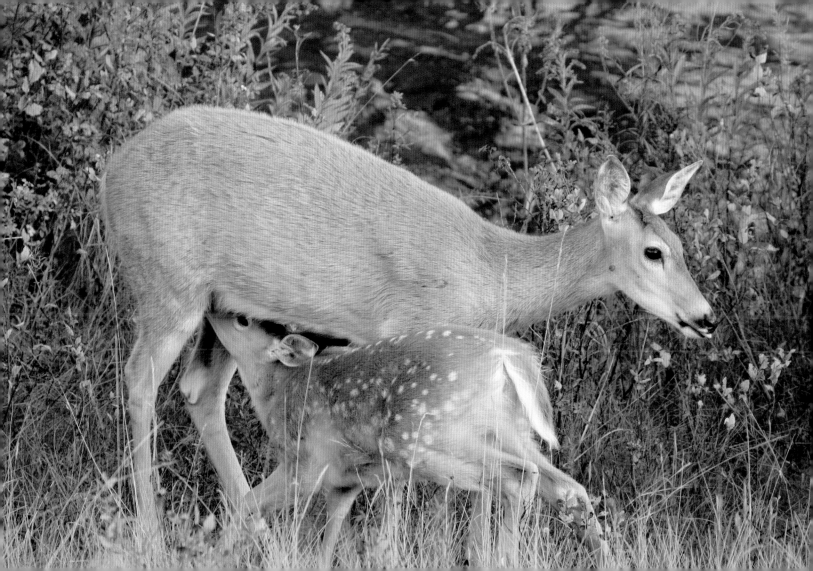

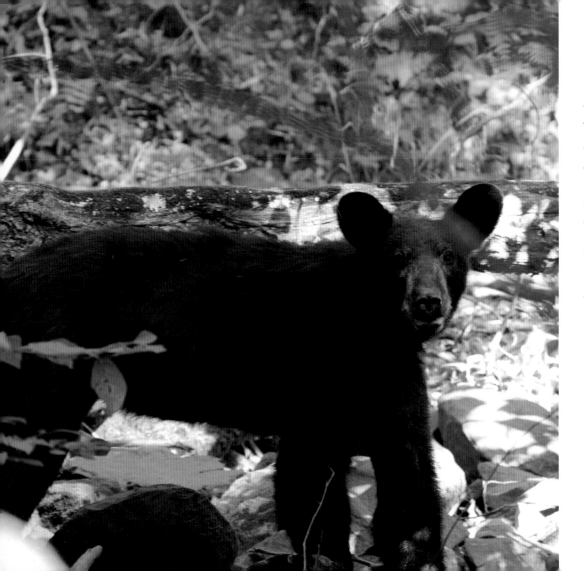

August 4

The age of a black bear can be estimated by the size of its ears compared to its head. Older bears have larger skulls and their ears appear smaller. This is a three- or four-year-old bear. It has not yet begun its binge feeding and is still quite thin. *Virginia*

August 5

Habitat is a factor in selecting the physical features of white-tailed deer. Deer found in dense cover have smaller bodies and antlers. Those found in more open areas have larger bodies and antlers. *Virginia*

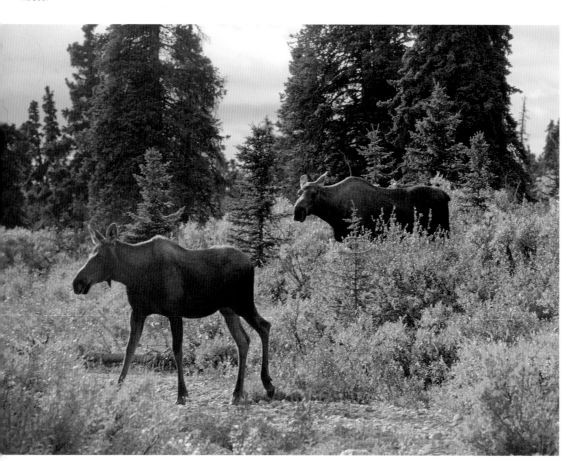

August 6

Fall comes early to the Alaskan tundra. Calf moose have already taken on the appearance of the adults. They are smaller and are only now beginning to develop the pendulum nose so characteristic of moose. The nose and lips are almost prehensile. *Alaska*

August 7

This bull shows the distinctive color pattern found in Alaskan bull moose. Other moose races are not so showy. This animal has not yet begun to rub of the velvet covering from its antlers but it could be a matter of only a few weeks before does. *Alaska*

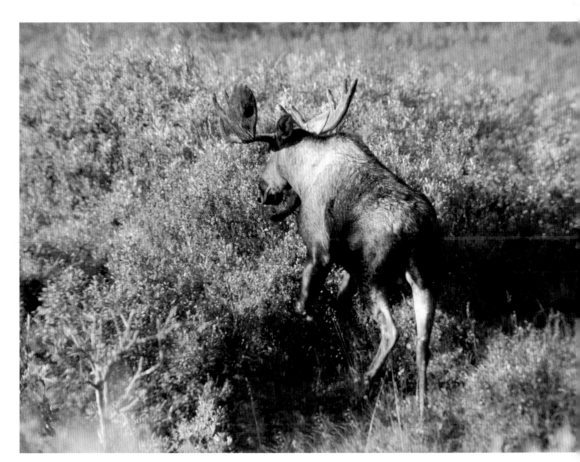

August 8

The Alaskan/Yukon moose is the largest race of moose and the largest deer that ever lived. It ranges in weight from 1,100 to 1,566 pounds (500–710 kg). It sports the largest antlers of any; a spread of 82.7 inches (210 cm) has been recorded. *Alaska*

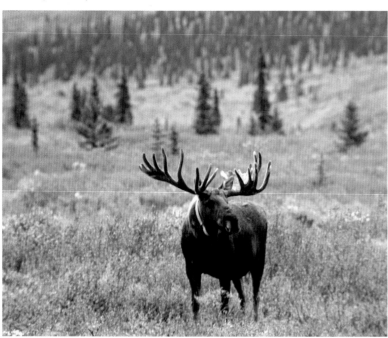

August 9

Lichens are a good source of energy but they are not a good source of protein. With the coming of spring, caribou change their diet to fresh green vegetation, which is rich in nitrogen. As summer progresses, the quality of the green vegetation becomes poorer and the herds turn again to lichens. Mushrooms are an important source of nitrogen in August and September. *Alaska*

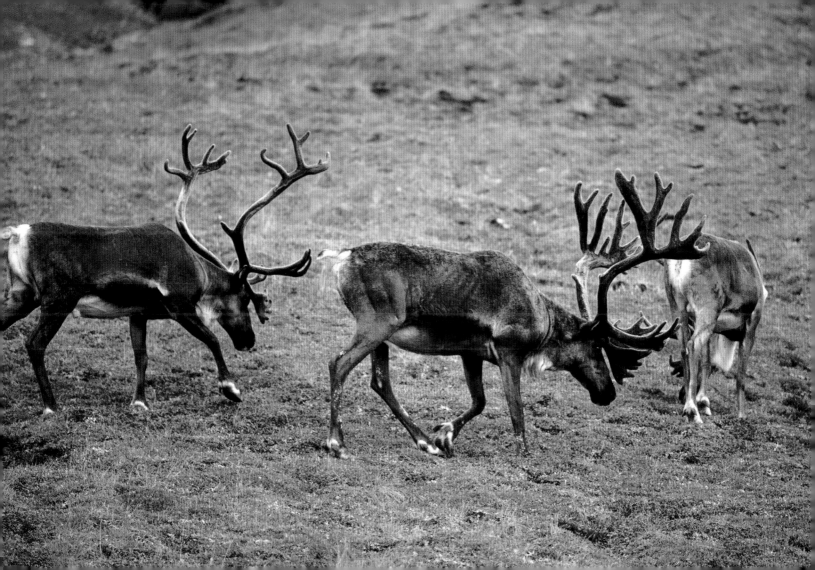

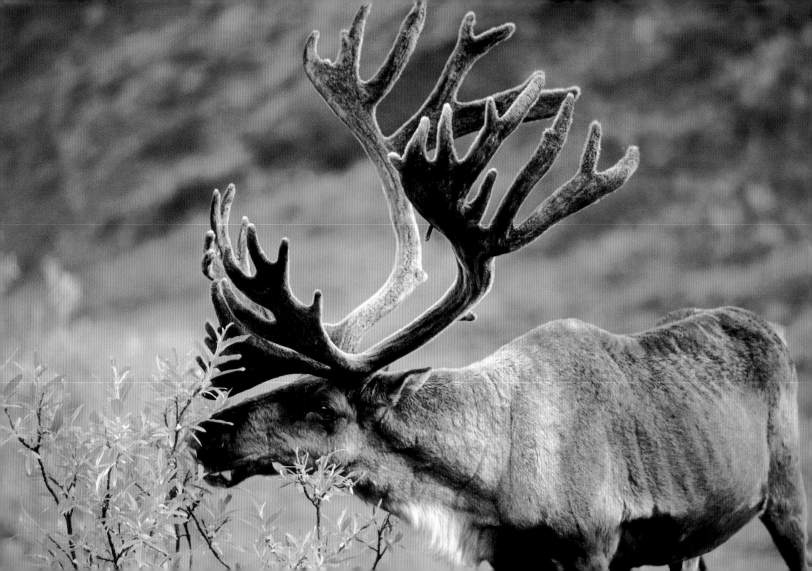

August 10

Alaska has only the barren-ground subspecies. Canada shares Alaska's largest herd, the Porcupine Herd, which crosses the border between them. The herd winters in the mountains of Canada's Yukon Territory. Most calving occurs on the Alaska's coastal plain and its mountain valleys. There are around 2.4 million caribou in Canada and of these, 1.2 million are the barren-ground subspecies. The other Canadian subspecies are the woodland caribou, found in the boreal forests, and Peary's subspecies of the high Arctic islands. *Alaska*

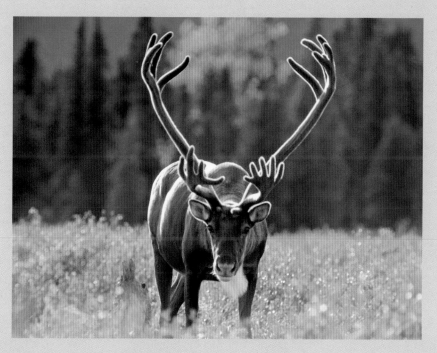

August 11

Caribou, like moose, are also susceptible to meningeal brain worm. An infection is fatal. Alaska's herds are safe, but as white-tailed deer expand their range more caribou herds will become infected. This has occurred with the woodland race in Quebec and Manitoba. *Alaska*

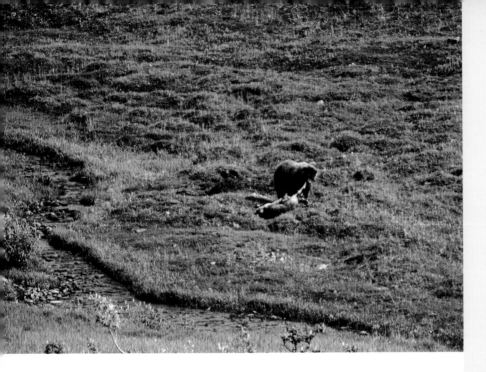

August 13

Caribou are an important food source for many Arctic people both aboriginal and non-native. A pair of caribou antlers resting by Hudson's Bay gives mute testimony to a successful hunt. They were likely the only parts of the carcass not used. *Manitoba*

August 12

A cow caribou was walking with the wind at its back across the tundra. It could not see or smell the sleeping grizzly boar until it was too late. Death was almost instantaneous. The boar guarded this kill for several days, never wandering far from it. Wolves picked up the last remains. *Alaska*

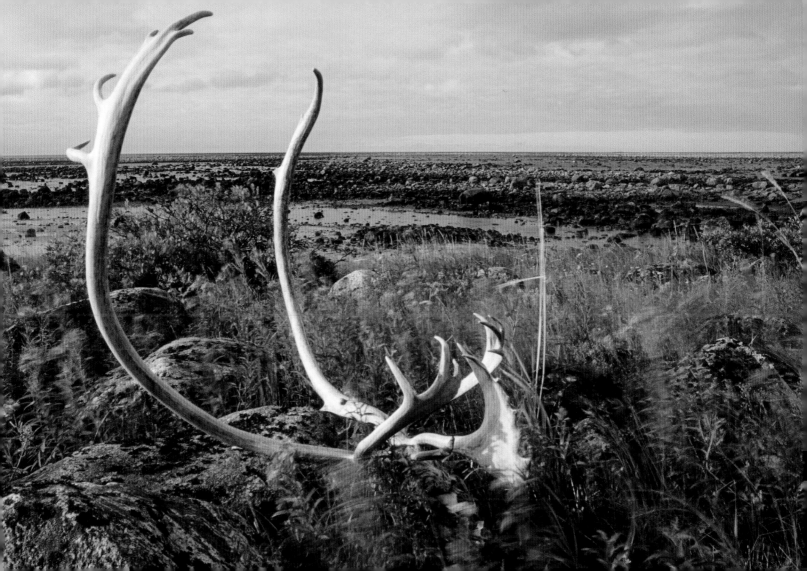

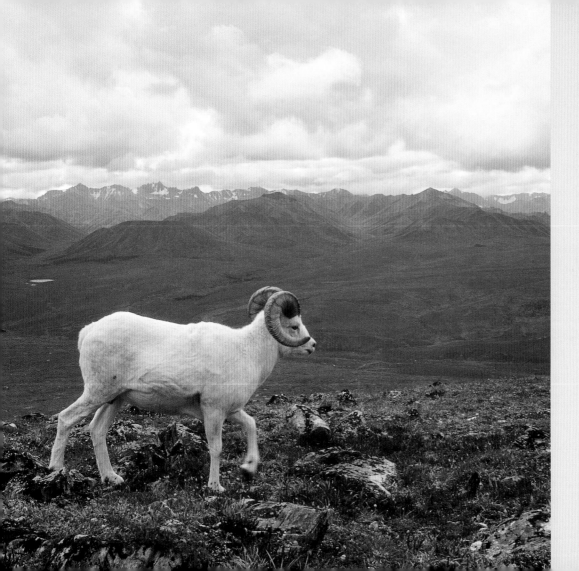

August 14

There are between 80,000 and 100,000 Dall's sheep in North America. Their range includes Alaska, northern British Columbia, the western mountains of the Northwest Territories and the Yukon. *Alaska*

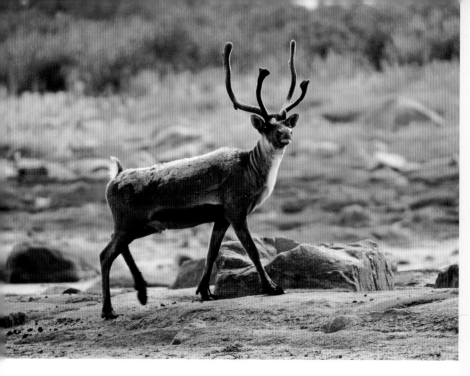

This willow ptarmigan still sports its breeding plumage. It will soon change over to its winter white. *Manitoba*

August 15

We were looking for summer polar bear up by the Seal River when we came across this lone bull caribou. Why he was here at this time of year remains a mystery. It was the only caribou we saw in a week of searching the coast. One factor may have been the unusually warm weather that summer. Perhaps he came to the coast to escape the millions of mosquitoes that seemed to be everywhere.

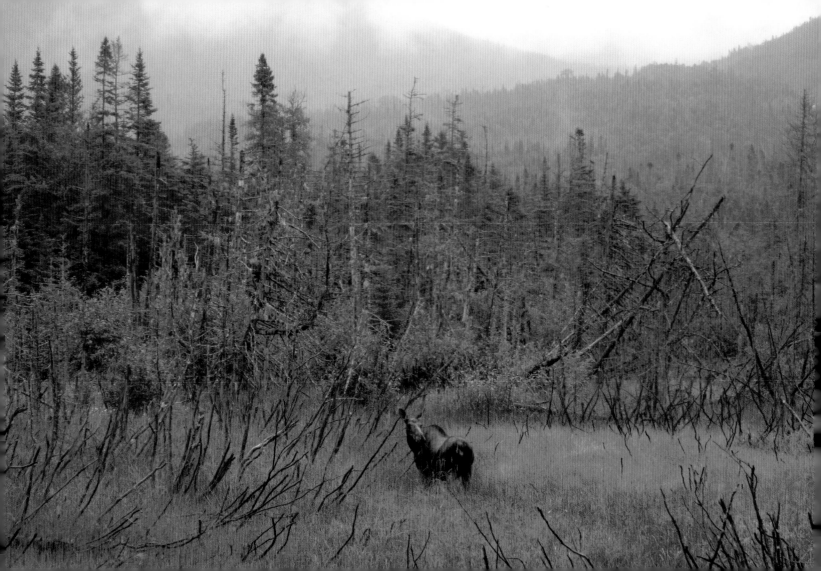

August 17

Coyotes are not at all reluctant to scavenge. In this case, an elk carcass has been deserted by the wolves that killed it. Coyotes have taken it over but they remain vigilant because the wolves could return at any time. *Wyoming*

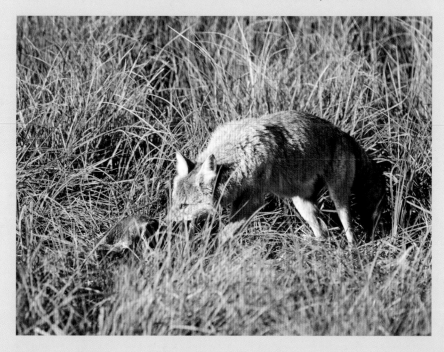

August 16

Newfoundland has one of the largest herds of moose in North America. They were introduced to the island in 1878 as a game animal. By the early 1900s their major predator, the wolf, had been eliminated and the moose herd expanded. Today black bears prey on the island's moose and caribou. *Newfoundland*

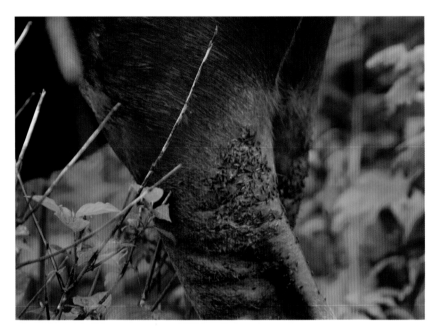

August 18

In the late summer and fall, many moose bear small red wounds on their legs. These are the bites of moose flies. Flies are a constant companion of moose during the warmer months. Even taking to the water does not discourage their attention, the flies just hover above the moose until enough of his body surfaces for them to land on. *Newfoundland*

August 19

Currently moose are expanding their North America range. They have invaded the Yellowstone-Grand Teton area within historical times. The range has also expanded in the northern New England States and New York in recent decades. *Wyoming*

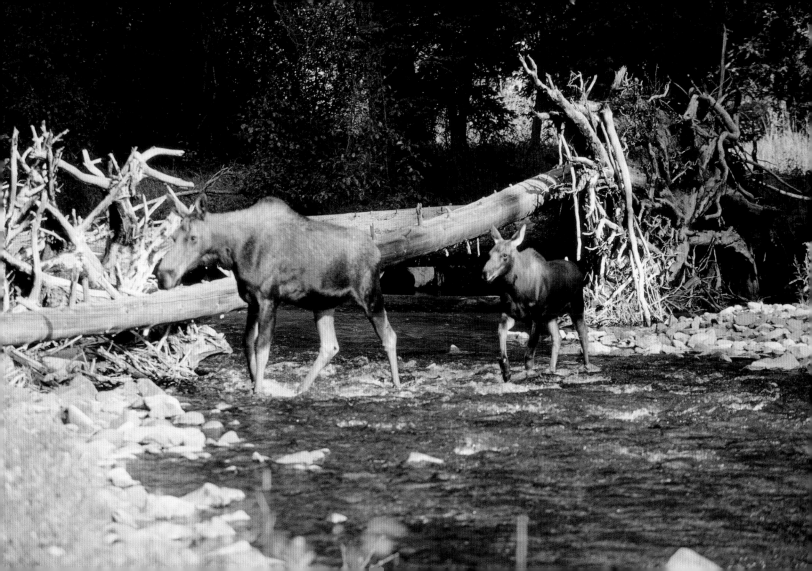

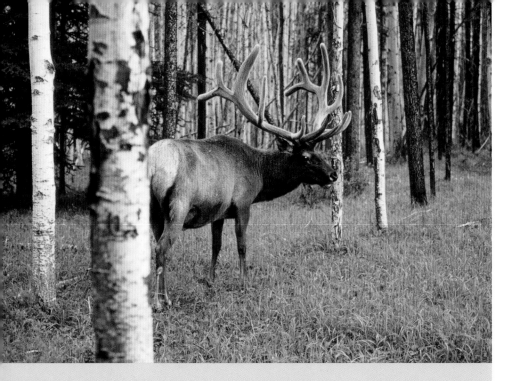

August 20

This was one of the first bull elk I ever photographed. The picture was taken with a wide-angle lens. I was far too close. Had it been the rut, this might well have been the last picture I ever took of a bull elk. *Alberta*

August 21

The woodland caribou is the largest and darkest of the caribou subspecies. Its range includes much of the boreal forests from British Columbia and the Yukon Territory to Newfoundland and Labrador. A small number of these animals still exist in Idaho. An attempt to reintroduce them into Maine a few years ago failed. The two largest herds are the Leaf River and George River herds of Quebec and Labrador. They are have about 600,000 and 400,000 individuals respectively.
Newfoundland

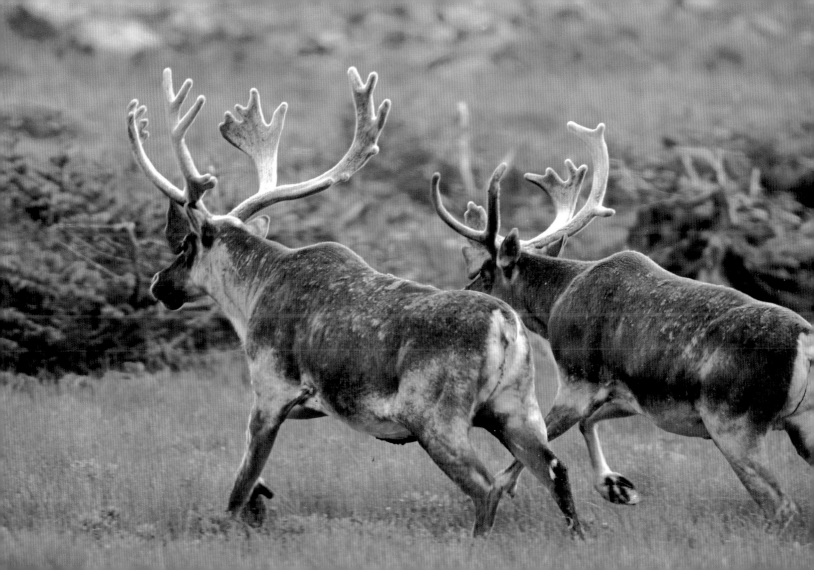

August 22

Blacktails in California will not begin to shed their velvet for a few more weeks. Blacktails are ancestral to mule deer and predate them by several hundred thousand years. DNA studies suggest that blacktails evolved from whitetails. The species was isolated along the western coastline by the ice age. When the ice age ended eastward-expanding blacktails met westward-expanding whitetails and interbred. This led to the birth of the youngest deer species: the mule deer.

California

August 23

Technically the rut begins when the bucks and bulls scrape off the velvet of their antlers. They will begin seeking out females at that time but actual matings will not occur for a few weeks or months when the cows and does come into heat. For the black-tailed deer on Vancouver Island, the rut begins in late August.

British Columbia

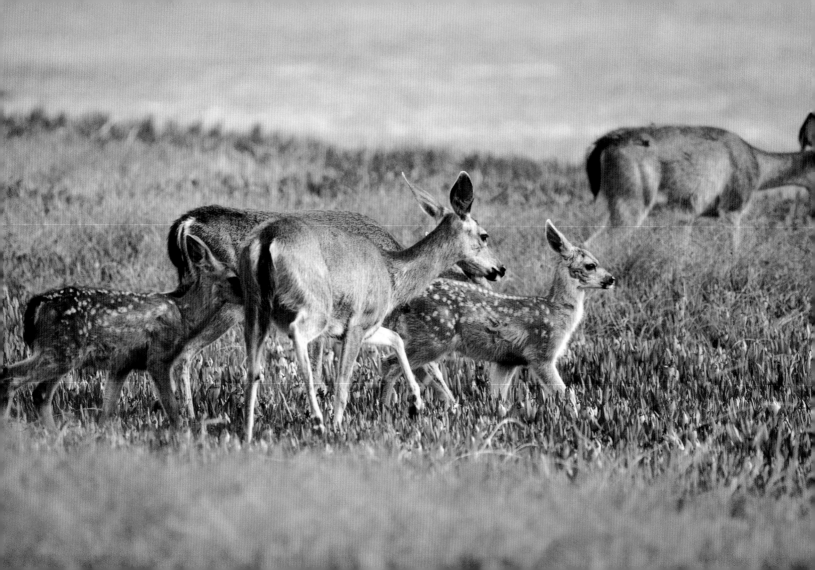

August 24

California blacktails are the most "primitive" of the blacktails. The farther east you go the more the blacktails resemble mule deer. The classic mule deer is found in the Rockies. It has a large white rump patch and a tail tipped with black. The California black-tailed deer has a rump and tail resembling the white-tailed deer's. *California*

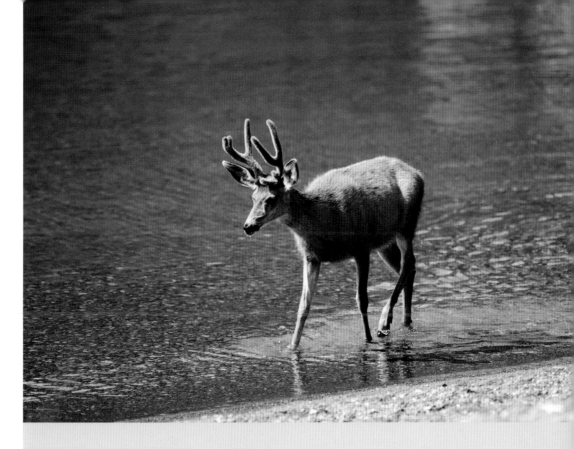

August 25

On a late summer day a young mule deer buck wanders along the shore of Waterton Lake. His antlers are hardened and he will soon enter the rut but he is probably too small to successfully breed this year. *Alberta*

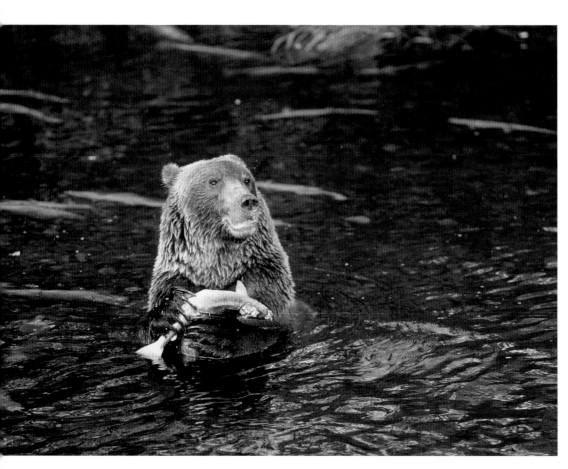

August 26

Coastal grizzlies are not particular as to whether they eat fish they catch or fish that die during the spawning run. This one is feeding on pink salmon. His larder is full.

British Columbia

August 27

Another coastal grizzly is working for his meal. This is a young bear and is not yet adept at catching fish. I never saw him come up with one. Why doesn't he feed on the dead ones? Most of those fish are found in a few pockets of slow-moving water, and the big males have those spots staked out. *British Columbia*

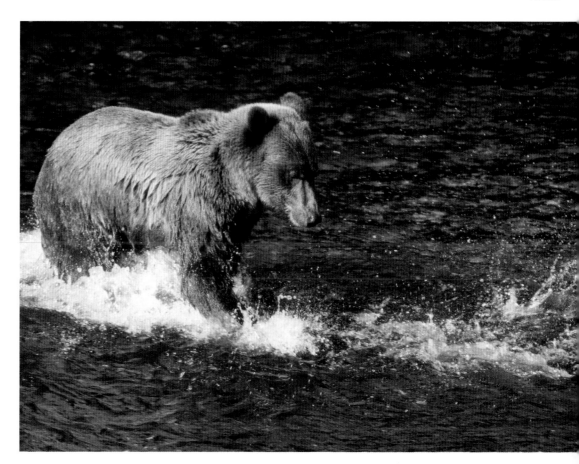

August 28

This cow elk is not yet ready to breed but the actions of the bulls will soon stimulate her reproductive hormones. Note that the calf in the foreground has not quite lost all of its spots. *Wyoming*

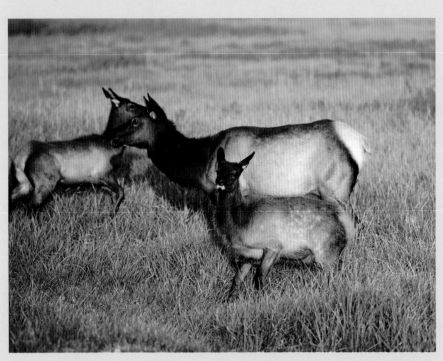

August 29

The rut begins! This bull elk might well girdle this sapling conifer in its effort to rid its antlers of velvet. The sapling is not just a rubbing post; it also serves as a sparring partner. *Wyoming*

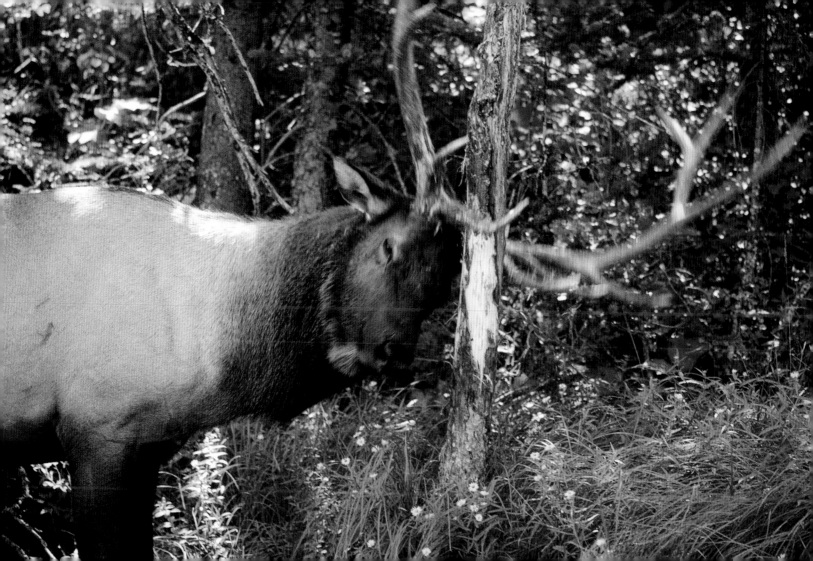

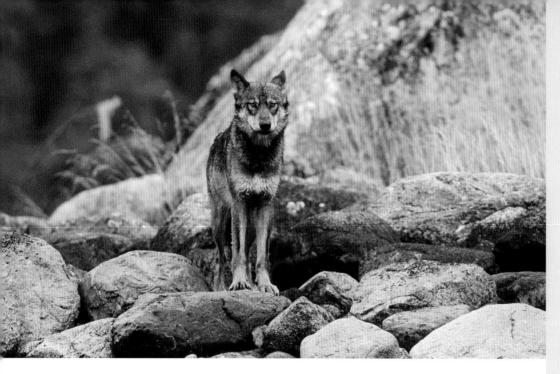

August 31

Wolves will growl and snap at each other when feeding on a kill but they will also carry home leftover parts (or even regurgitate meat) to wolves that stayed behind to mind the pups. *Montana*

August 30

There are wolves and then there are wolves. The wolves of coastal British Columbia's island rain forest are genetically and behaviorally different from the mainland wolves. They eat fish, for one thing, and not mountain goats. In fact, most of their diet comes from the sea and includes beached whales, sea lions, seals, salmon and even crabs. Coastal Sitka deer are also on the menu. *British Columbia*

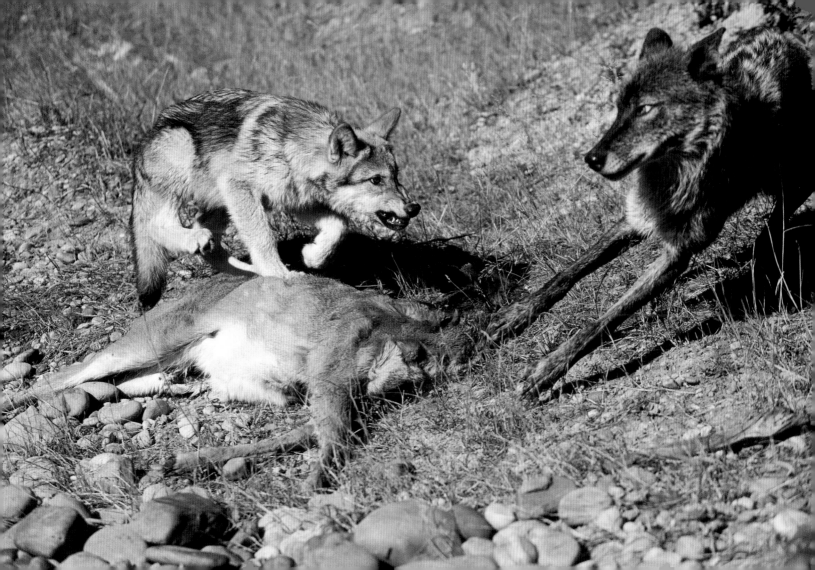

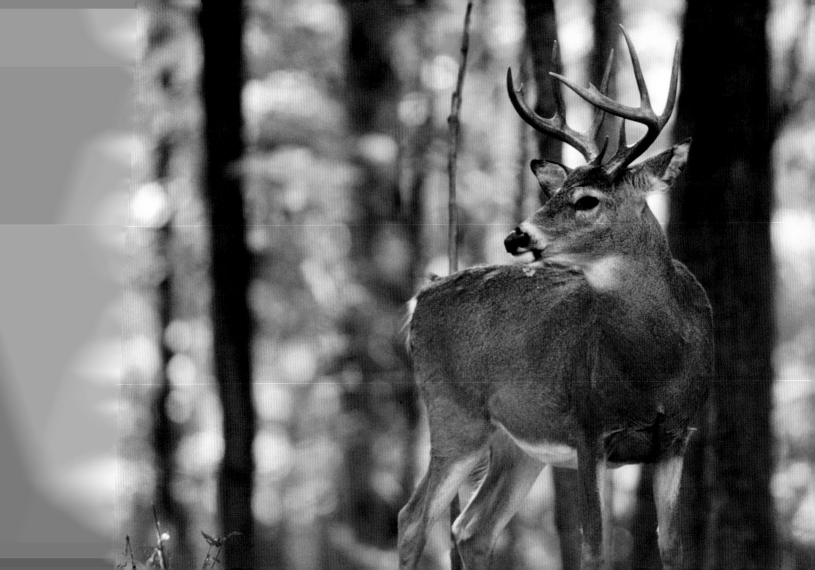

SEPTEMBER

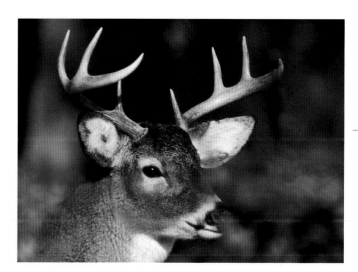

September 1

The deer rut is tied to photoperiodism. This is the relationship of daylight hours to nighttime hours. Therefore the further north the deer live the sooner their rut will begin. Northern whitetails rut in November while in the southern parts the rut may not occur until January and February. Antler growth also corresponds with the increasing amount of sunlight in the spring. *Montana*

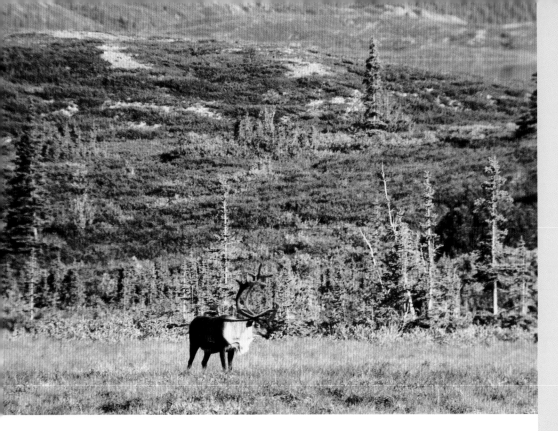

September 3

Caribou antlers have a distinctive "C" shape. A palmated front tine protrudes over the animal's nose. This will help protect the animal from injury in the battles to come. Antlers are male ornaments that declare the animal's status. The larger the set of antlers, the better standing a bull (or buck) has among the females of his kind. They are seldom used against anything but other members of their species. *Alaska*

September 2

By beginning of September, the Alaskan tundra has been painted with the vibrant brushstrokes of fall. The white manes of bull caribou are at their fullest. This bull stills retains velvet on his antlers, something oddly out of place with the rest of its environment. *Alaska*

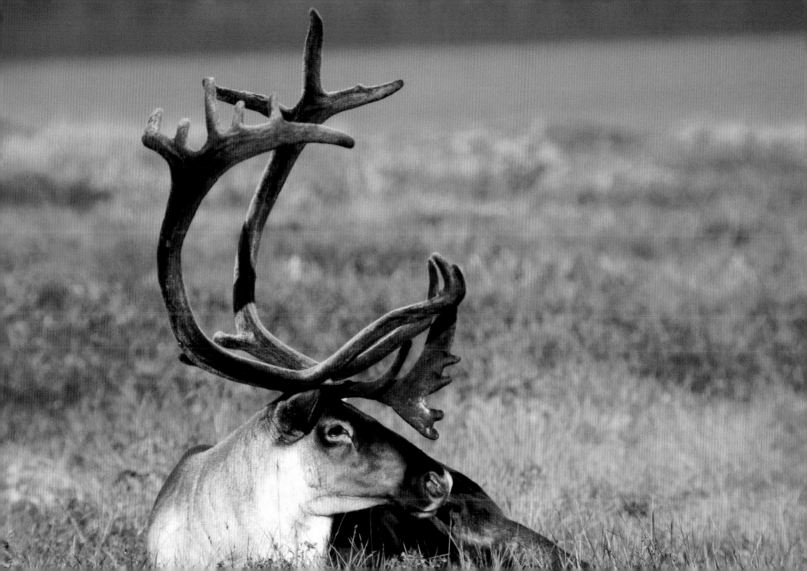

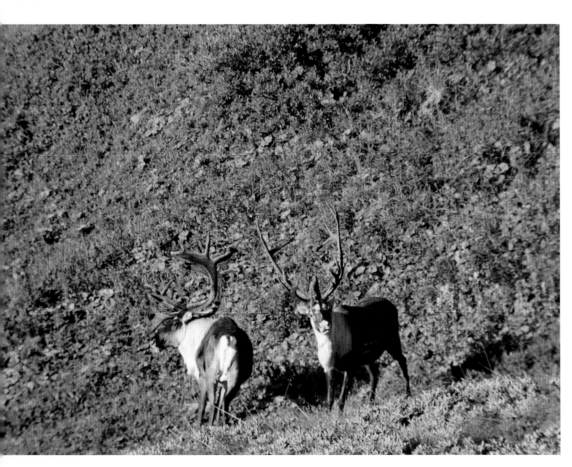

September 4

One bull (on the left) has yet to shed his velvet while the other has just done so. The red color is blood. When the antler was growing, blood carried the needed nutrients to it. When the velvet covering is rubbed off, the remaining blood is visible. *Alaska*

September 5

His antlers hard and shiny, a bull caribou sets out to find the females. He will soon begin to urinate on his belly and hocks, and roll in a scrape he makes by using his front hooves to push debris off the surface and then urinating in the bared soil. In effect, he is perfuming himself for the ladies. *Alaska*

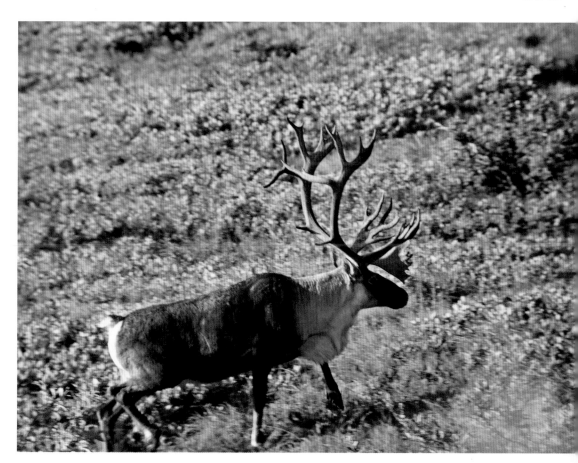

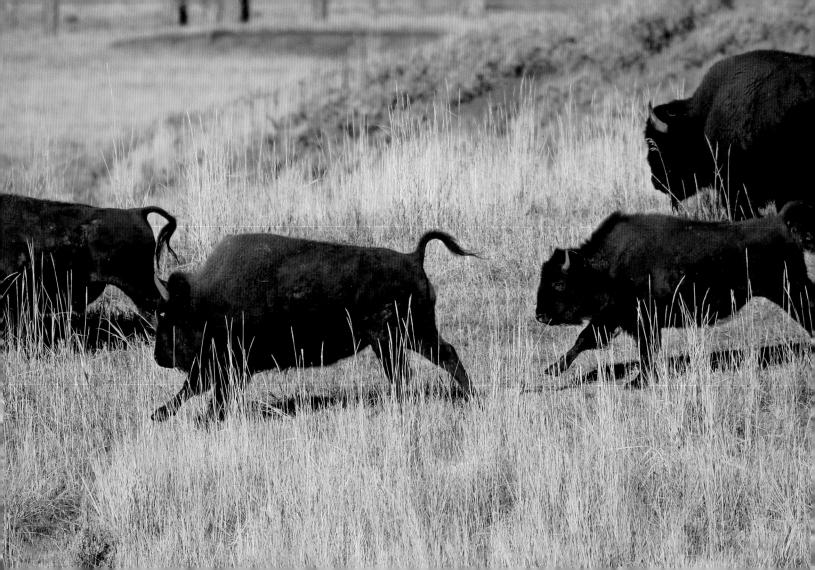

September 6

Bison herds once numbered in the millions. Estimates put the population at around 30 to 40 million animals in 1860. Over-hunting reduced the herds to a few individuals. The only free-roaming bison in the United States inhabit the Greater Yellowstone ecosystem. *Wyoming*

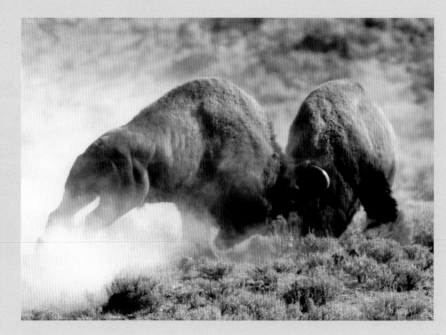

September 7

The bison rut begins in the summer but mating continues well into September. Rival bulls still face off and engage in brief fights over females. Such fights will gradually become less frequent as winter approaches. Bull bison are often found alone or in small loose groups during the rest of the year. *Wyoming*

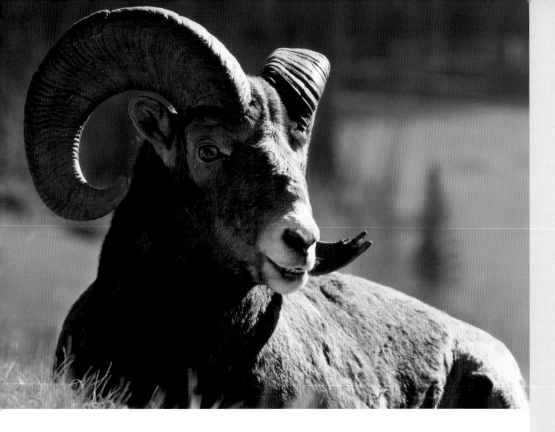

September 9

The ram in profile is almost a full-curl ram. The other two are also mature rams. A ram's place in the social structure is determined by his horn size. Rams with big horns dominate all others with smaller horns. Simply displaying one's horns to a rival can often solve disputes. Even ewes follow this pattern. Ewes with bigger horns dominate ewes and lambs with smaller horns. Since horns are not shed, the hierarchy of the herd does not change much over the years. *Montana*

September 8

Bighorn "broom" the tips of their horns, breaking off the ends in their fall battles over females. This is a three-quarter-curl ram. He is not yet in his prime. *Alberta*

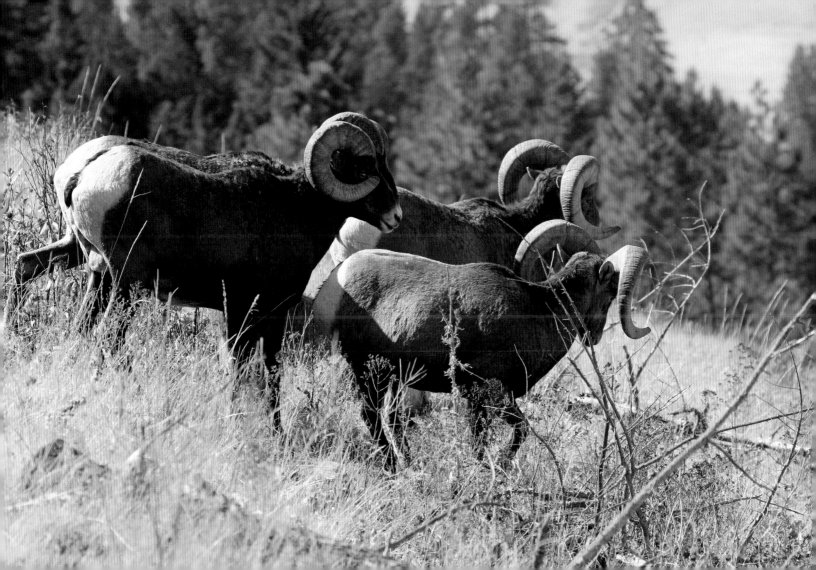

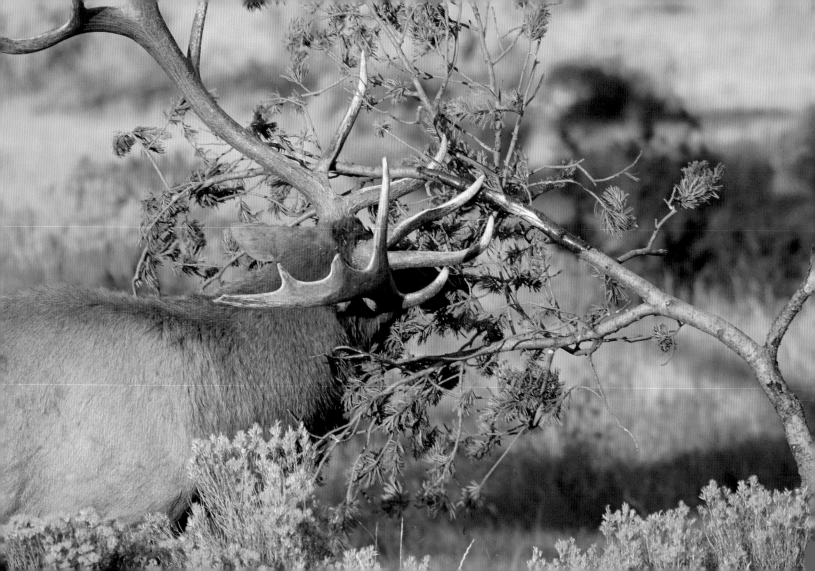

September 10

This bull elk is tossing a broken limb around for at least two good reasons. First, it feels good to vent. He, like other bulls at this time of year, is very aggressive — and letting off steam helps. Second, the branch draped over his antlers makes him that much more conspicuous to the cows and to rival bulls. *Wyoming*

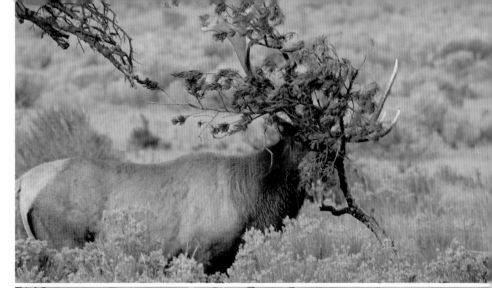

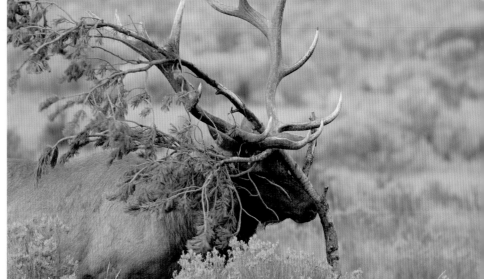

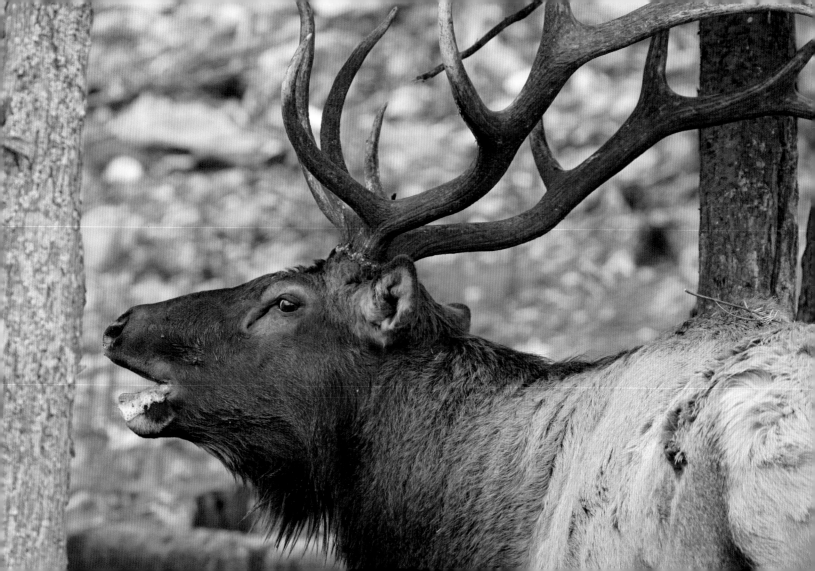

September 11

The term "rut" is used to describe the breeding season of all deer, but the term has it origin firmly tied to a close relative of North America's elk; the Eurasian red deer. Elk bugle, but red deer roar. The Middle English term *rutte* comes from the Middle French *ruit*, meaning to roar. The term is now applied to all members of the deer, sheep, cattle and antelope family that have a distinct breeding season. *Wyoming*

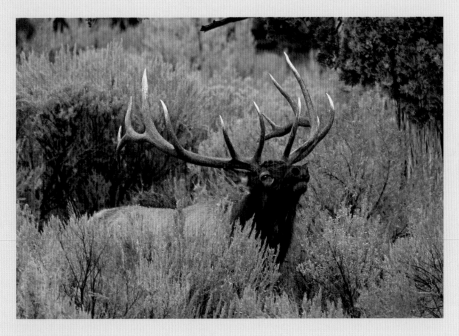

September 12

As noted before, the rut for all species of deer begins with the shedding of velvet. Bugling accompanies this phase among elk. The elk's bugle is a clear message. The deeper the bugle, the more mature the bull. The sound also conveys information about the health of the bull. More bugles equal a healthy bull. It is a challenge to other bulls, and a come-hither call to cows. *Wyoming*

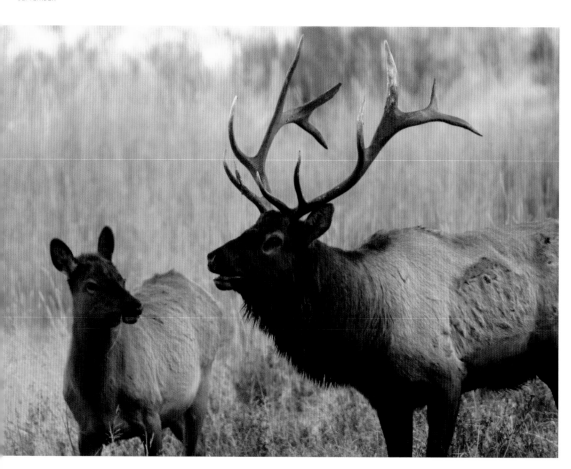

September 13

The calf standing beside this bugling bull is not the object of attention of the bull. First-year calves seldom are ready to mate. In fact, having an adult bull mount might cause severe damage to its backbone. The calf will need another season to mature. This bull is calling to a more distant bull up on the mountainside. *Wyoming*

September 14

Bulls collect herds of cows and their calves. The bull will move to where the cows are and then try to impose his will on them to keep them from wandering off. Neck stretches, hissing and brief charges are all intended to keep the cows in line. *Wyoming*

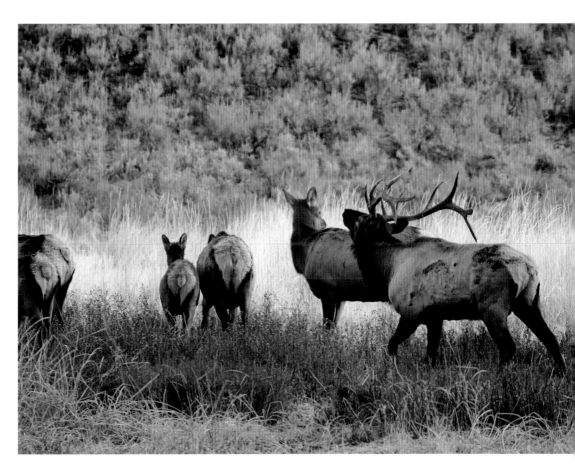

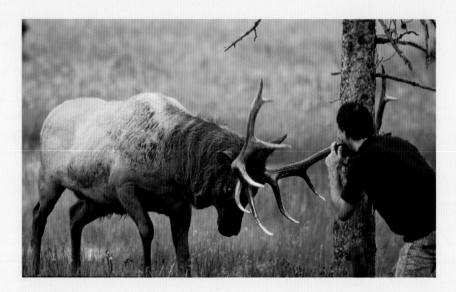

September 16

This bull wanted to go where I was standing. His attitude left little doubt in my mind that he was prepared to back up his challenge with might. I moved. *Wyoming*

September 15

Bull elk, along with bison, kill or injure more people in national parks than do bears or cougars. The numbers are not even close. People seem to think that these habituated animals are tame animals. They are not. In fact, habituated animals are more dangerous than truly wild ones because they have learned that humans are not a threat. *Wyoming*

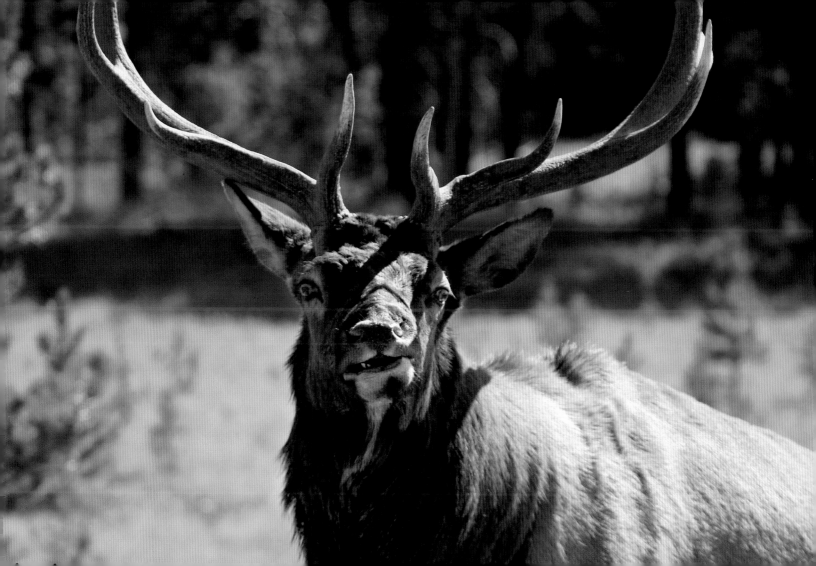

September 17

Since the arrival of wolves in Yellowstone, grizzly numbers have increased. This came as a bit of a surprise to biologists. It is now thought that the wolves are providing the bears with more meat since large bears can push a pack of wolves off their kill. But it is not that simple. Often wolves will steal a grizzly's kill or scavenged carcass. Female grizzlies with cubs avoid wolves. I suspect that one of the reasons more grizzlies are seen along Yellowstone's roads is that the sows with cubs know that wolves avoid these areas. I've no proof of this, but there are studies that suggest sows with cubs use fishing streams when people are around and the boars are not. *Wyoming*

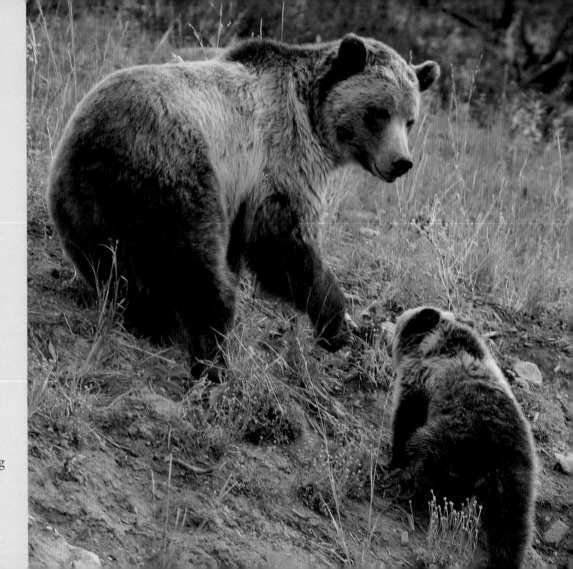

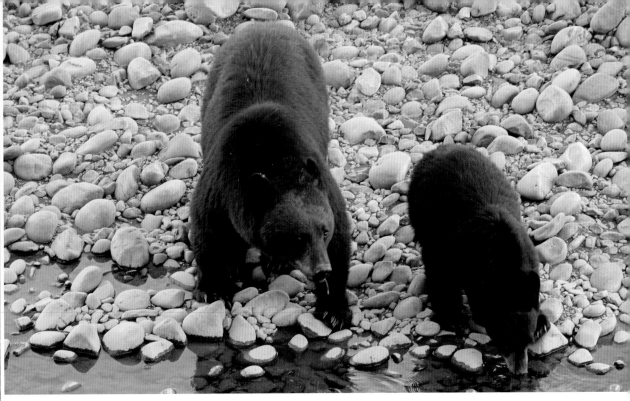

September 18

Black bears are amazingly tolerant of people. This sow and her cub crossed the stream and emerged just a few feet from where a group of us stood watching her. She fed for a bit and then wandered down the road only to disappear a few minutes later. The bear watchers, I might add, were tolerant and respectful of her too. We did nothing to make her nervous and we did not approach her or the cub. *Wyoming*

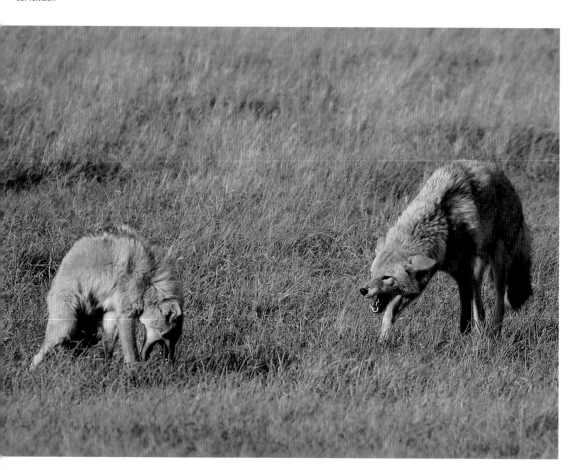

September 19

Coyotes have their own social protocols too. The larger of these two rushed up at the interloping smaller coyote and took on this hunched-back aggressive stance. The smaller coyote immediately became submissive and lowered its head, tucked its tail and whined. This went on for a few minutes and then they both returned to their separate pursuits.

Wyoming

September 20

Across North America cougars are making a comeback. This is almost certainly tied to the increase in white-tailed deer, their main prey species. Hot spots for cougars (also called pumas, mountain lions and many other names) are British Columbia, including Vancouver Island, as well as California and the other West Coast states. Cougars are also making a comeback in the east, with more and more sightings being reported. Twenty years ago Yellowstone did not have cougars, but today it does.

Alberta

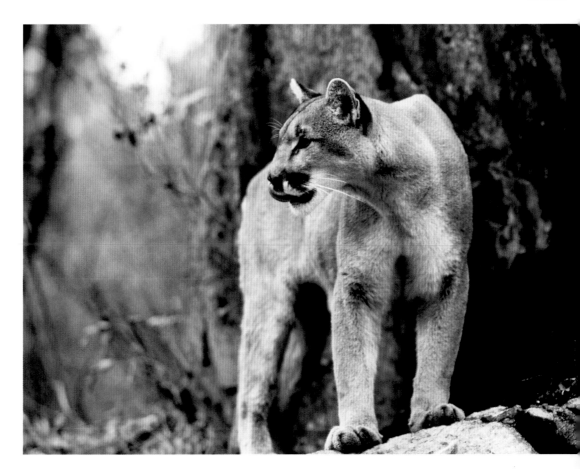

September 21

Wolves are the main predator of Yellowstone's elk (next, of course, to human hunters). They do not manage to keep the elk herd in check — it is still growing — but they do weed out surplus animals. The myth that they take only the sick, the infirm and young is nonsense. They are quite capable of killing healthy adult elk, even bulls. Yellowstone is one of the best places to view wild wolves. The openness of the countryside makes seeing the wolves quite easy but bring a spotting scope. They are seldom close. *Wyoming*

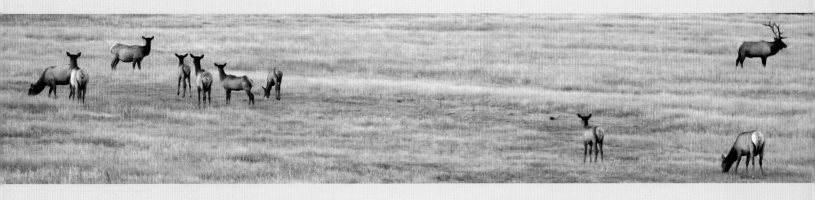

September 22

Not every cow comes into estrus at the same time so a bull tries to keep as many as possible in the herd. The cows don't necessarily want to be kept in a herd. Consider this bull's predicament. There is a rival bull approaching from the west and the lead cow wants to go southeast into the woods to ruminate. If he moves to meet the challenge he loses his harem. If he chases her, the rival may steal one of the females that linger. In the end, the lead cow goes where she wants and the bull, dignity askew, follows. *Wyoming*

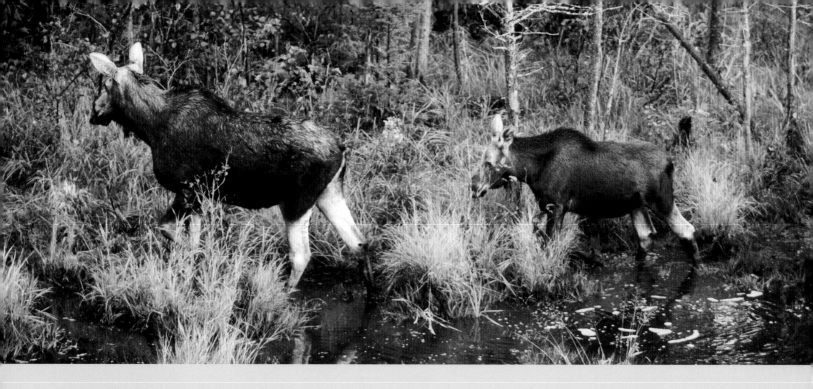

September 23

By urinating in a small pond, the cow sends out a sound sure to attract any nearby bull. Cows urinate frequently and their urine serves to advertise via pheromones the cow's condition. Sometimes they will urinate in water, a sound that travels a fair distance in the woods. *Ontario*

September 24

During the rut, bull moose wallow in urine-sauced scrapes or rutting pits. This perfuming of their bodies seems to be very attractive to females and it is not unusual for a bull moose to have more than one cow in attendance near these pits. Alaskan moose may in fact have several cows vying for his attention. *Ontario*

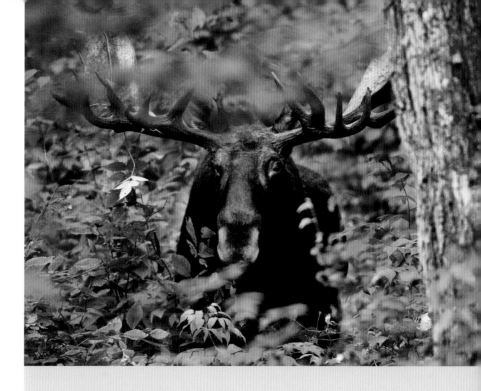

September 25

Calling elk, or any animal, is against park regulations in most, if not all, western parks. Some eastern parks still permit moose calling. I wonder how long it will be before it ends too. This bull came into our calls and he was not happy to find photographers instead of cow moose. One day a bull might just do something serious about being fooled. *Ontario*

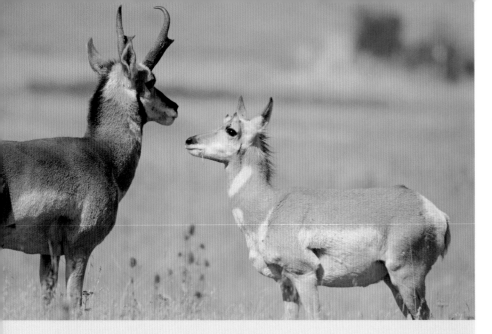

September 26

Pronghorn rut in the fall too. Males do not collect harems but instead visit one female after another, spending time with her until he knows if she is in breeding condition. He will chase off other males. Pronghorns are the only horned animals to shed their horns annually. (Note: This buck is with a yearling, not a potential mate.) *Montana*

September 27

This is the largest buck mule deer I've ever photographed in Yellowstone. He came barrelling up a hill (mulies almost always run up hill) toward me, I knew something was up and, sure enough, about five minutes later a black wolf trotted down the valley. The buck was obviously not taking any chances. The wolf had to be a mile away when the deer spotted him. *Wyoming*

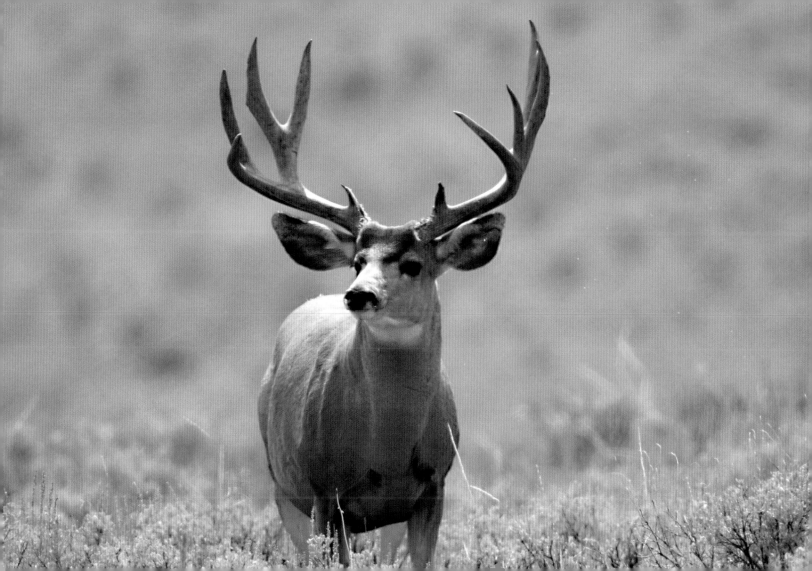

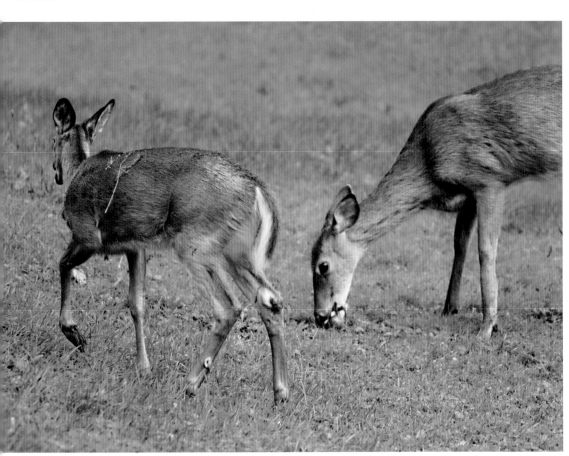

September 28

Apples that fall off trees during harvest time attract whitetails. Deer like the somewhat over-ripe apples because of their high sugar content. Many farmers and even urban gardeners consider deer "predators" because of their preference for human crops, be they apples, flowers or other plants grown for food or their decorative appearance.

Ontario

September 29

In the Rockies, snow can fall in any month. Elk and, for that matter, elk-watchers have to be prepared for sudden changes in the weather. The day before these elk were enjoying mild temperatures. This early snowfall won't last long. Within a few days warmer weather will return.

Montana

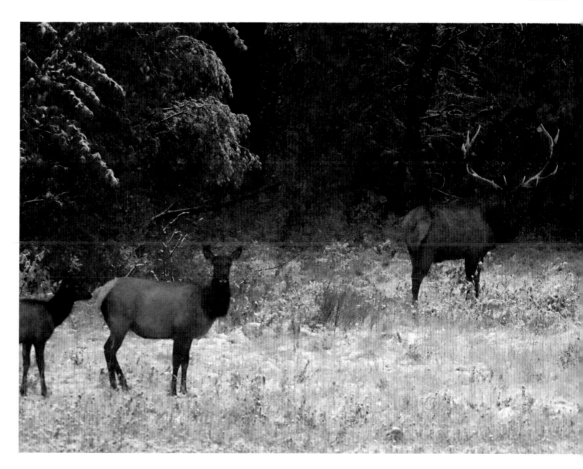

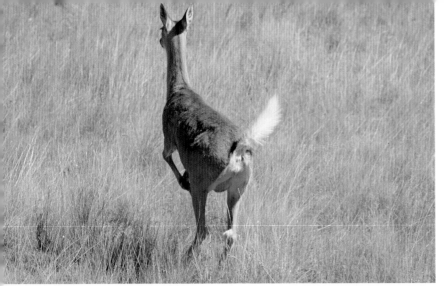

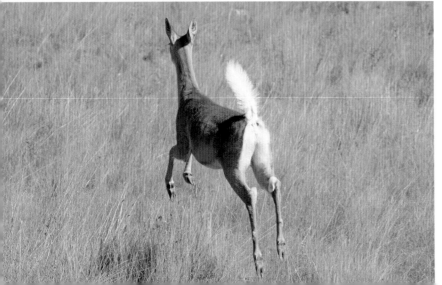

September 30

When fleeing a predator, white-tailed deer run down hill, leaping over obstacles and seeking the cover of bush or water. Whitetails will often take to water to escape a predator. This is an effective strategy except in the winter, when it backfires on the deer. The deer's hooves are unable to get a grip on the ice and the animal slips and slides. Wolves' paws are able to get good traction on ice and making the kill is relatively easy. *Montana*

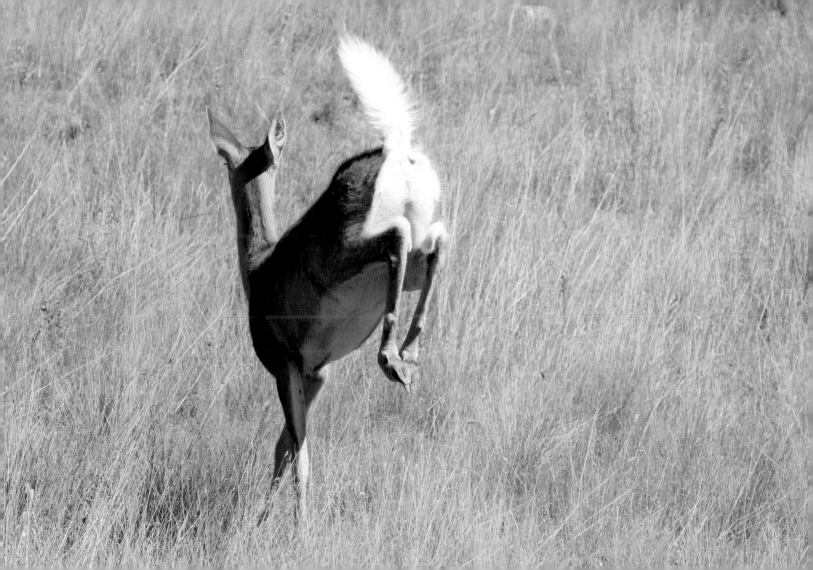

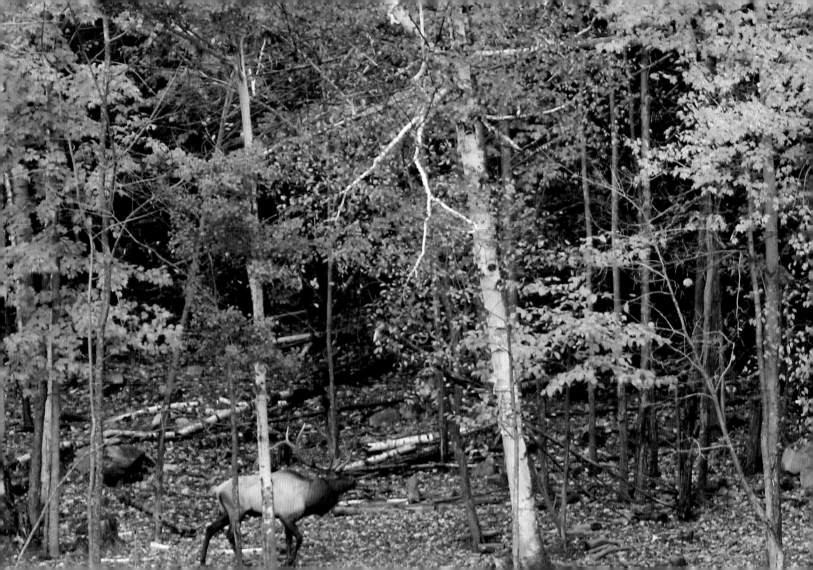

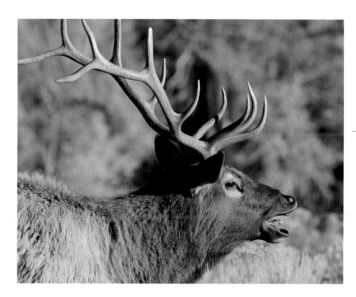

October 1

Fall colors in the northeast are more varied than those of the west due to the greater variety of deciduous trees. It seems odd to see elk wandering in this fall splendor but four hundred years ago elk had expanded their range well east of the Mississippi River to grassy meadows in the eastern forests. *Quebec*

October 2

Young bull elk will hang around the edge of a breeding bull's harem in the hopes of stealing a brief mating opportunity while the herd bull is otherwise occupied. Elk callers imitate the high-pitched calls of these young bulls. Mature bulls will respond to such calls in order to chase off these interlopers. *Ontario*

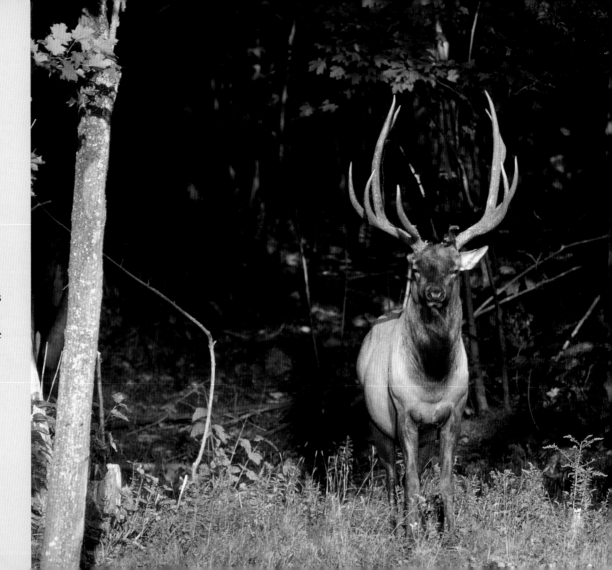

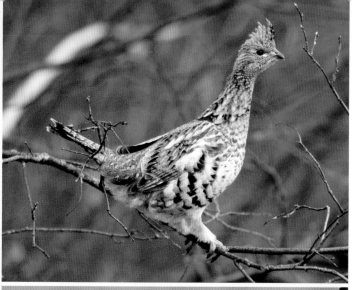

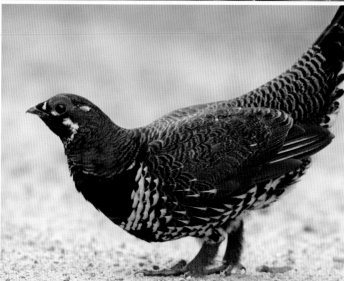

October 3

Both ruffed grouse and spruce grouse inhabit Raiding Mountain National Park's forests, but their ranges seldom overlap. The spruce grouse is found in the boreal forest region of the park. The ruffed grouse (which is close to its northern limit) prefers young aspen forests and oak forests. Ruffed grouse are found in all Canadian provinces and 34 of the 49 continental states. Spruce grouse are absent from all but the most northern states but are found across Canada.

Manitoba

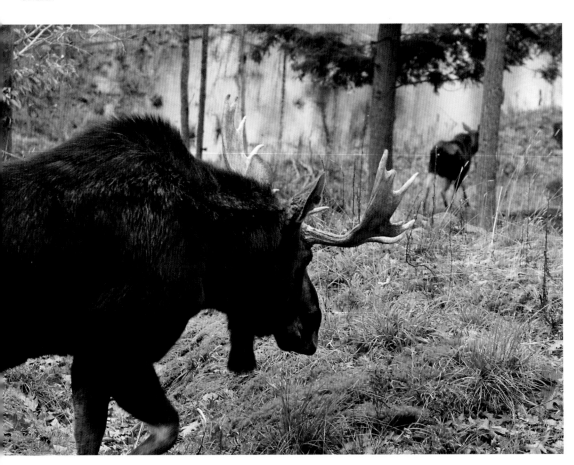

October 4

The presence of a rutting male seems to stimulate the female to ovulate. This is especially important for moose, which more than other members of the deer tribe, have greater difficulty finding each other. Territories are often so large and so wooded that a cow that ovulates when no bull is present just wastes her egg. *Quebec*

October 5

Cow moose have many strategies for finding a mate. They are very vocal, especially in the evening and near dawn, and they will also wander a lot. A courting bull has chased off this calf but it will soon return to its mother's side. *Ontario*

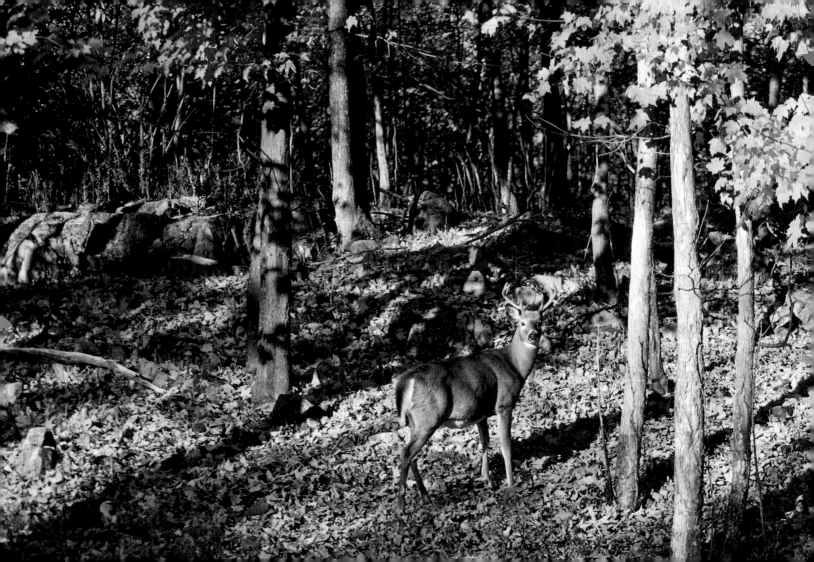

October 6

Both does and bucks snort, a sound that often signals danger. A buck's grunt-snort-wheeze pattern also serves to warn other deer that he is aggressive. Aggression is usually brought on by competition over a resource such as food or a female in estrus.
Quebec

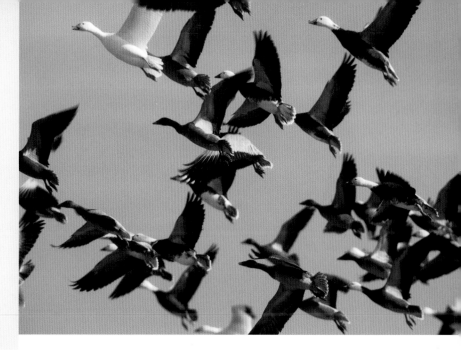

October 7

Snow geese numbers have steadily increased since the early 1900s when they hit an all-time low. Today there are over three million of these geese. They come in two color phases, the all-white snow goose and the darker colored blue goose. Both nest on the tundra. *Manitoba*

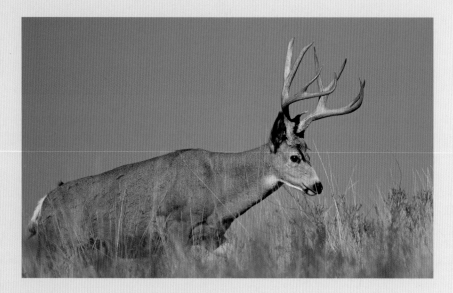

October 8

Mule deer are selective feeders, meaning they do not feed on any one species for very long. In late fall they feed mainly on the year's growth of leaves and stems. As the plants rot they form silage, which is high in sugar content and an important part of the deers' diet. *Montana*

October 9

The Rocky Mountain mule deer (*Odocoileus h. hemionus*) is the largest of the mule deer races. Bucks weigh between 125 and 250 pounds but can be as heavy as 400 pounds. Does average between 100 and 150 pounds. This race feeds on over 800 plant species. One quarter of these are trees, while forbs (non-woody herbaceous plants) make up 60 percent and grasses make up 12 percent. *Montana*

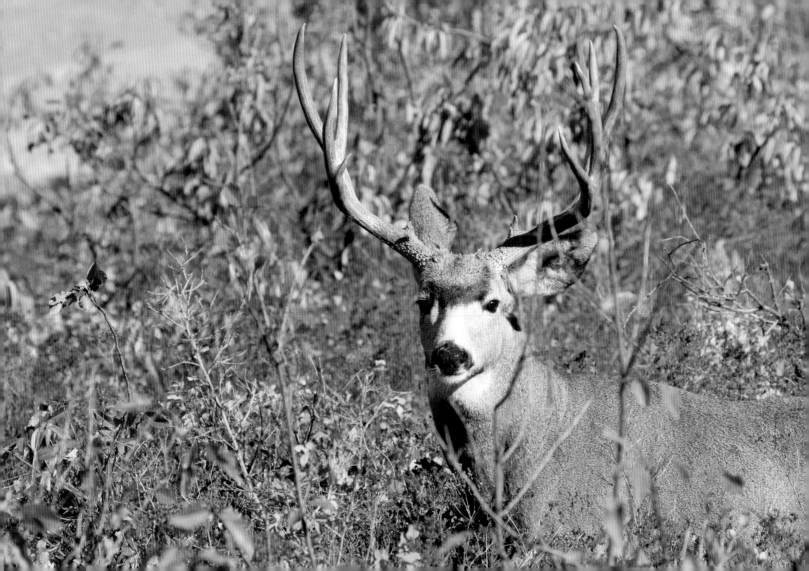

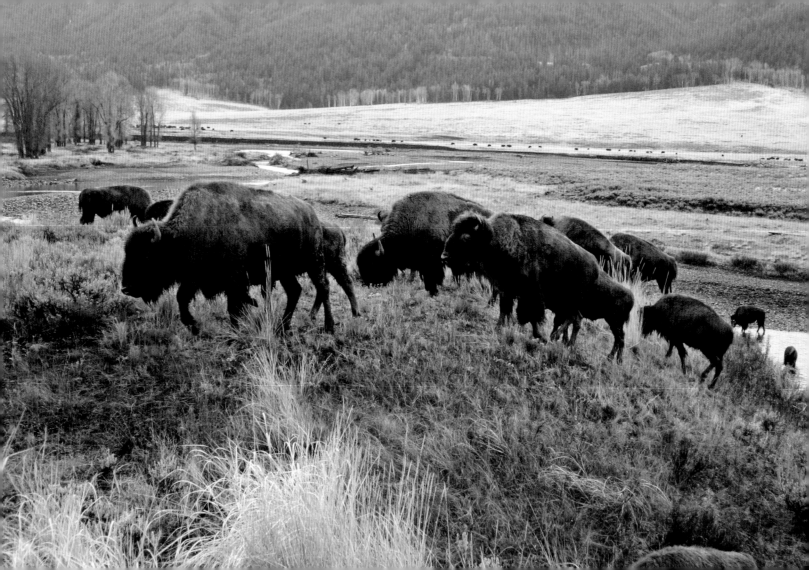

October 10

About 1,200 to 1,500 bison winter in Yellowstone National Park. In 1997 the State of Montana introduced a new bison management plan that was designed to control the spread of brucellosis, a disease that bison carry that could spread to cattle. As a result, the herd was reduced from nearly 4,000 animals to the 1,500 living in the park. A reduction in the number of bison living in Grand Teton National Park is also planned. This program, if implemented, is designed to remove competition between bison and elk during the winter-feeding program. Bison, because they are so much bigger than elk, chase the elk away from the food pellets. *Wyoming*

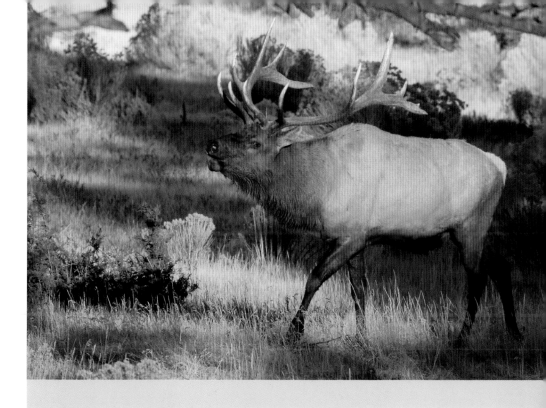

October 11

For moose, the main rutting season is usually over by early October. A second peak follows a few weeks later. The elk's rutting season follows a similar pattern. *Wyoming*

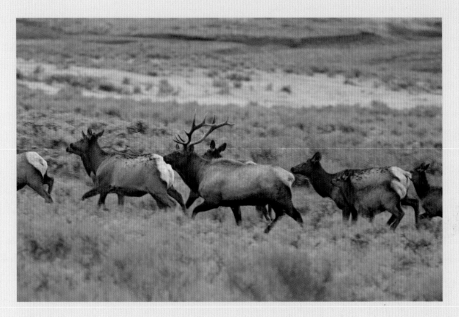

October 12

Elk migrate into Yellowstone's Lamar Valley in the late fall. The valley gets less snowfall than the higher meadows the elk use during the summer. The valley is home to two or three of the park's largest wolf packs and several grizzlies. Elk here seemed to me to be very nervous. *Wyoming*

October 13

The pre-rut stage begins with older bulls bugling, sometimes as early as mid-August. By the first week in September younger bulls have begun and a few cows may come into heat as well. The first breeding peak, when most cows are bred, follows within a few weeks. Generally by mid-September most herds are well into the rut. Bulls are extremely aggressive and some will die or sustain serious injuries in their ritual battles. *Wyoming*

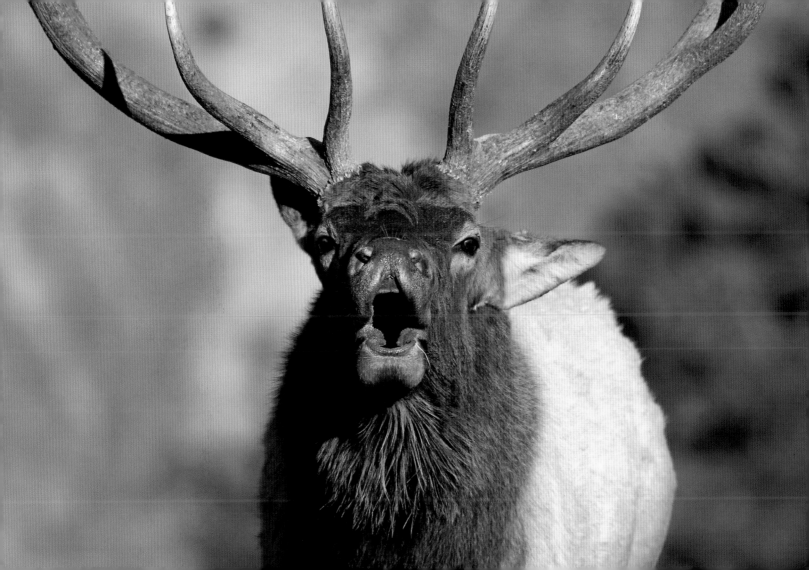

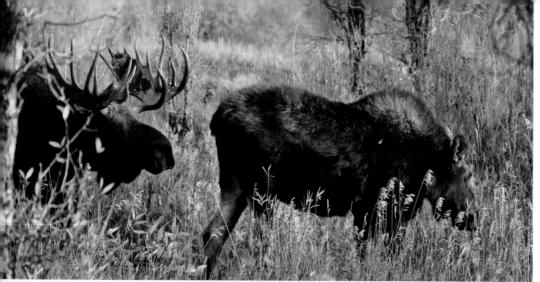

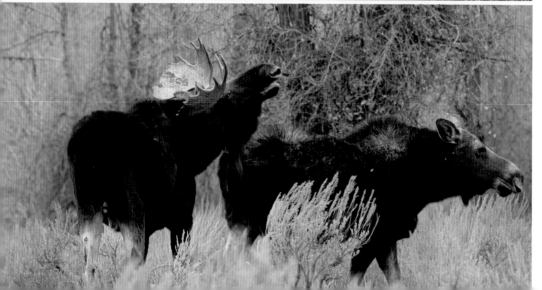

October 14

A bull moose may court a cow for several days. He will sniff her vulva and investigate her urine. He "tastes" the scent using a sensitive part of his mouth known as the Jacobsen's Organ. If she is in estrus, he will perform a flehem. Among many mammal species, the flehem serves to confirm the female of the species is in heat. Domestic and wild cattle do it, and all members of the deer tribe do it, as do wild sheep. I have even seen lions do it. In all cases, the male stands very still and frequently the female will wander off. Other males often are made aware of her condition by the displaying male's action, which sometimes leads to his losing the female. *Wyoming*

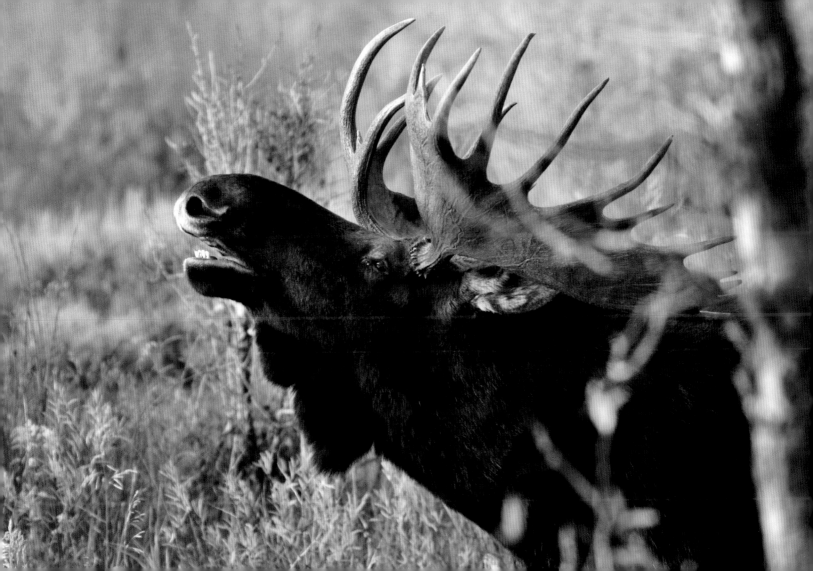

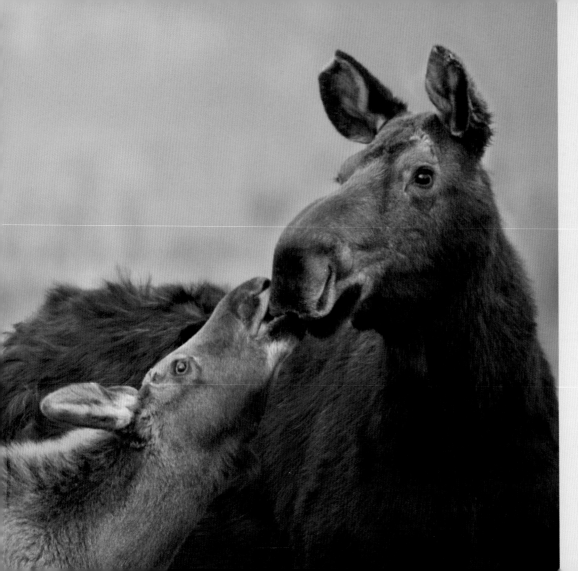

October 15

Cow moose can easily be distinguished from a bull by the more uniform color of their faces. Bulls tend to have much darker noses. Calves can be distinguished from cows by their smaller size. *Wyoming*

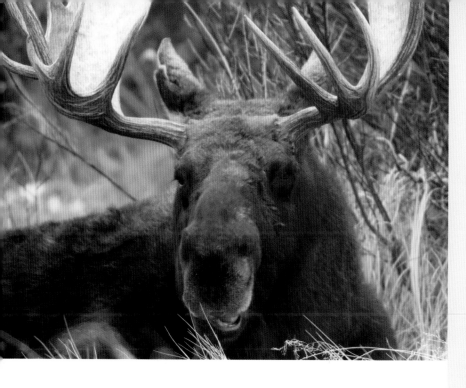

October 17

Moose have a varied approach to mating. This bull has a harem of cows. They chose him over the other three bulls that were seeking their attention because he was the largest male in the area. In fact, there were three other bulls hanging around the herd. Had this been a month earlier, the bull would have been much more aggressive toward the other bulls (and this photographer). It is likely that all of the cows are now successfully mated. *Wyoming*

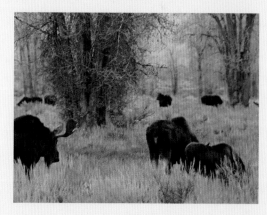

October 16

A healthy moose (bull or cow) is usually capable of standing off a pack of wolves. A moose that runs is often inviting trouble. This bull was very relaxed and confident in his ability to defend himself. He was the largest bull that I saw in the Grand Tetons. *Wyoming*

October 18

As winter approaches the deer's reddish coat begins to turn a gray-blue color. This new coat has guard hairs to help insulate the animal against cold and moisture.
Montana

October 19

As the evening approaches, whitetails will leave the shelter of the forest to feed in farmers' fields. Three fawns follow this doe. They may all be hers but it is just as possible that the offspring of another doe (likely related to the lead doe) has joined up with its peers to socialize. *Quebec*

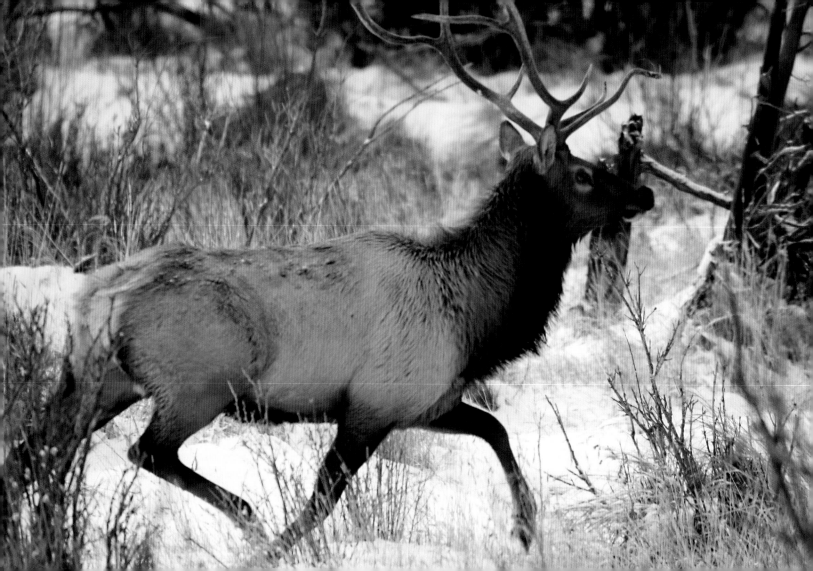

October 20

A second period of rest will follow; by now the vast majority of cows are pregnant. A third breeding peak will follow but it is much less intense than the past two. Many bulls have lost interest and have wandered off to feed and restore their conditioning for the rigors of winter.
Colorado

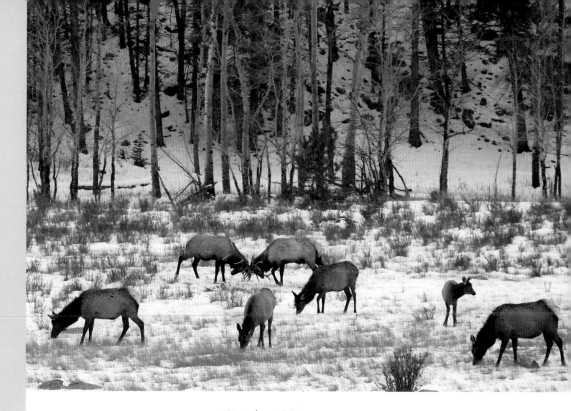

October 21

After the first peak in breeding activity there is a lull. Many of the females have been bred but there are always a few left unserviced. They will come back into estrus in a few weeks. Bulls are exhausted as well and need to feed and rest. *Colorado*

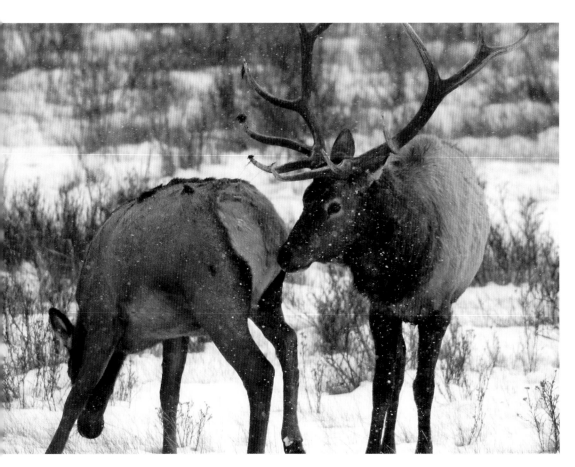

October 22

About three to four weeks after the first breeding peak, the unbred cows are in heat again. The big bulls are not nearly as aggressive and will even tolerate younger bulls hanging about on the fringe. Some of the younger bulls may even be lucky enough to succeed in mating.

Colorado

October 23

These two bulls are sparring, but it is a half-hearted battle. There is even a sense of play to their contest, the smaller bull backing away and then coming back for more pushing and shoving. *Colorado*

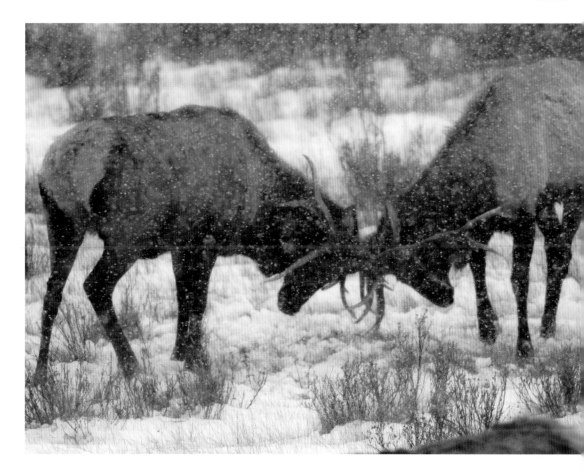

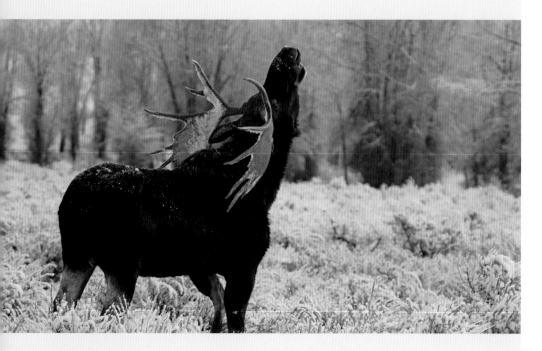

October 24

The flehem, or lip curl, is done when the bull senses a cow's urine contains the right signals indicating that she is ready to breed. This bull is obviously enraptured but the cow in question has wandered off. As it as late in the season, other bulls in the area paid him no attention. *Wyoming*

October 25

The Jacobsen's organ or vomeronsal organ is found in the upper palate of several animals including humans. It is important in conveying information about the condition of one animal to another, especially among ungulates during their rut. The sensory neurons pick up subtle chemical clues (pheromones) and relay that information to the brain. The nose is also used to pick up signals, but it is not as sensitive to the reproductive pheromones. *Wyoming*

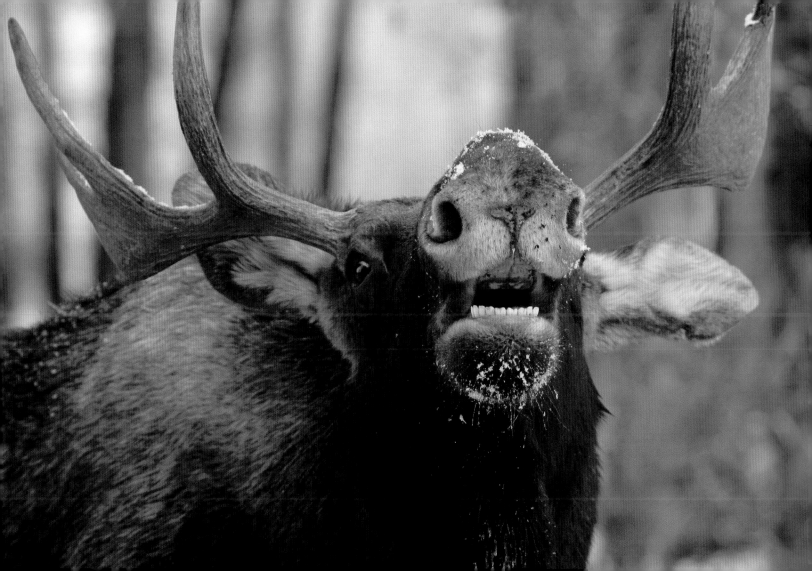

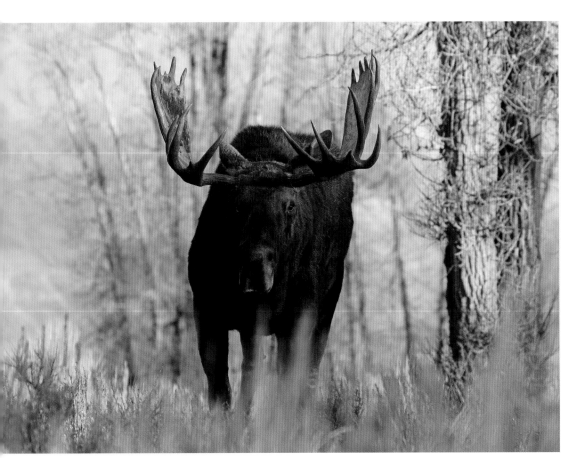

October 26

Moose/car collisions are brutal to see. The moose's long legs often mean that when hit squarely the moose's body will either land on the roof or come through the windshield. My advice is to drive the speed limit in moose country. Another piece of advice is to never assume that a moose will turn one way or another. Moose have a disturbing knack of doing the opposite of what you think they will do.

Wyoming

October 27

Mule deer will make seasonal migrations in areas of high snowfall. They spend summer at higher elevations following the green-up as it advances with the warming temperatures. Winter is spent at low elevation in areas where snowfall is low or blown off the hills.

Colorado

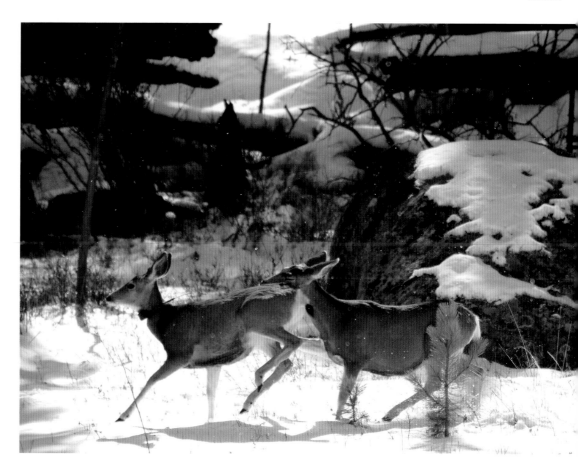

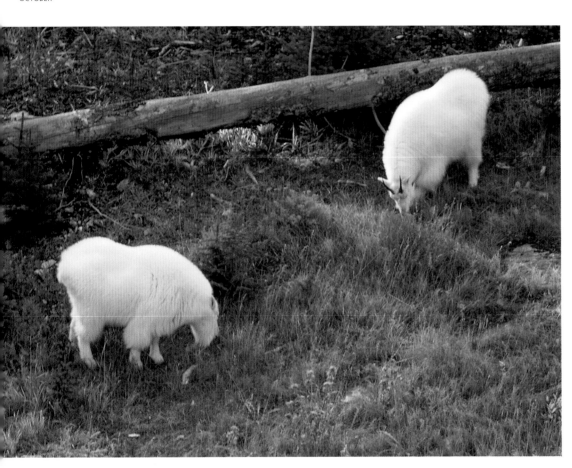

October 28

Mountain goats occupy the heights of mountains year round. They are well adapted to survive in this harsh environment. Unlike the deer family, mountain goats are the only member of their genus. A mountain goat has no other surviving member of its group.

Alberta

October 29

Woodland caribou are one of the least seen mammals of Jasper National Park. There are between 200 and 350 animals living in two herds in the park. The caribou live in subalpine regions of the park in areas where they also have access to alpine tundra. The herd's numbers are controlled by the amount of slow-growing lichen available, predation and climate change. *Alberta*

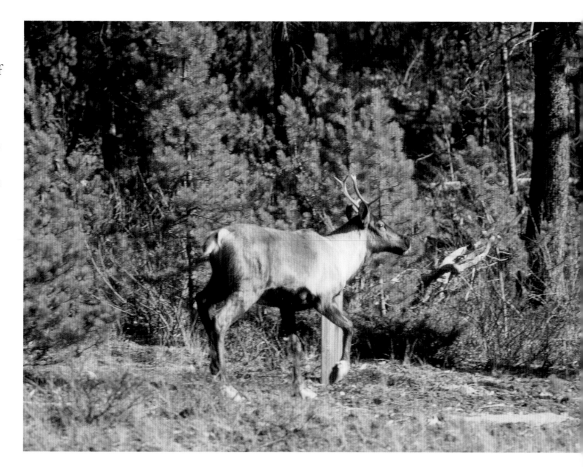

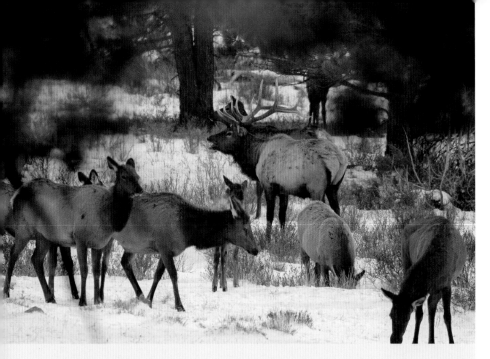

October 30

The first snows of the season present little to no challenge for the elk herd. They can easily get at the grass by simply pushing the snow aside with their hooves or nose.
Colorado

October 31

It is little wonder that an insurance company would look to elk as a symbol. The elk is a regal animal and it is inspiring both in its appearance and in the country it resides in. Elk, however, are not easily domesticated or even trained. The "elk" in the ads and television commercials is actually a European red deer. Red deer are ancestral to elk and do look a lot like them, but their antlers are less symmetrical and sometimes have some show some palmation. *Alberta*

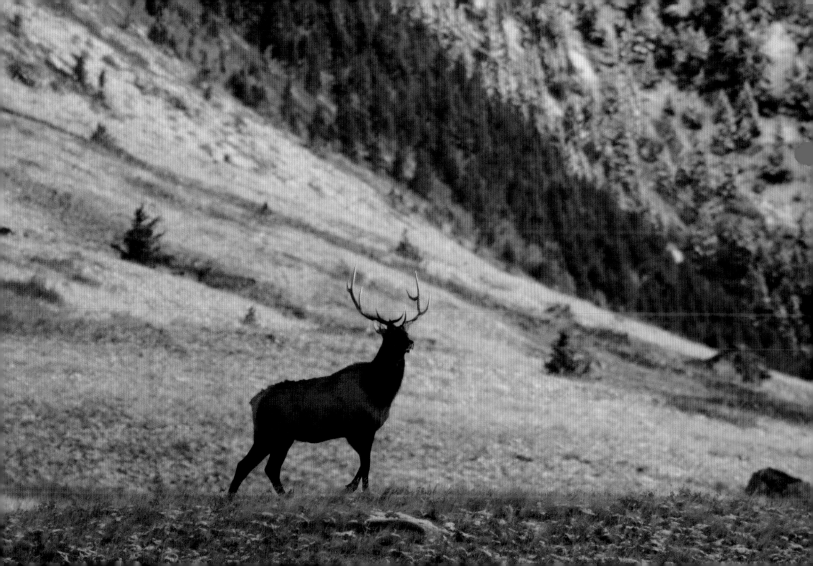

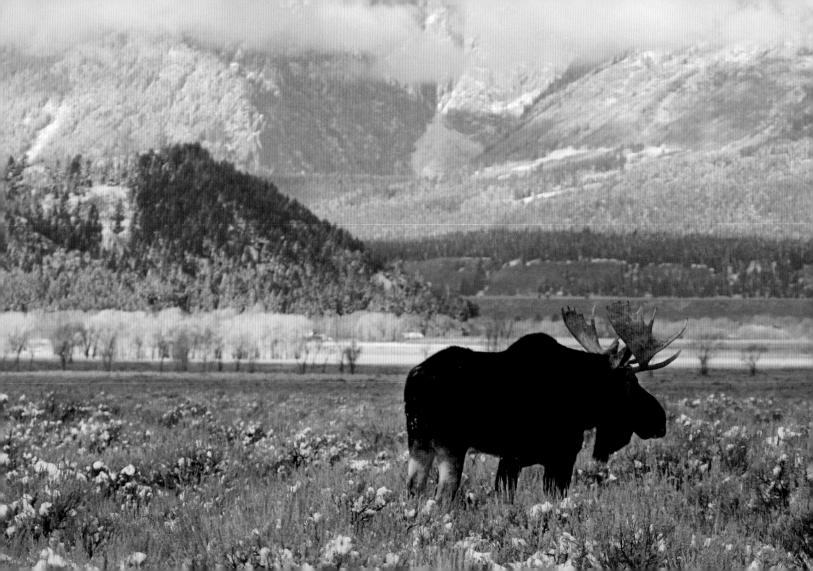

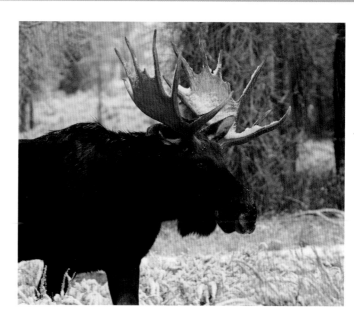

November 1

When on the move, moose avoid open terrain. They prefer a landscape where there are lots of obstacles to slow down predators. In the Grand Tetons, where wolves are not yet well established, moose will make use of the sagebrush flats.

Wyoming

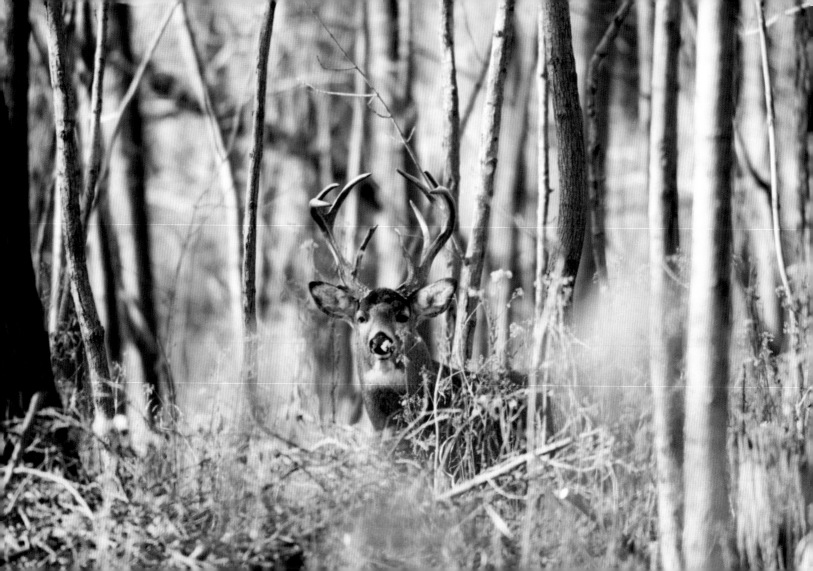

November 2

This is another example of a high-horned buck whitetail. Note the thick neck. The neck thickens as the rut approaches to put on necessary muscle mass for the battles to come and also protect the animal from injury. *Ontario*

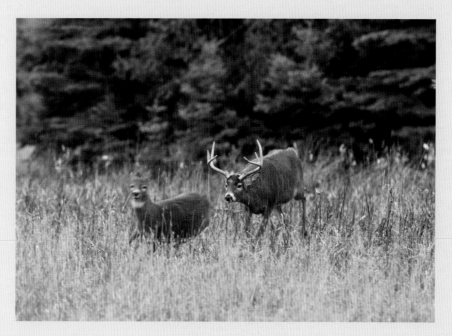

November 3

A doe remains in heat for about twenty-four hours. If mating does not occur in that brief window of opportunity, it will be another month before she is able to successfully breed. Most breed in their first period of estrus. *Ontario*

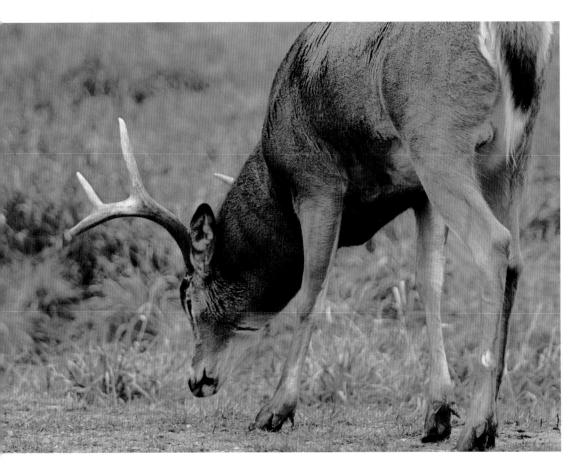

November 4

White-tailed bucks follow the scent trails laid down by does. Deer have tarsal glands on the lower side of each hind leg that deposit a scent as they walk. A doe in estrus also urinates more frequently and her urine contains hormones and pheromones which convey her condition. *Quebec*

November 5

Mature bucks (two years old and older) form small groups of two to six unrelated males during the spring, summer and winter. During the fall, these groups break up and most bucks travel alone as the rut reaches its peak. Congregations of estrus does will draw bucks together, sometimes resulting in battles. *Ontario*

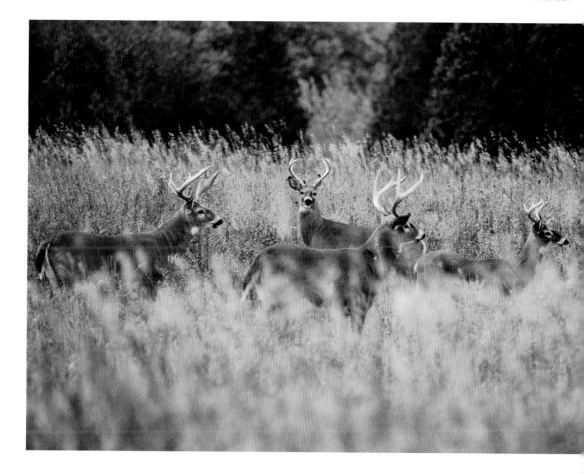

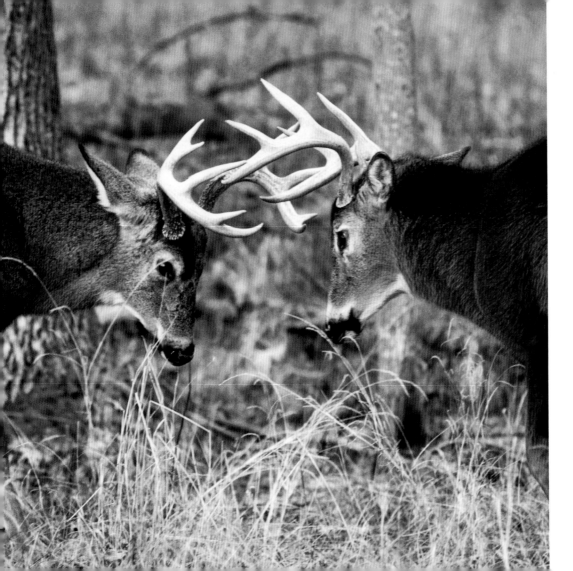

November 6

The white-tailed deer rut, like that of other members of the deer tribe, has several phases. The rut begins in late August with the rubbing off of the velvet covering. Bucks will begin sparring and scent-marking then. At that time the bucks are still in all-male groups. Courtship begins a month to a month and a half later when the bucks start to actively follow the does. *Ontario*

November 7

A buck begins by trailing a doe some distance away with his nose close to the ground. As he approaches and closes in he will approach her with his neck extended and his head down. *Ontario*

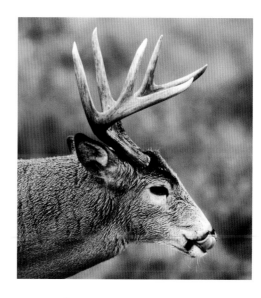

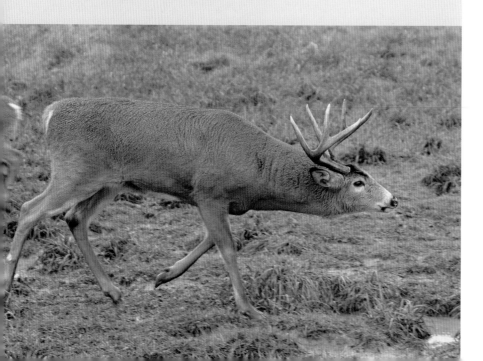

November 8

The buck will continually lick "the air." This brings telltale scents to his Jacobsen's organ in the roof of his mouth. He will also stop to investigate any does' urine to ascertain her breeding condition. He will perform a flehem if he senses the right chemical mixture. *Ontario*

November 9

There is a hibernation order that both grizzlies and black bears follow. Pregnant sows and sows with yearlings enter their denning areas first. Smaller bears (single females, young males and females) are next. Last are the adult males. The bears sense when the snowfall will be sufficient to hide their dens. Dens can be dug out, they can be under tree roots or even in caves. Southern bears will even den in tree cavities several feet above the ground. *Alberta*

November 10

Male polar bears do not den. They hunt seals all winter. There are reports that some of Yellowstone's male grizzlies may not be hibernating or are hibernating for only short periods of time. Speculation is that these males, like male polar bears, may be getting enough meat to stay active all winter long. It appears the grizzly boars are robbing the wolves of their kills. *Wyoming - Manitoba (right)*

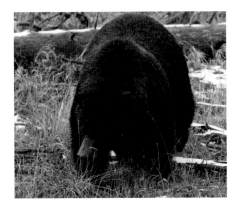

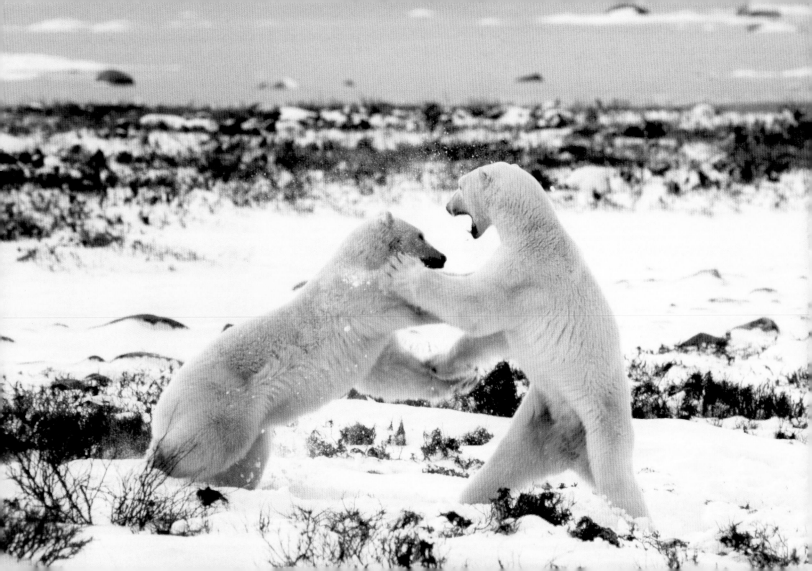

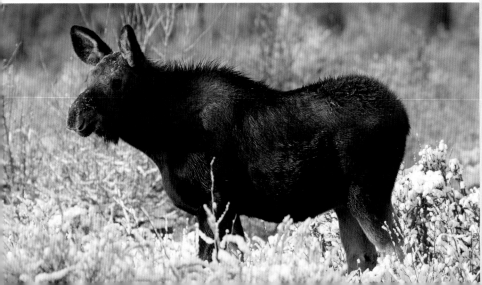

November 11

Calves will stay with their mothers through the winter months. Come spring they are large enough to confront most predators. The distance between cow and calf slowly increases, but until the spring calving season the calf will run to mother for protection. *Wyoming*

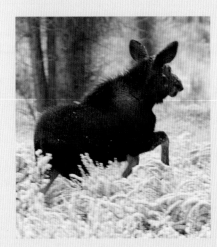

November 12

Moose depend on fat stored during the summer and fall to get them through the winter. A cow without sufficient fat will abort her fetuses. A bull without sufficient fat reserves may be too lean after the rut to survive the winter. *Wyoming*

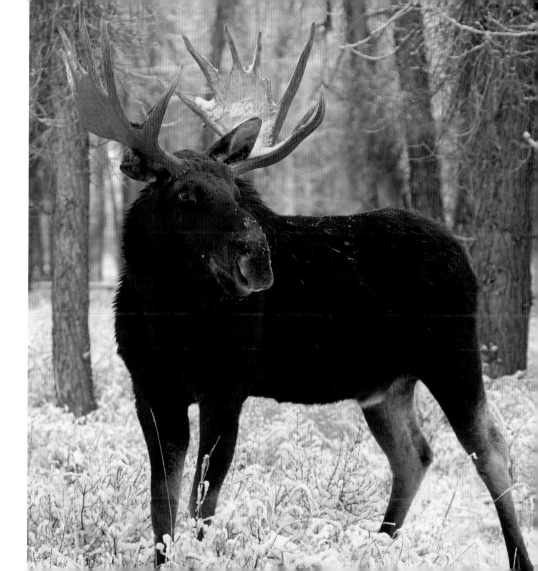

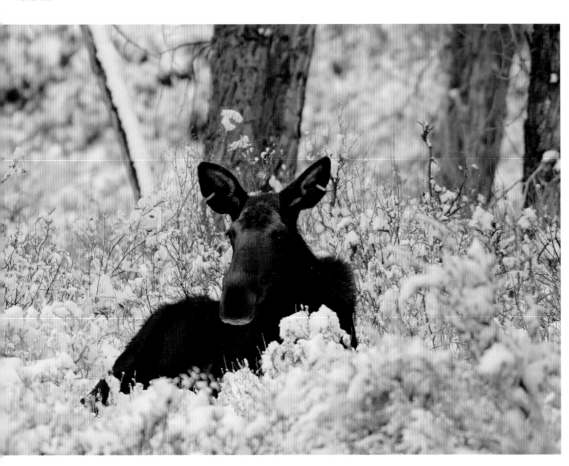

November 13

Note the ear tags this cow moose is wearing. Ongoing wildlife research is greatly adding to our understanding of the needs of native wildlife. *Wyoming*

November 14

Moose bed down to ruminate during most of the day. They are active near dawn and dusk. They may seem like large animals when you are facing one head on, but they are skilful at disappearing into the brush when they want to be. *Wyoming*

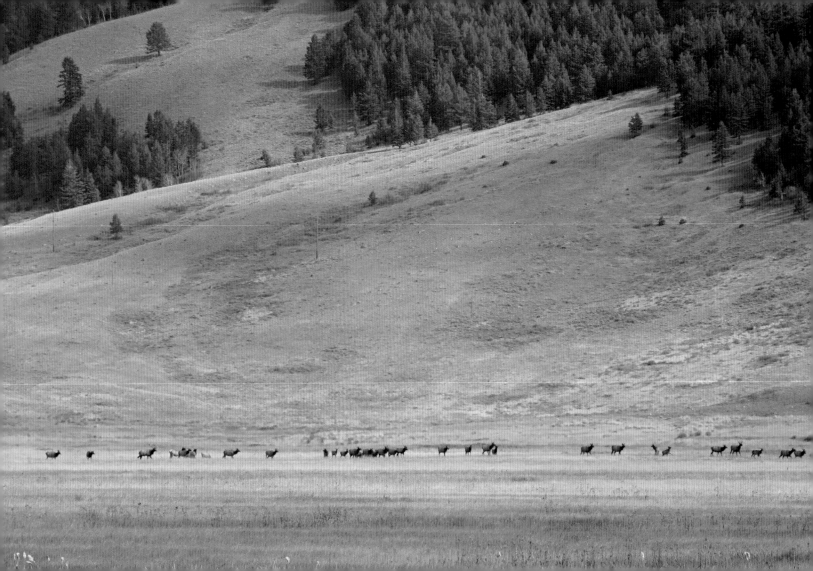

November 15

The elk begin to arrive in Jackson Hole, Wyoming, around the end of September. Gradually the herds continue to grow until some 14,000 elk will be present. The National Elk Refuge will feed about 7,000 of these animals. In recent years the number of bison sharing the refuge has grown from 18 animals to over 1,200. In 2007 a bison hunt was begun to thin the herd. Bison were so numerous they were preventing the elk from accessing the food pellets and hay set out for them in the winter. The aim is to reduce the bison herd to 700 animals. *Colorado*

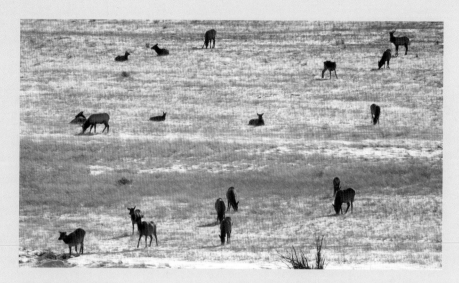

November 16

Feeding programs are coming under increasing pressure. Many states and provinces have banned such programs because they artificially maintain a population of animals at too high a level. Even Wyoming, which in Jackson Hole has one of the most successful feeding programs, bans feeding everywhere but in the northwestern portion of the state. This elk herd is found in Rocky Mountain National Park, Colorado, where there is no elk feeding. That state feeds wildlife when snow conditions are exceptionally bad. *Colorado*

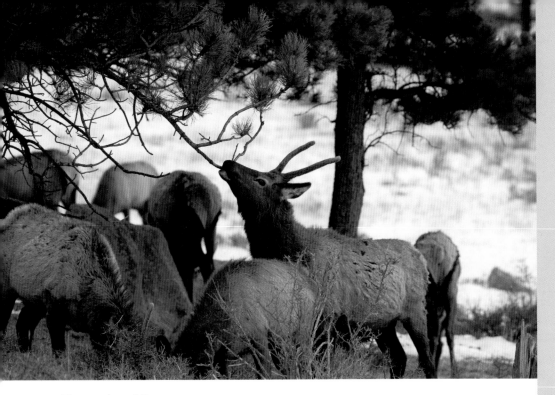

November 17

This young bull just tastes the twig of this ponderosa pine tree. It is not an elk's preferred food. There is still plenty of grazing to be had and he will soon join the other members of his herd in this pursuit. *Colorado*

November 18

The trees lining this meadow are aspens. In Yellowstone's Lamar Valley scientists have discovered and interesting relationship between elk, aspens and wolves. This picture was taken in Rocky Mountain National Park, Colorado, where there are no wolves. There are also very few aspen seedlings. Elk eat the seedlings. But in the Lamar Valley, danger from wolves has kept the elk out of areas where the seedlings grow. The aspen population is increasing. *Colorado*

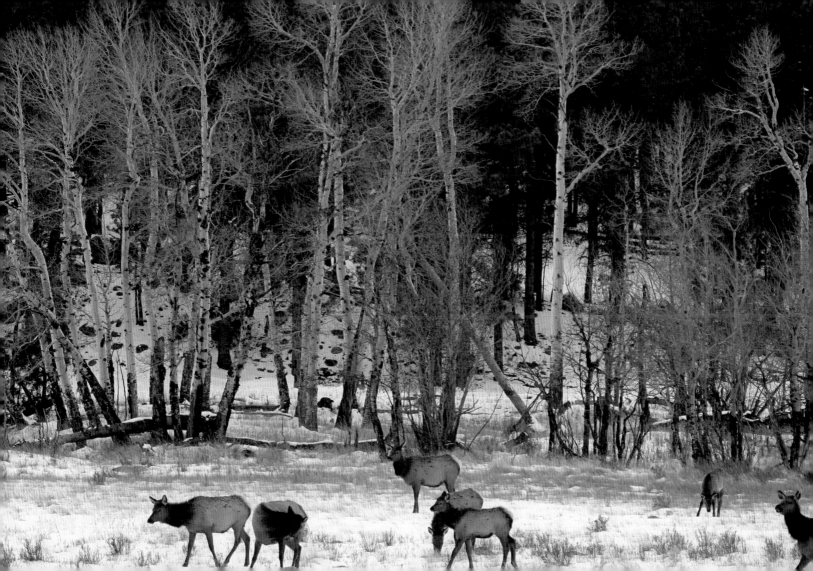

November 19

In 1910 the U.S. Forest Service estimated that there were as few as 500 to 1,000 elk left in Colorado. Market hunters decimated this once plentiful species. Reintroductions from 1912 to 1928 of elk from Yellowstone started the species recovery. Thanks to good management, the elk herd now numbers over 250,000. *Colorado*

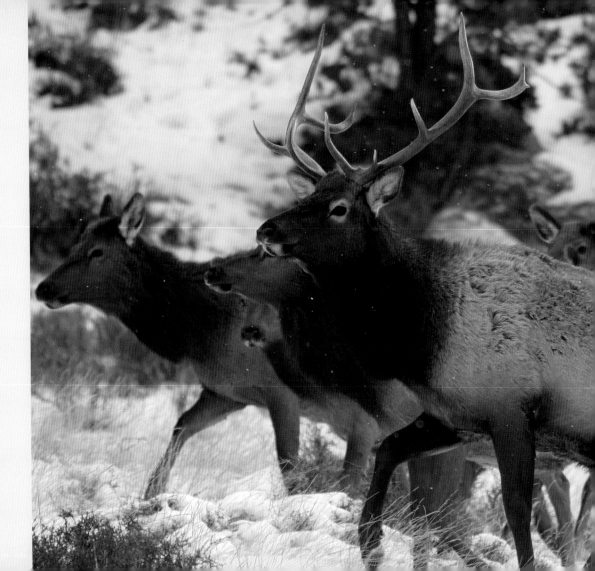

November 20

Like mule deer, elk will stott. This cow is doing it for no particular reason I could see. The rest of the herd was peacefully feeding when she just went on this wild careening run. I suspect she did just for fun, although we don't usually attribute such a motivation to elk. None of the elk took any notice of her and she soon stopped and went back to feeding. *Colorado*

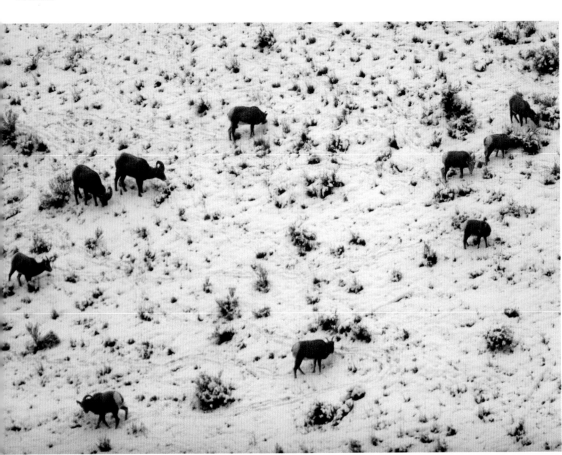

November 21

It was minus 20 degrees when I photographed these sheep feeding on a wind-blown slope in the foothills of Alberta's Rockies. It doesn't matter if that is in Fahrenheit or Celsius. The reading is the same. The sheep didn't seem to mind, but I found it doggone cold. *Alberta*

November 22

Bighorn sheep handle the cold very well. For young lambs, however, a combination of early spring rains and cold temperatures can lead to hypothermia and death. Some populations have declined in recent years due to unseasonably wet weather. *Alberta*

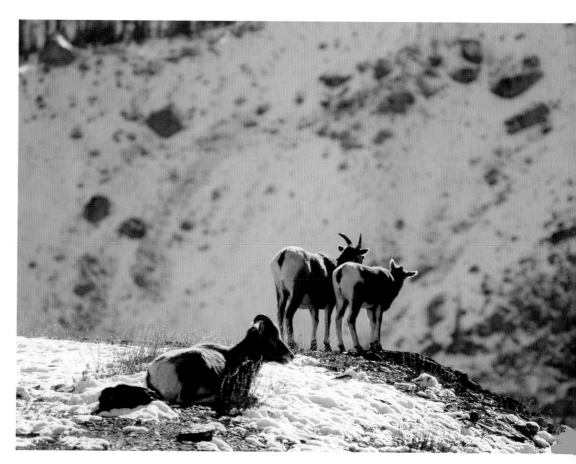

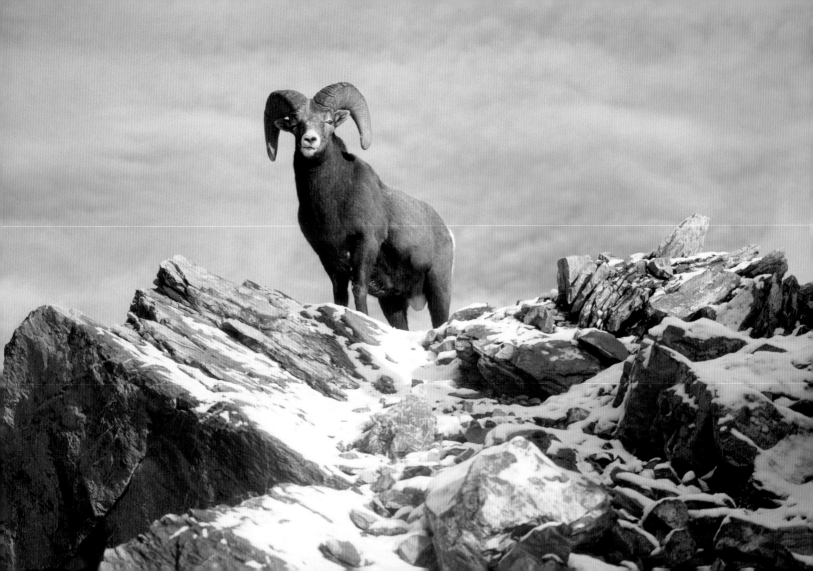

November 23

Some animals just know how to pose and look regal. Bull elk, mule deer bucks and bighorn rams seem to have the posture down pat. Bighorns do not like the sheer vertical cliffs that mountain goats do, but they do like rocky country with steep sides. They rely on their eyesight to spot predators, and then they use their steep rocky environment to their advantage. *Alberta*

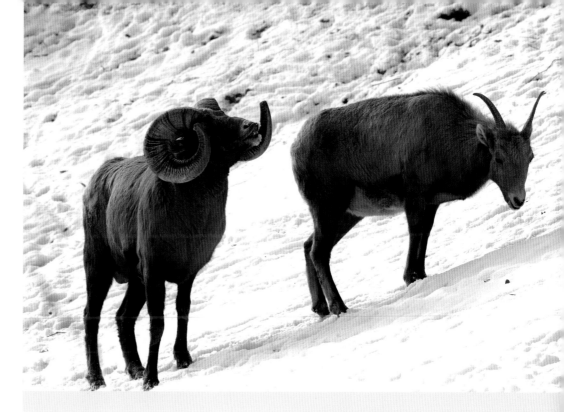

November 24

Bighorn rams also perform a flehem. Their rutting season is one of the latest of North America's ungulates. The rams begin to seek out the ewes in mid to late November. *Alberta*

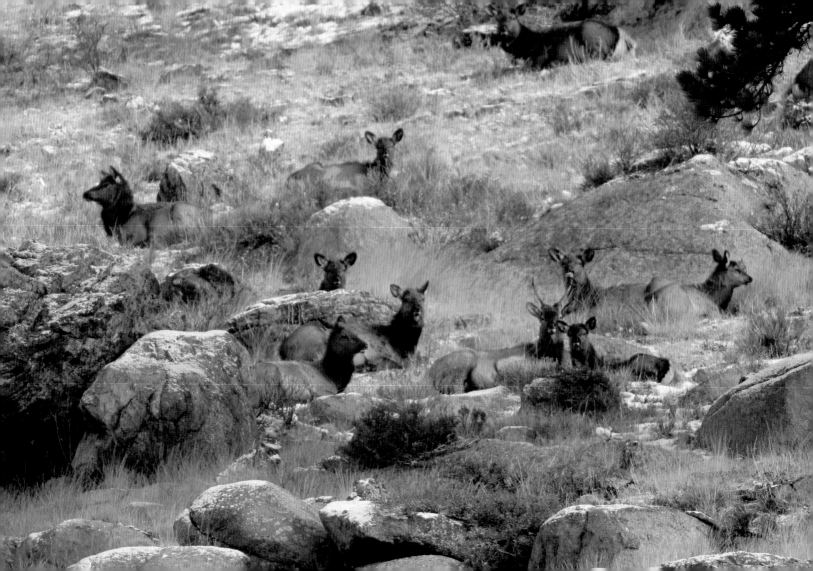

November 25

Elk, like all animals, play several roles in their ecosystem. They are herbivores that compete with other elk and with other herbivores. They are prey for some predators and food for scavengers. Their waste enriches the soil for plants but they also feed on plants. They modify their environment. They carry plant seeds in their droppings and help establish new growth. They inhibit the growth of some plants. *Colorado*

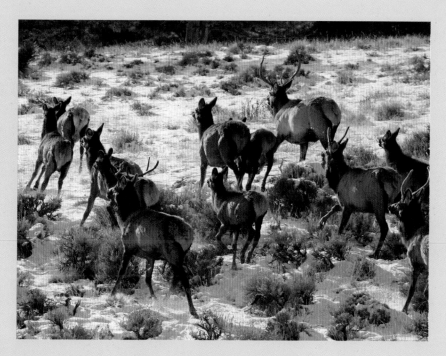

November 26

The distance elk migrate to and from their wintering areas varies with their location. It can be as little as a few miles up to 70 miles (117 km) in extreme cases. *Colorado*

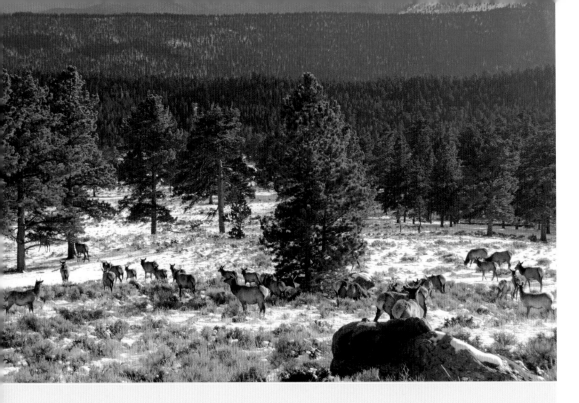

November 28

Like moose, elk and caribou, white-tailed bucks also perform a flehem after investigating the urine of a doe. Female deer typically will urinate when they stand after resting. Males will "coax" a female to stand by making a low-level aggressive move toward her as if they want to lie down in her spot. *Ontario*

November 27

Elk inhabit a wide range of ecosystems. They are found in the temperate rainforests of the west coast, the non-forested valleys of California, the dry forests and chaparral of the southwest, mixed forests of the east, the prairie grasslands and the Rocky Mountains. *Colorado*

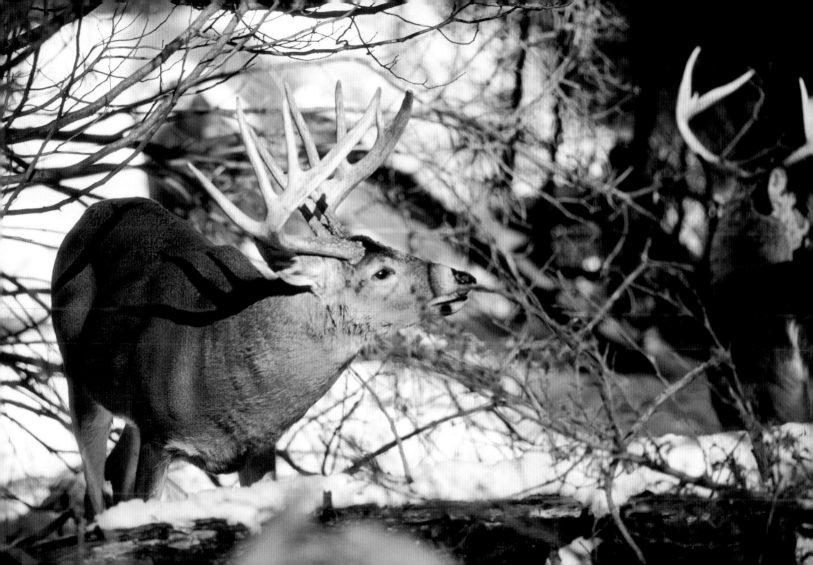

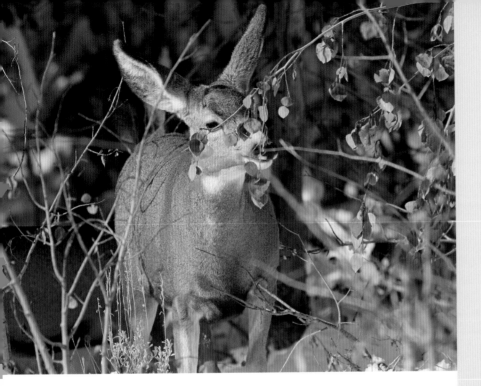

November 30

With the settling of the west, traditional migration routes of wildlife have been often altered or closed off entirely. A new trend in wildlife management is to establish wildlife corridors to facilitate animal movements. Over- and under-passes help them navigate roadways. Ranchers and farmers are encouraged to leave forested or brushy areas alone. Animals that have benefited most from these efforts include grizzlies, black bears, pronghorns and elk. Mule deer and many other species reap the benefits from efforts to help these other animals. *Colorado*

November 29

In many parts of their range, mule deer fawns, does and immature bucks are much easier to see than are the really big bucks. The big bucks live separate from these deer for most of the year. This is a fawn of the year and it was quite relaxed while I photographed it. *Wyoming*

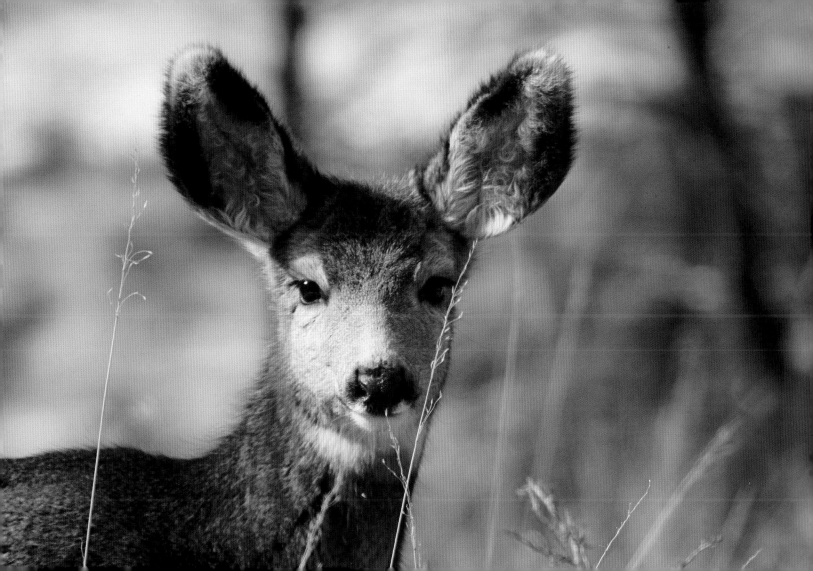

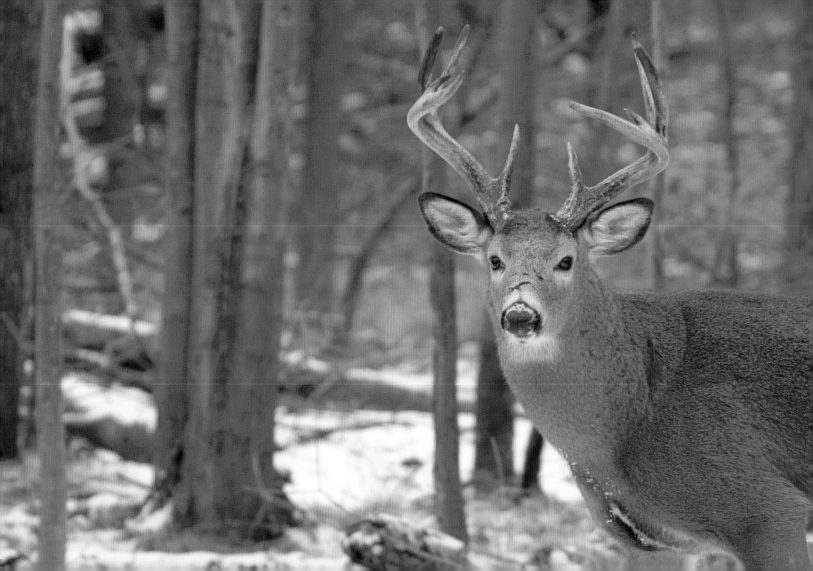

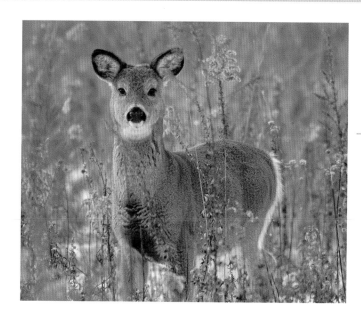

December 1

Whitetails communicate in a variety of ways including sounds, scent, and visual marking such as scrapes and rubbed trees. Whitetail deer also communicate by making noise: Fawns bleat. Does recognize and respond to their own calves' calls. Does also bleat as well as grunt. *New York*

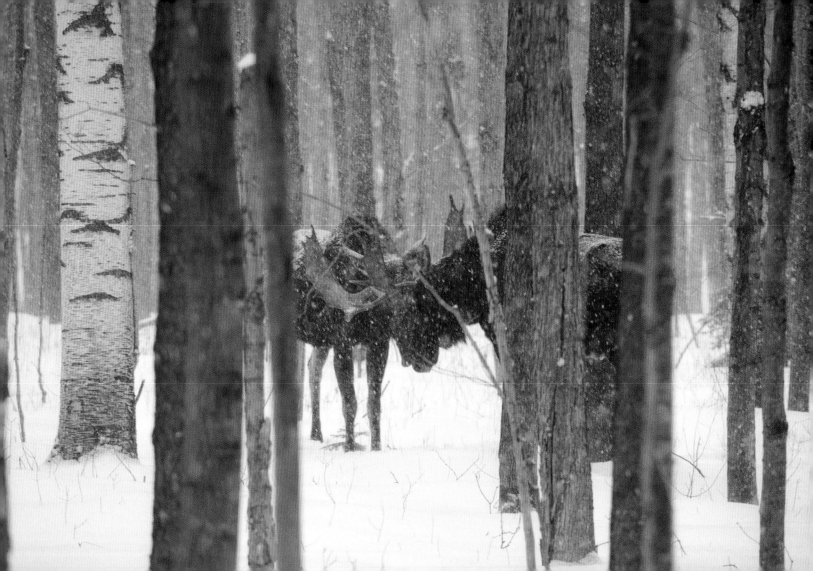

December 2

I have always held moose in high esteem. My Grandpa Jim and my Uncle Jack used to have a fall moose hunt every year, and I can remember day dreaming in school about the adventures they were having. I always looked forward to their return. They got their moose but it was seldom a bull. The one year they brought home a set of trophy antlers was really exciting. I have never hunted moose with a gun, but have enjoyed the many days with them I spent photographing and observing them. They remain a personal favorite.
Ontario

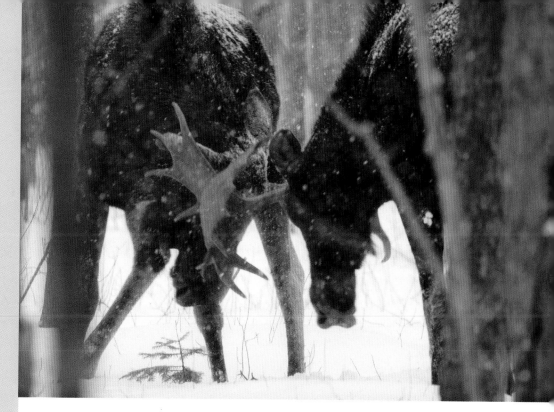

December 3

After the rut, bulls need to replenish fat reserves. They reduce their activity and will seek out the richer feeding sites available to them even if such sites expose them to greater risk of predation. *Ontario*

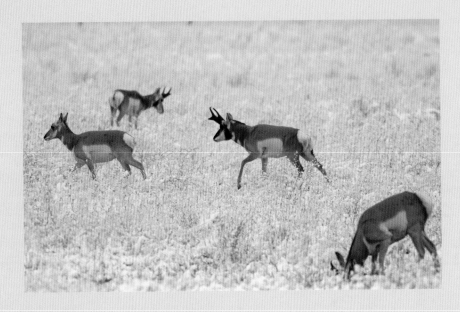

December 4

The pronghorn is the fastest North America mammal, and is capable of speeds up to 60 miles per hour (100 km/h). Until 12,000 years ago there was a predator fast enough: the American cheetah. It became extinct at the end of the last ice age. Once reduced to fewer than 12,000, there are now over a million pronghorns. *Wyoming*

December 5

The caribou rut is over by December, but bulls will still engage in some friendly pushing matches. The bull's antlers give him status in the herd but he will drop them long before the cows drop theirs. Cow caribou are the only female members of the deer family in North America with antlers. Their antlers are much smaller but they do allow the cows to intimidate the antler-less bulls. *Northwest Territories*

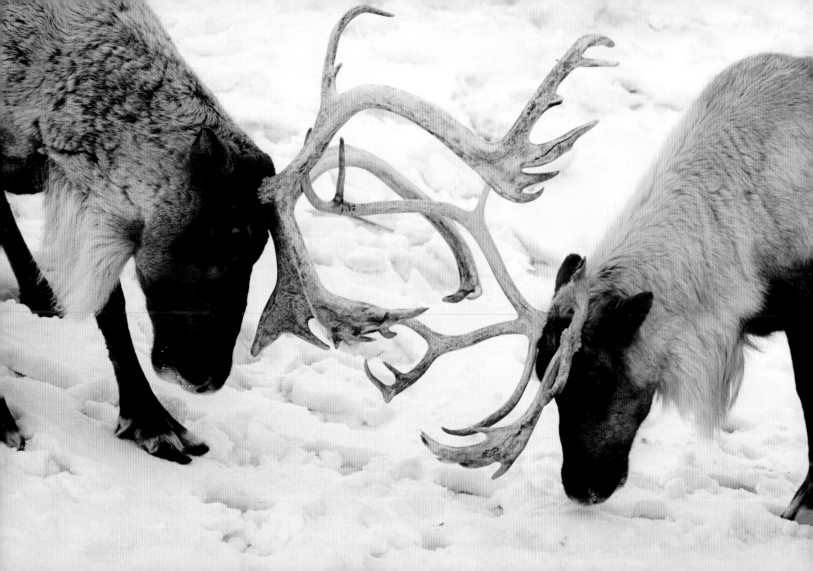

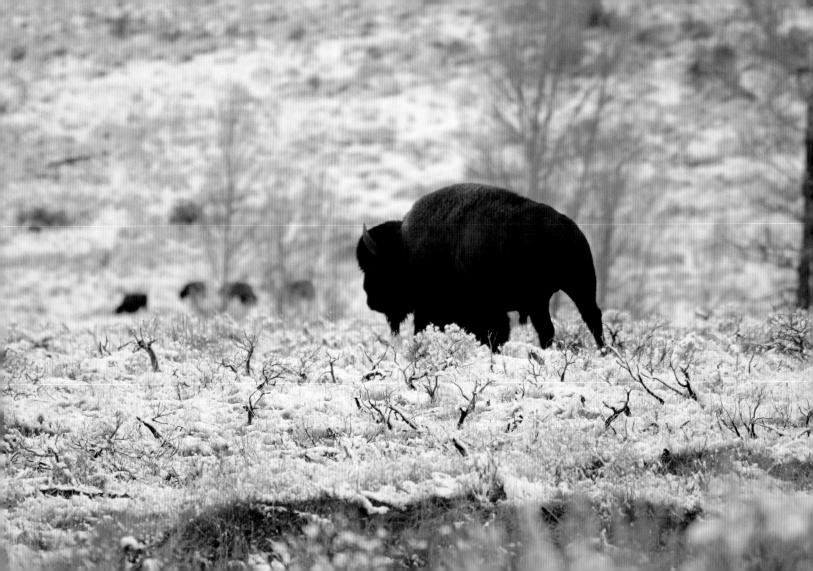

December 6

Bison are one of the newest species to evolve in North America. They have existed as a distinct species for only about 5,000 years. As human hunters spread across North America at the end of the last ice age, the larger long-horned bison disappeared, to be replaced with the smaller version we know today. *Wyoming*

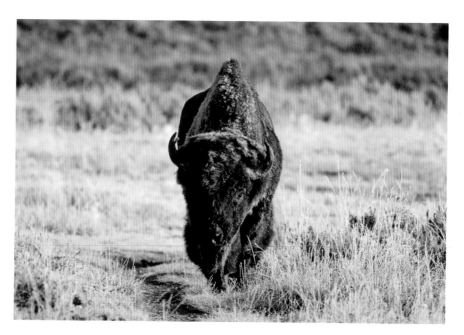

December 7

Bison are wonderfully suited for life on the prairie. Their thick winter coats protect them from winter storms. They use their beards to sweep the snow away to get to their grazing. Bison are much better suited to the Great Plains than domestic cattle are. More and more ranchers are turning to ranching bison. There are now over 250,000 bison living on the prairie. *North Dakota*

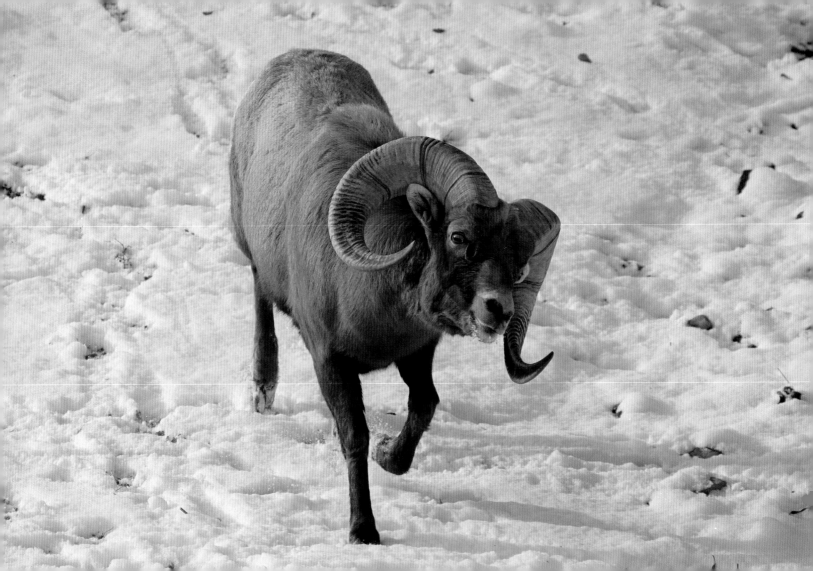

December 9

Rams fight by running at each other and then crashing their horns together. The sound of these crashes can be heard for some distance. Often the rams will stand stunned after a blow but serious damage is averted by suddenly twisting their horns so they meet on the edge. Sheep skulls have cushioning air chambers to lessen the effect of these blows. *Alberta*

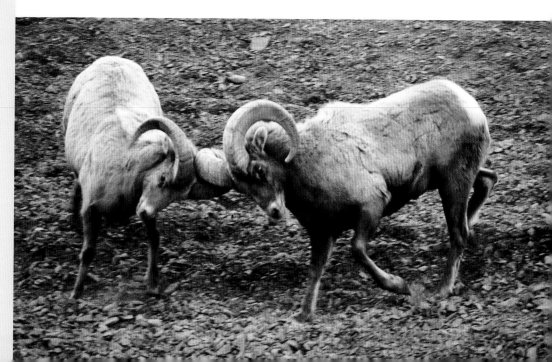

December 8

The outstretched neck and the slightly angled head of this bighorn ram signal his aggression. This behavior was aimed at a resting ewe. She stood up and he then sniffed the ground looking for clues to her condition. *Alberta*

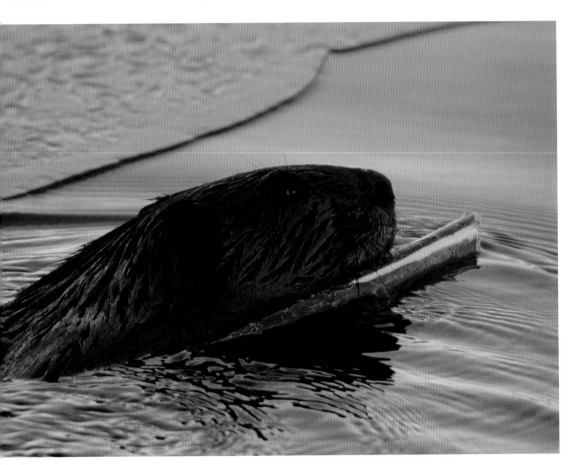

December 10

Beaver were instrumental in the opening of North America. The Hudson's By Company and the Northwest Company explored much of Canada in pursuit of this furbearer. Legendary mountain men of the early 1800s trapped and traded across the American West. Places such as Jackson Hole, Bridger National Forest, the Grand Tetons and Yellowstone National Park all celebrate and immortalize these explorers. Beaver were almost trapped to extinction but have rebounded across their range. *Ontario*

December 11

Many animals turn white when the snow falls. Short-tailed weasels, snowshoe hares, arctic foxes and ptarmigan all manage this feat. Very few animals are white year round. Those that are white live in the high Arctic or on the ice sheets. Polar bears and Peary's caribou (mostly white) are good examples of this. Some arctic foxes remain white all year round. White is good camouflage in the winter, but in the greener southern habitats, white animals are very conspicuous and soon fall prey in the warmer months. *Manitoba*

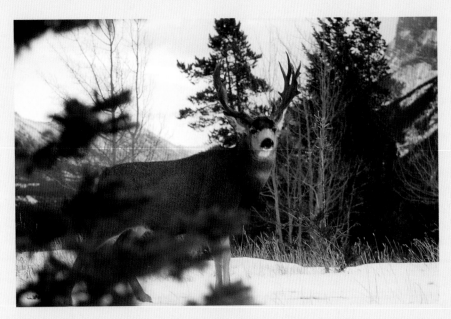

December 13

Mule deer were not common on the plains when wolves and bison were. Where wolves are part of the wildlife community they will prey on mule deer more often than on other species. Mule deer respond to this pressure by keeping to terrain that favors their escape. Where wolves are not a factor, mule deer can often be seen in flatter surroundings. *Alberta*

December 12

For their escape strategy, white-tailed deer rely on having trails that are relatively free of obstacles so that they can run full out. Mule deer are more unpredictable in their routes. They will leave trails in favor of places with blow-downs and other obstacles that will slow a predator. Mule deer may bound two times a second when pursued. *Alberta*

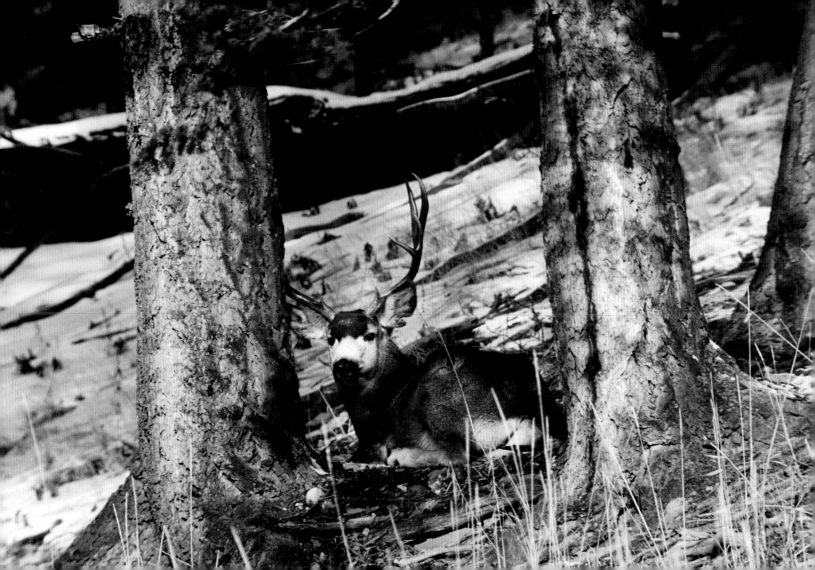

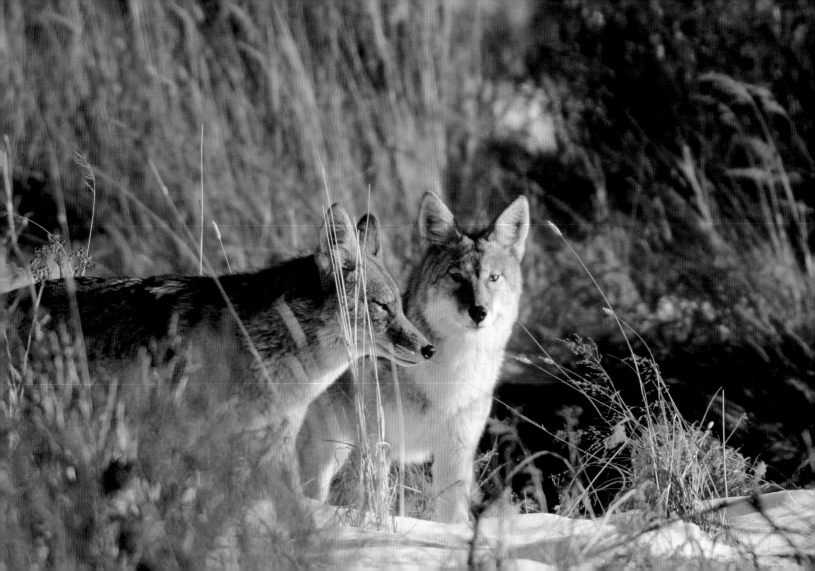

December 14

Where you find elk in winter, you will usually find coyotes. Winter-killed elk are an important source of food for all predators. Coyotes will sometimes help matters along and attack winter-weakened calves. The calf's mother will try to put up a defence if she has the strength.

Colorado

December 15

Mule deer are more likely to attack predators than whitetails. Coyotes that wander too close to a mule deer are very likely to run off. There is even a report of a buck mule deer killing a cougar.

Alberta

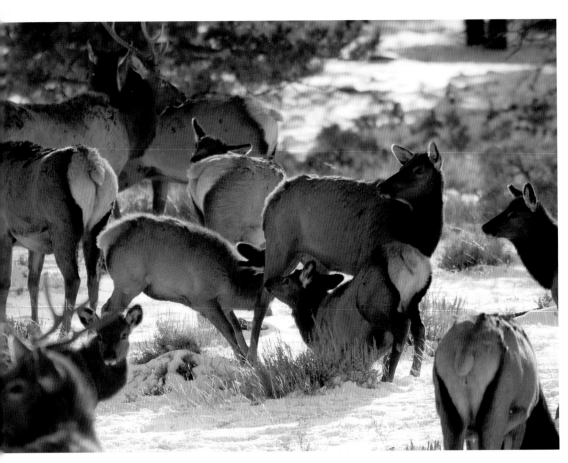

December 16

An elk calf will try to nurse from its mother this late in the season, but she is unlikely to tolerate it. She needs to conserve her energy for the months ahead. The second calf trying to steal a meal is not hers. As soon as she realizes what is going on, she will put an abrupt end to this bit of thievery. *Colorado*

December 17

Elk avoid snow depths of above 28 inches (71 cm). At depths of between 16 and 28 inches (41–71 cm), elk will stop pawing at snow to get to grazing and turn instead to browsing.

Colorado

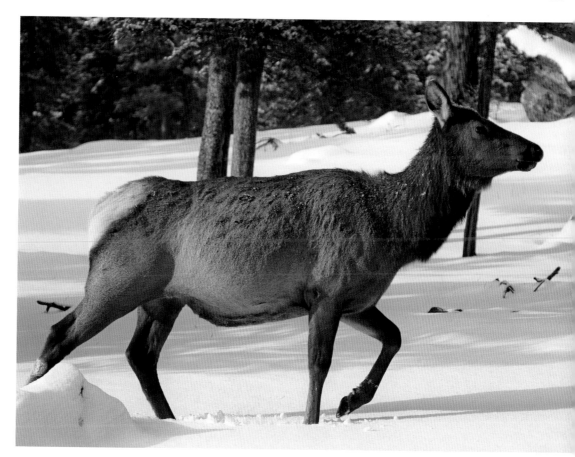

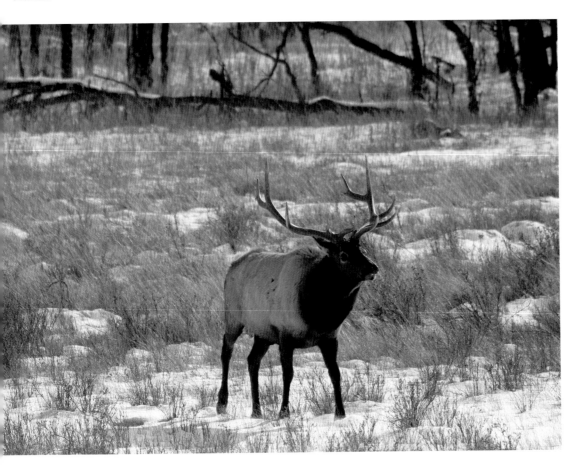

December 18

Elk are relatively easy to observe, especially in Yellowstone, Grand Teton National Parks in Wyoming and Rocky Mountain National Park in Colorado. Banff, Jasper and Waterton Lakes National Parks in Alberta also offer good elk viewing. They are just a few of the places where I've enjoyed watching these animals. *Colorado*

December 19

There are over a million elk in North America today. Of these, between 90,000 and 95,000 live in Canada. The five states with the largest elk herd (as of 1995) are Colorado (250,000), Oregon (120,000), Idaho (116,000), Wyoming (102,000) and Montana (93,000). *Colorado*

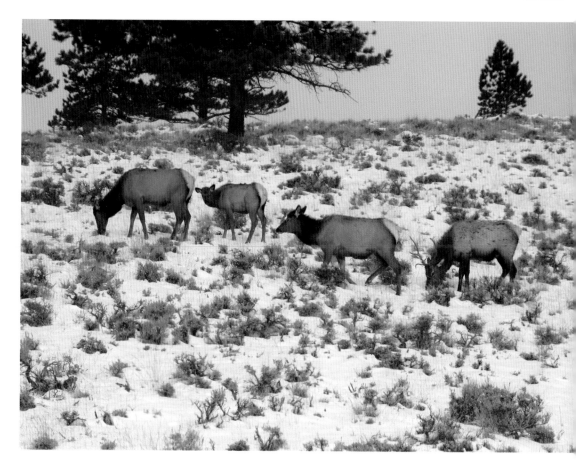

December 20

The trumpeter swan *(Cygnus buccinator)* is the largest native North American bird. Males measure from 57 to 64 inches (145–163 cm) and females range from 55 to 60 inches (139–150 cm). They weigh between 22 and 26 pounds (10–11.8 kg). *Ontario*

December 21

Otter are always a joy to encounter. They are curious creatures and will sometimes stay for a while to watch you watch them. They feed primarily on fish and crustaceans. As with other furbearers that were trapped out in the 1800s, the otter population is once again stable or growing thanks to reintroduction efforts. *Ontario*

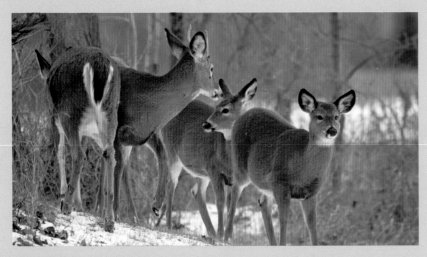

December 22

White-tailed deer form larger herds in the winter. These herds will stay together until the spring green-up, when they will begin to disperse. Deer will yard up only if the snow is too deep or icy for them to move about freely. They seem able to sense when a big snowfall is coming and move to a deer yard before it hits. A typical deer yard will have numerous well-established trails, which give them access to food and allow them to flee from predators. Deer will leave the yard as soon the conditions allow them to. Deer yards are found on the northern fringe of the whitetails' range. *New York*

December 23

Because of their greater bulk, bucks tire more rapidly than does. They will sometimes flee into a group of other whitetails to confuse their pursuers. Often this succeeds in diverting the pursuing predator onto another deer. They use this tactic when pursued by domestic dogs; the larger breeds of domestic dogs running off leash are a real threat to deer. *Ontario*

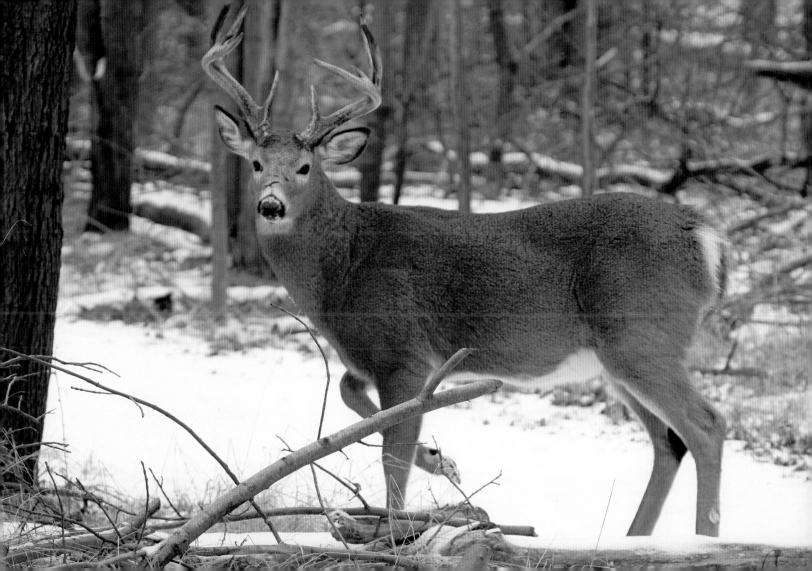

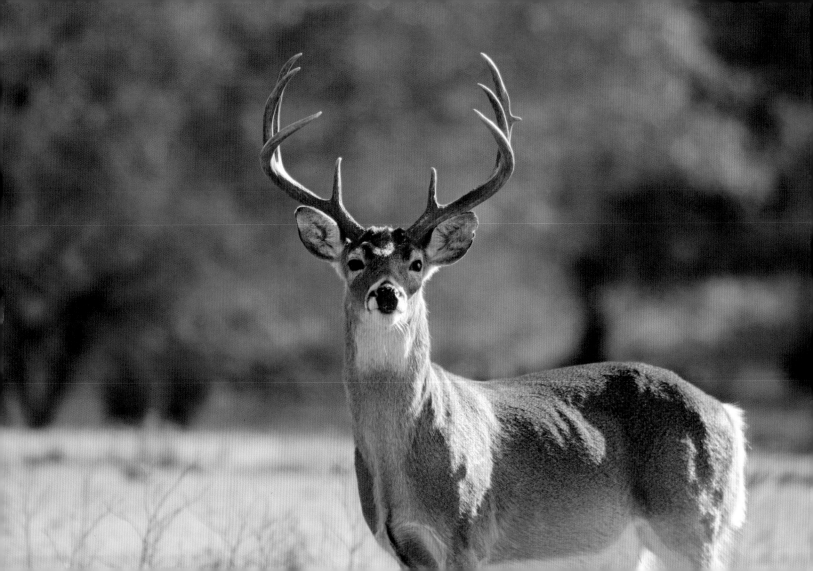

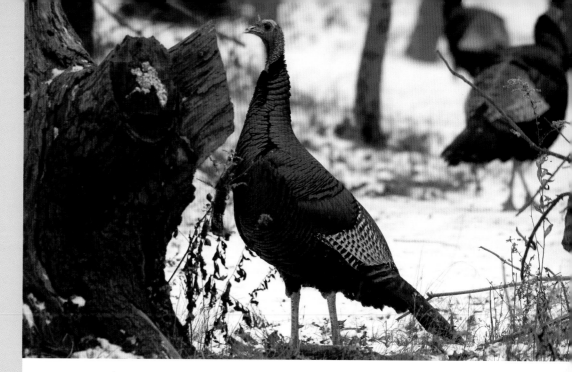

December 24

While white-tailed deer in the north are coping with the challenges of winter, southern deer are enjoying the balmy weather. Wherever I find them they add to my enjoyment. *Texas*

December 25

The eastern wild turkey is the most abundant of the five races found in North America. It is found in the eastern half of the United States and in the Canadian provinces of Manitoba, Ontario, Quebec and the Maritime provinces. Currently the population is estimated at something between 5 million to 5.3 million birds. Males are polygamous and will occupy a territory that overlaps that of several females. Territories are maintained only during breeding season. In the winter the birds have once again grouped into distinct flocks of makes and females. *New York*

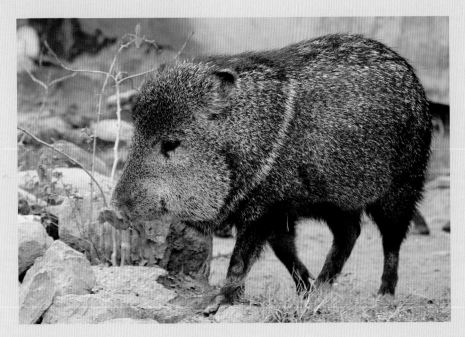

December 26

Javelina breed all year long. Their mating season depends on when the rain falls. Each herd has a dominant male, and he does most of the breeding. Females usually give birth in den, either a hollow log or a natural cavity in the ground. They leave the herd to give birth but rejoin it a day or so after the young arrive. *Arizona*

December 27

Predators are essential to the health of any ecosystem. In the past the uncontrolled slaughter of wolves and cougars upset the natural order of things. There was a time when they were our direct competitors for the wild animals we ate. Perhaps control measures were justified then. Today, the role of cougars and wolves is a necessary one if we are to truly have wild country to enjoy. *Montana*

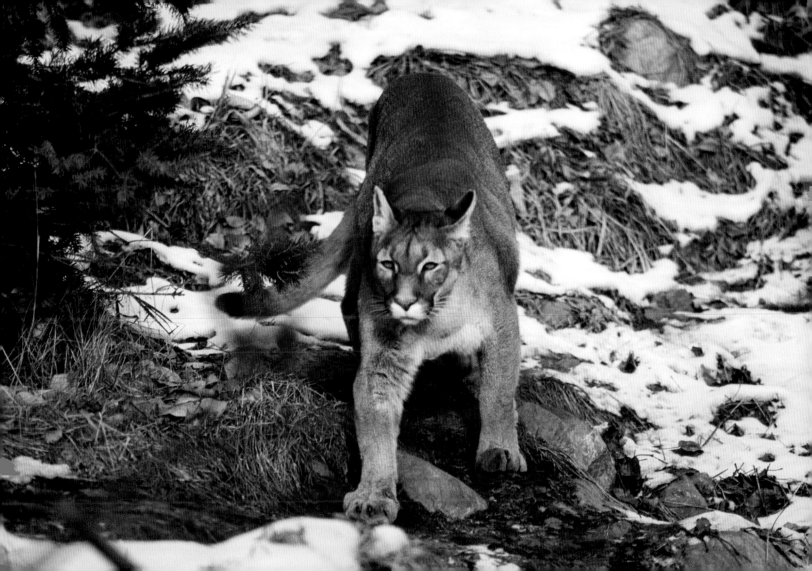

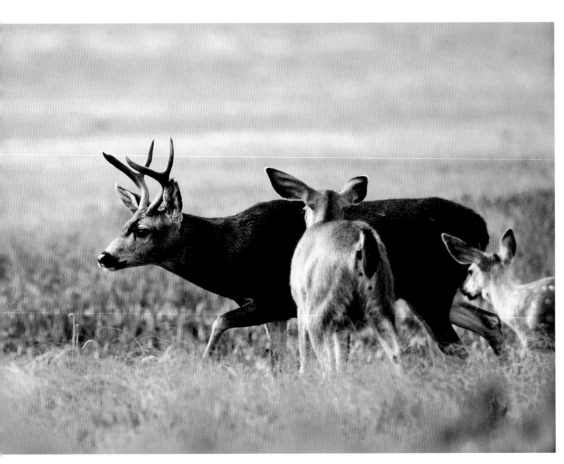

December 28

Black-tailed deer are smaller on average than whitetails and mule deer. They will use a wide variety of habitats on the west coast from Alaska to California. With all the riches found along the coast, it might be expected that these deer would be larger, but appearances are deceptive. There is not as much food available to them due to the maturity of the forest. They make use of blow-downs, logging areas and burns.

California

December 29

Mule deer will feed in the open during the day more readily than will whitetails. They will often venture far from cover if there are no wolves in the area. Mule deer bucks, after they drop their antlers, are much more likely to join a herd than white-tailed bucks are. *Wyoming*

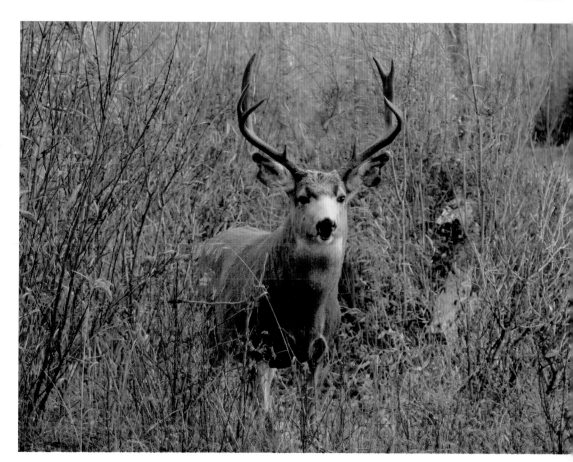

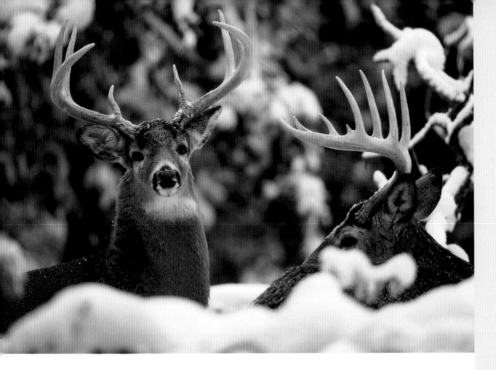

December 30

While mule deer tend to select areas of low predator density, it is not clear that whitetails do this as well. Since whitetails are more territorial than mule deer, it seems likely that they do not do this, but as yet no one really knows for certain. *New York*

December 31

These two bucks are equally matched. Both sport antlers that are roughly the same size. During the rutting season they will solve disputes over a female by fighting. Antlers have evolved to allow the deer to bring their antlers together in such away that little serious, damage is done to the opponent. Should an antler break, serious injuries could result. Sometime antlers lock, condemning both bucks to a slow death by starvation. *Ontario*

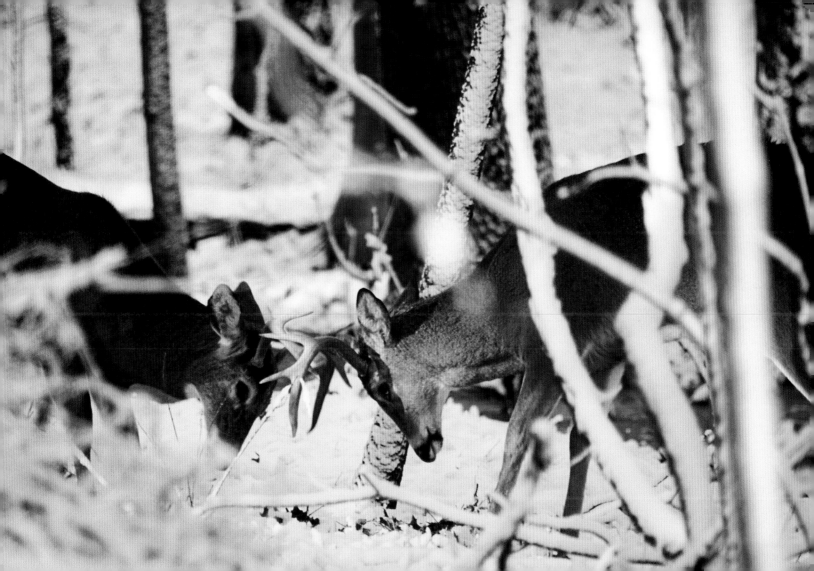

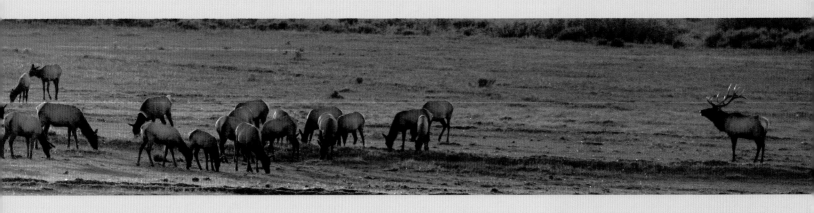

In the evening a bull and his harem emerge from the woods to feed. The best elk-viewing is in the hours before dusk and dawn.